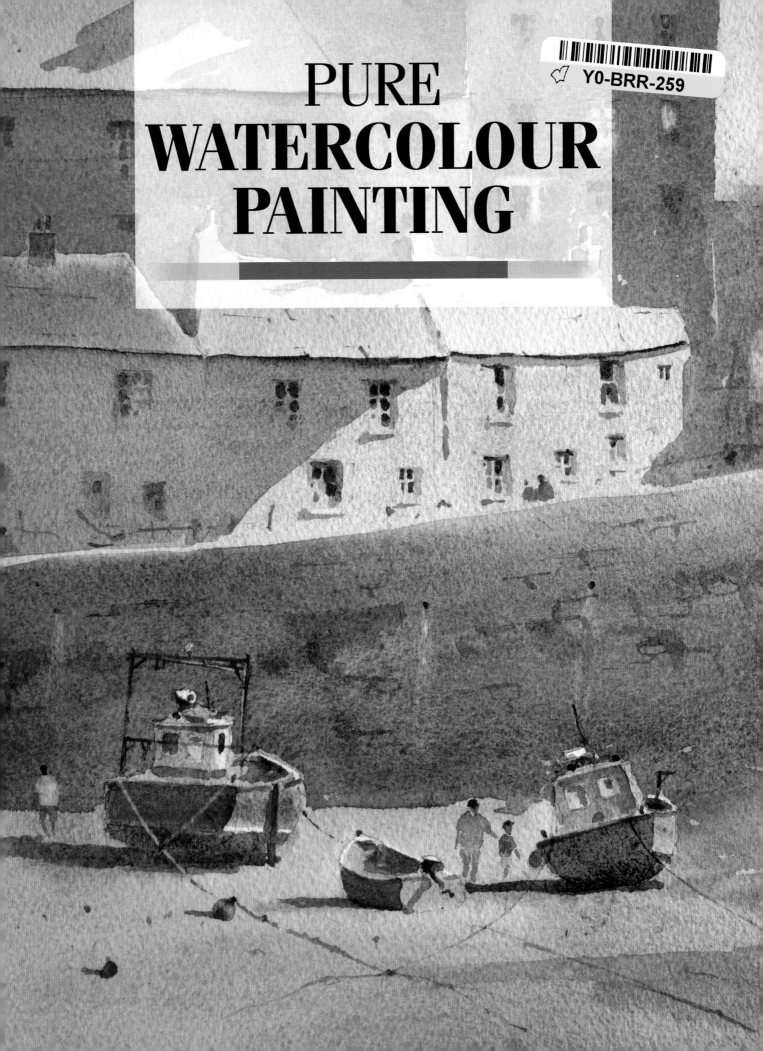

PURE
WATERCOLOUR
PAINTING

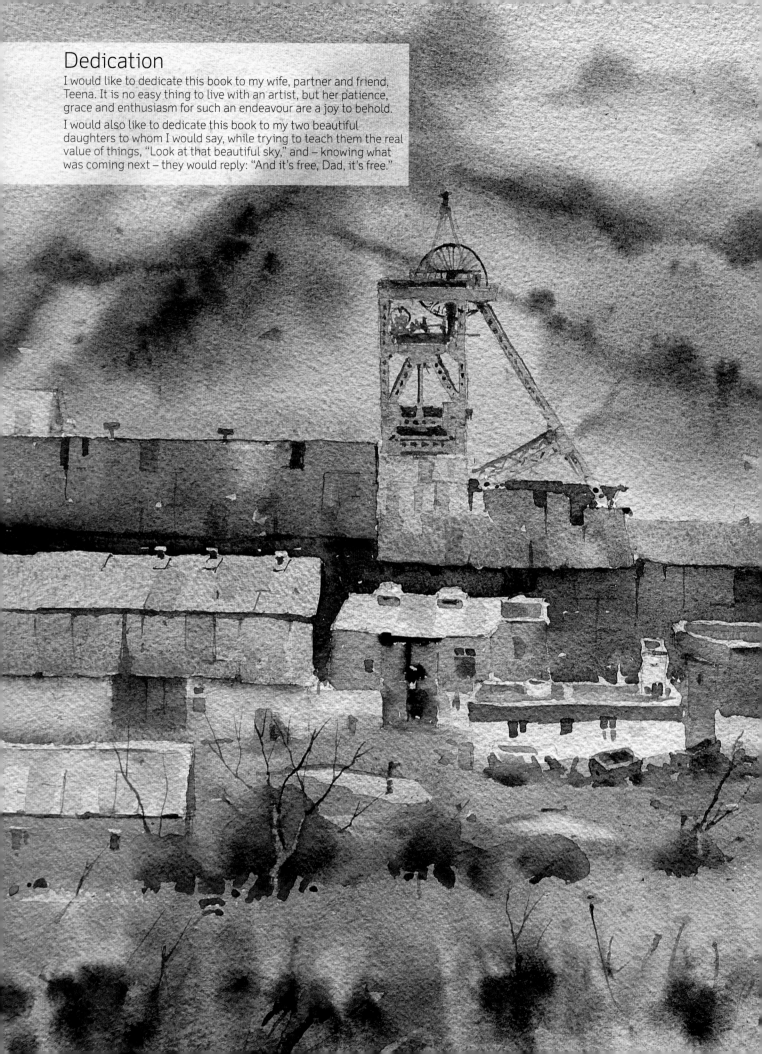

Dedication

I would like to dedicate this book to my wife, partner and friend, Teena. It is no easy thing to live with an artist, but her patience, grace and enthusiasm for such an endeavour are a joy to behold.

I would also like to dedicate this book to my two beautiful daughters to whom I would say, while trying to teach them the real value of things, "Look at that beautiful sky," and – knowing what was coming next – they would reply: "And it's free, Dad, it's free."

Peter Cronin

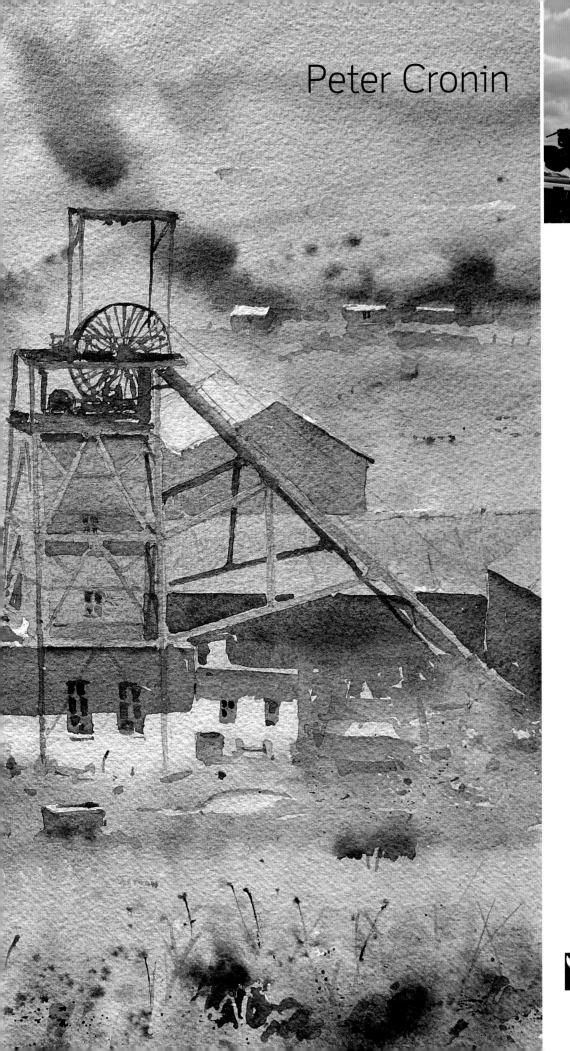

PURE Watercolour Painting

Classic techniques for creating radiant landscapes

SEARCH PRESS

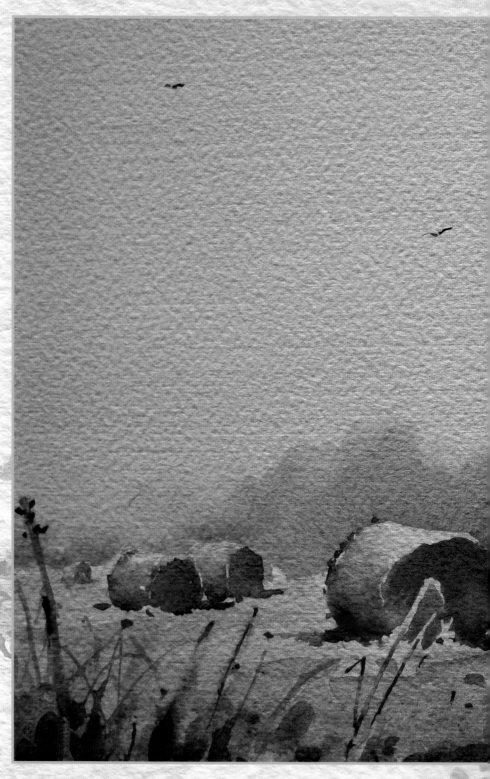

First published in 2018

Search Press Limited
Wellwood, North Farm Road,
Tunbridge Wells, Kent TN2 3DR

ISBN: 978-1-78221-435-9

Suppliers
If you have difficulty in obtaining any
of the materials and equipment mentioned
in this book, then please visit the
Search Press website for details of suppliers:
www.searchpress.com

Printed in China through Asia Pacific Offset

Cover:
Polperro Corner
Polperro is an old fishing village in the
UK, and I stayed there for a week trying to
untangle the maze of streets, buildings,
boats and trees.

Page 1:
Tenby
I think I must have been a crab in a
previous life, because I just love being
around, and in, harbours like this delightful
scene painted in the seaside town of
Tenby, in western Wales.

Pages 2–3:
Merthyr Vale Colliery
Scenes such as this once littered the
valleys of southern Wales. Although not
immediately attractive, they appeal to me
on an emotional level. There is an infinite
variety of subject matter contained within
the genre of landscape painting, and in
time we learn to tune in to the facets that
stir our creative juices.

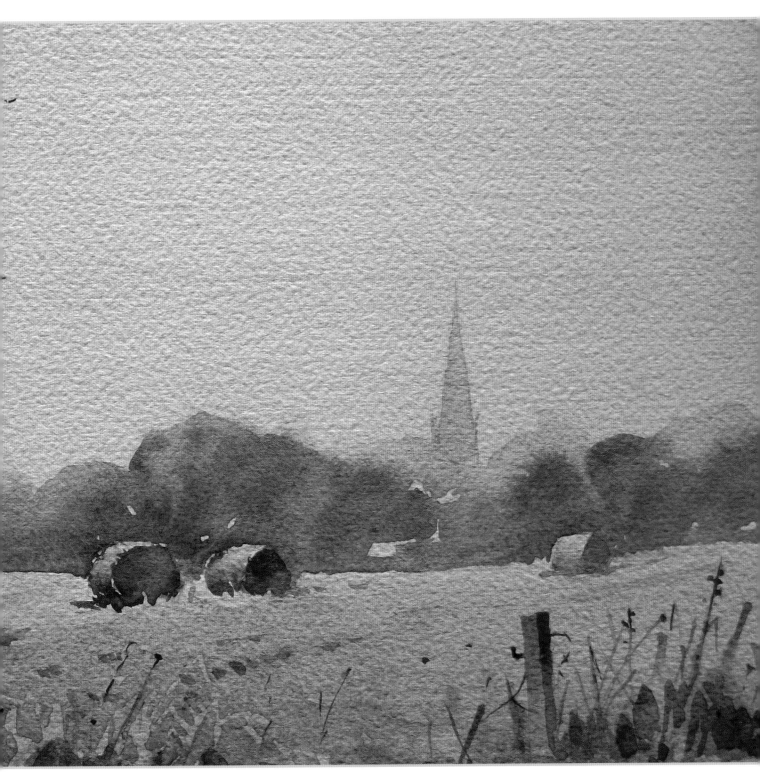

Above:

Hay Bale Haze

I find a quietness in such scenes as this, and I keep soft edges here and there to emphasise the mood of calm contemplation that seems to pervade on such mornings. At one point I could even hear the distant church bell.

Acknowledgements

Leaving a steelworks and supporting oneself as an artist is not for the faint-hearted. I must thank all those who nudged me onward when those unavoidable doubts crept in: my wife, students, friends and buyers who, at times, appear to have more faith in my abilities than me.

Thanks are also due to the two Davids, Curtis and Bellamy, who have so generously put pen to paper on my behalf. Their work has been a great inspiration to me, long before I put brush to paper.

Finally, I must applaud the sterling efforts of Edward 'the editor' Ralph and all at Search Press for presenting me with the opportunity to write and support in the production of this book.

Sunday Morning Sun, Cardiff

British cities remain a little quieter on Sundays, but, alas, this is slowly changing in the 24/7 world. I have passed this road many times, but the backlit, fused nature of the scene on this particular morning excited me tremendously.

CONTENTS

Opposite:
Venice Canal

My long-suffering wife says that I run around Venice like a terrier after its favourite treat. I cannot help it. I start off at a brisk walking pace which quickly turns into a march and, as I spot a subject, I confess that I will on occasion break into a jog. Only after finishing the sketch will I realise that I am lost, alone and have possibly (definitely) upset said wife; once found, I am punished by being led to a café to eat cake and study the art of being a 'normal couple'.

On the positive side, such an approach leads to spontaneous finds like this bridge. Notice how all the shapes, with the exception of the white building and boat, are fused so that the painting too busy.

6

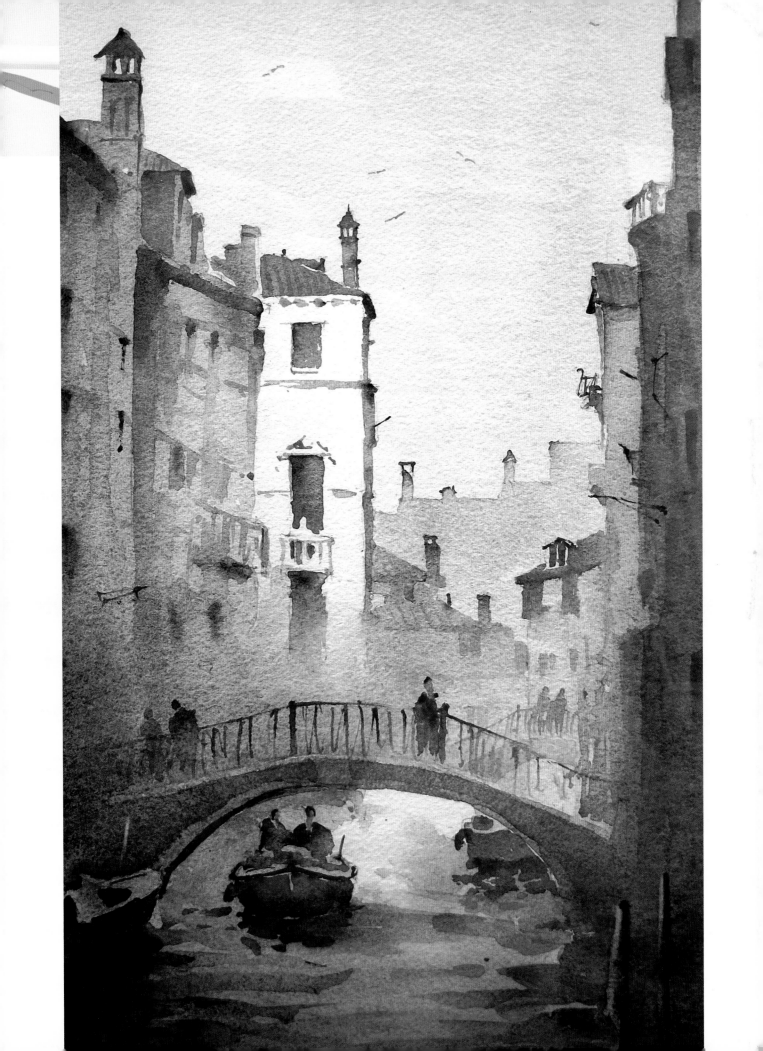

FOREWORD

BY **DAVID CURTIS** AND **DAVID BELLAMY**

I am delighted to have been asked to pen this foreword to Peter's new book. Here is a painter whose enviable skill has been honed by many years of diligent observation of the world around him. In choosing the pure watercolour medium, Peter has set himself the task of interpreting all he sees using one of the most elusive and transient media at his disposal. Within these pages, there are numerous examples illustrating superb technique, fine compositional value and exquisite handling of this loose, direct and vibrant watercolour approach.

Beautifully transparent washes are evident in all his work, which is never overstated and is mostly painted on the spot in a single session. There is a sublime honesty in Peter's paintings – the images convey such a wide range of subjects, all buzzing with light and life.

This book is a feast for the eye and will appeal to all who embrace the fascination of the watercolour medium – emerging practitioners and experienced painters alike.

David Curtis *is a member of the Royal Society of Marine Artists and the Royal Institute of Oil Painters. He has penned a number of books on both watercolour and oils.*

Watercolour is not the easiest medium to handle, especially in its purest form, and many students turn to other, less technique-driven media to satisfy their creative passions. In most contemporary exhibitions mixed media is now regularly introduced into water-based media, and increasingly the more traditional watercolour skills seem to be less in evidence.

It is therefore a great pleasure to see Peter Cronin putting together a book on pure watercolour with his inspirational landscapes in which light and atmosphere play a crucial part. His enthusiasm for the medium shows through in every brush-stroke and you will benefit from examining his beautiful, clean washes, laid with great assurance and dexterity, and those masterly touches of fine detail here and there that reveal an artist well in command of his working methods.

As we all know, it is easy to overwork a composition, so take advantage of this superb book and note how Peter effortlessly creates a sense of apparent simplicity – especially those devilish foregrounds, where even the most straightforward can at times stump the best of us. Take note also of his use of colour, with so many vibrantly rendered passages, and how even dull, snowy scenes in his approach can evoke a feeling of winter cheer that you can recall when sat in front of a warm fire.

Study this book not just for the sound, practical advice, but also for the inspiration you will find in these exquisite images to help you produce exciting new compositions in pure watercolour.

David Bellamy *is a well-known and award-winning artist, tutor and author of a number of books on watercolour.*

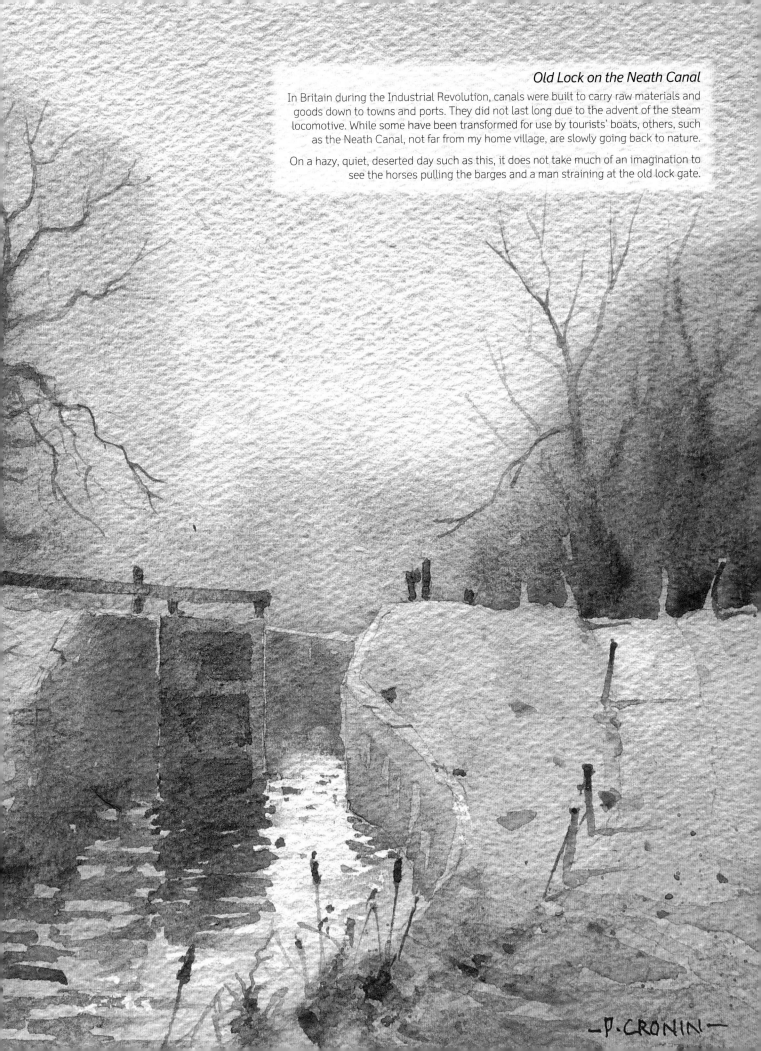

Old Lock on the Neath Canal

In Britain during the Industrial Revolution, canals were built to carry raw materials and goods down to towns and ports. They did not last long due to the advent of the steam locomotive. While some have been transformed for use by tourists' boats, others, such as the Neath Canal, not far from my home village, are slowly going back to nature.

On a hazy, quiet, deserted day such as this, it does not take much of an imagination to see the horses pulling the barges and a man straining at the old lock gate.

—P·CRONIN—

INTRODUCTION

Today, the leisure painter and professional artist are presented with the largest array of art materials ever available. Art material fairs now resemble sweet shops, with lots of new 'flavours' and 'tastes' to sample. I must admit I sometimes wonder what it is all about. Don't get me wrong; I am all for new and inventive ways of doing things, but how much is marketing, and how on earth did past masters manage to produce anything of merit, given that they did not have the massive assortment of bits and pieces available to the modern artist?

One may suspect that perhaps there is more to good painting than a huge toolkit, and that it may be possible to take simple tools and use them well. This concept and approach to painting are at the heart of pure watercolour.

Evening Field

I much prefer bare trees to summer greens. I do not think that I could be called a painter of 'happy' scenes. To me, happy, exuberant paintings have lots of gaudy colour and hard edges. I prefer nature's softer, quieter side. I like feelings of peace, serenity and, on occasion, even melancholy.

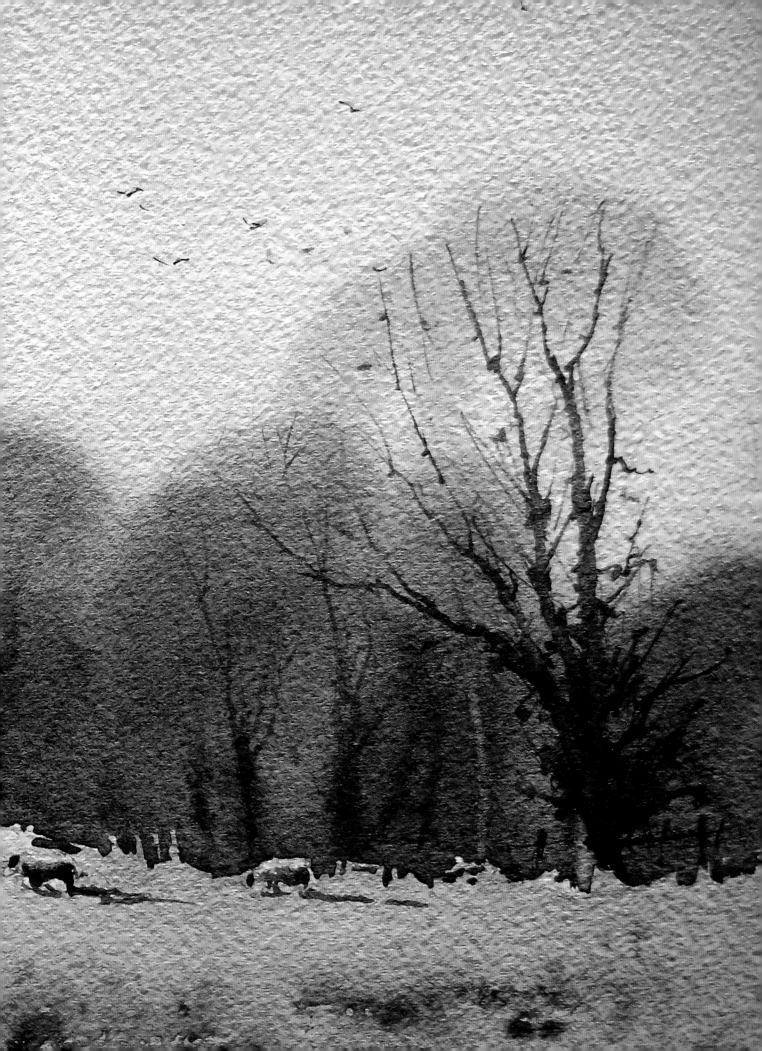

In essence, watercolour is a spectacularly simple medium, yet some describe it as fiendishly difficult. There is no doubt that it is high on craft, but this is what facilitates the huge potential for endless progression and joy. We are involved in a journey of discovery that has no end. For me, watercolour has become a temperamental friend and a critical companion. I now understand some of its ways – how it gets moody and uncooperative on very hot days and its other quirks. It is obvious too, that I now paint to a far higher standard than when I started all those years ago, but the thrill has always remained the same.

In these pages I offer you my interpretation of a very special medium. There are, of course, other interpretations, but the wise reader may discern enough common ground to add to their own repertoire of ways and techniques.

The book starts with a look at materials. There is an overload of information available regarding to various paints, papers and other painting materials, so this area is intentionally kept brief and deals with what I consider to be the 'essential ingredients' for cooking up a watercolour.

We shall look at the necessity of a good set-up, using simple equipment and sound basic techniques for both dry and wet paper. The merits of both indoor and outdoor working are discussed and compared, along with the role they play in honing and developing our painting skills. This section of the book also introduces and explains the necessity of planning a painting and the methods employed to facilitate this. We shall also have to confront, briefly, the ogre of drawing – though let me reassure you that it is not that painful really – and its value to the journey we are to undertake. Do pay due attention to these early sections of the book; they are the prerequisites, the fundamental elements of good watercolour.

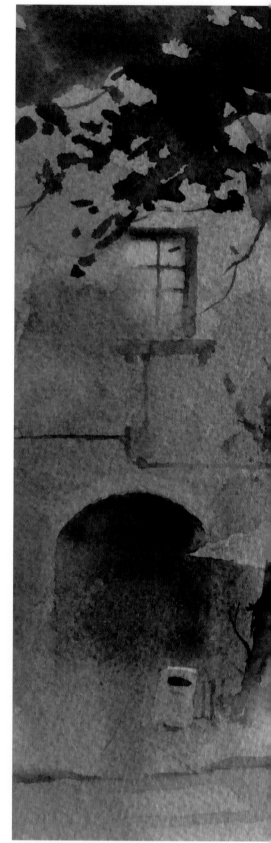

The Waiter – Lucca, Tuscany
The nature of painters and poets is to watch and look. To pick out small pieces of time and place, then present them as words or images, to see the romance in the mundane.

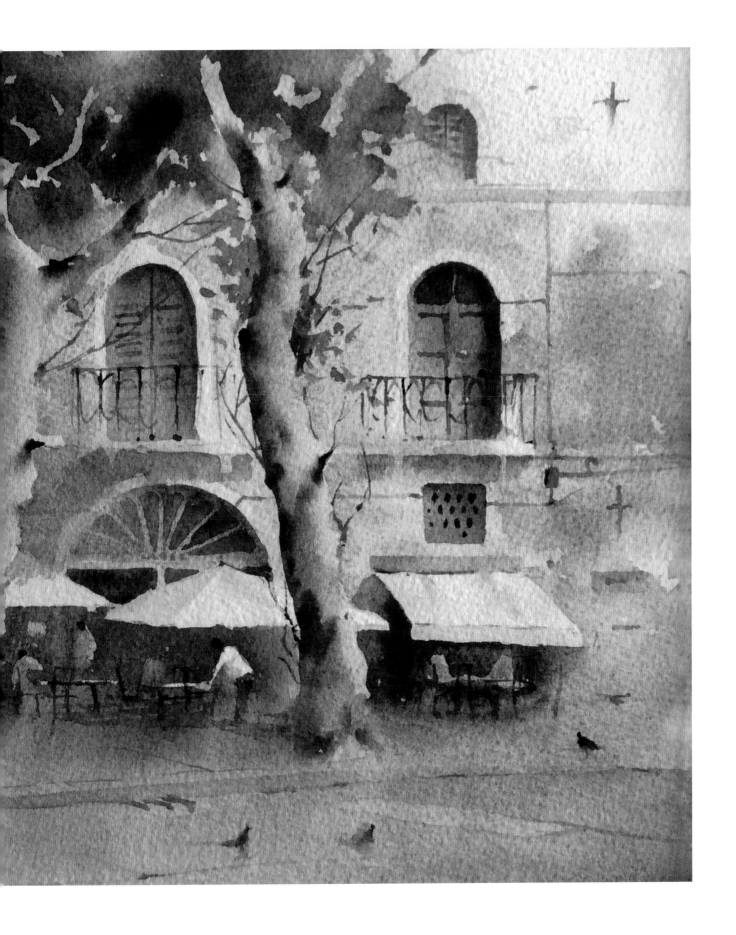

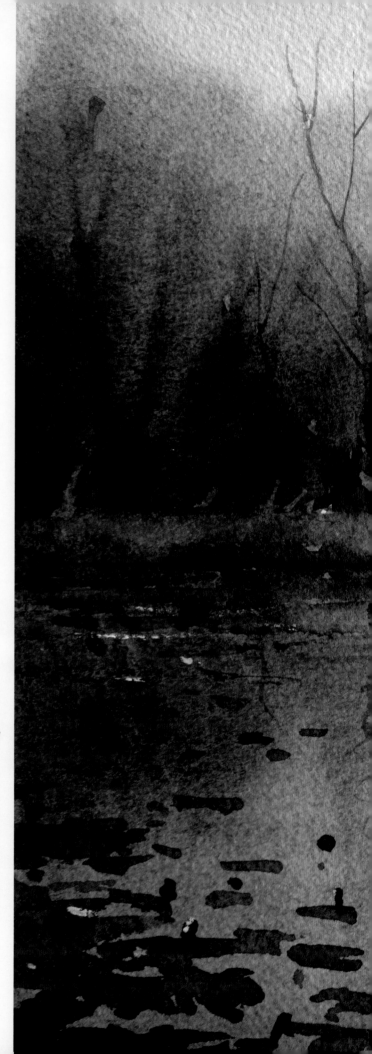

Having established how to apply fresh watercolour, it is on to the exciting business of how to turn subject matter into luminous, clean paintings. The ability to translate and distil a scene is often what separates the novice from the more experienced artist. This is the theme of the second part of the book, where we look at strategies and methods to achieve different moods in pure watercolour.

It is true that painting well in any medium is a demanding business, but it is also one of the most satisfying and intense experiences available to us as human beings. If diligent study of this book contributes in any way to the progress of your own artistic endeavours, then my fumblings with the written word contained within these pages has been well worthwhile.

Pond in Hensol Wood

I arrived very early in the morning. It had been a mild winter and a fair amount of water lily leaves still lay on the surface. There was a nip in the air but as I painted I could hear the croaks of the frogs in the reeds telling me that spring was around the corner.

While waiting for the initial wash to dry enough to put it over the camping stove, I was doing my usual jigging and dancing about to keep warm. At this point, I suddenly became aware that I was being watched by an elderly man and his bewildered dog as they approached. The two drew closer and, without looking up, the old chap said, "I do hope you're a better painter than you are a dancer."

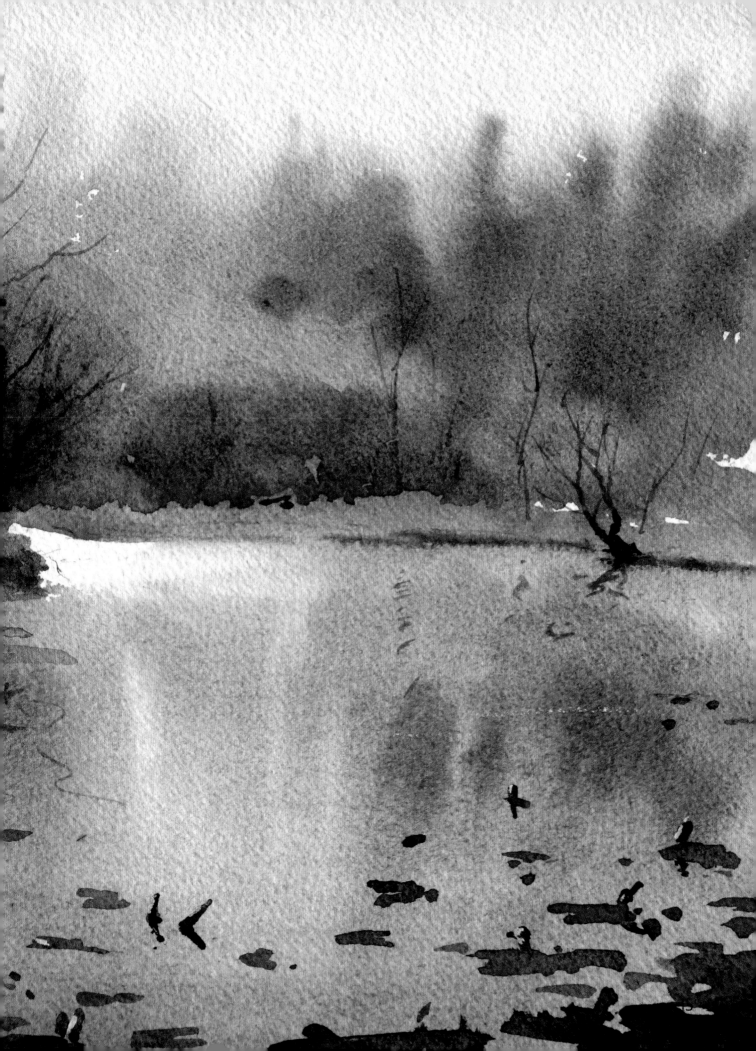

MATERIALS

In this chapter we shall discuss materials and equipment with regard to both the quantity and quality required. Let us consider what materials we actually need to paint a watercolour and discuss the various merits, or drawbacks, of our choices. We obviously require paint and water. Then we require something to paint on – paper – and finally something to paint with – brushes. The soundest advice when selecting materials is to choose as few as possible and the best quality you can afford.

It may sound a little harsh but, if possible, discourage family and friends from buying you art materials as presents unless they know what they are looking for – however well meaning and generous, most people will buy for quantity, through simple lack of knowledge on quality. This happened to me when I started, and I ended up with a paintbox containing more colours than a sweet shop, scores of little brushes that were perhaps suitable for painting a model aeroplane and a pad containing a generous fifty pages of 'watercolour' paper that was so thin it would be better suited as tracing paper. Of course, if they insist, you could nudge them in the direction of gift vouchers instead.

In short, rather than having large amounts of cheap materials, the watercolour artist is best equipped with a few quality items. If the budget is very tight, I should go for paper, paint and brushes, in that order of quality.

Pack just what you need

I once met a lady who brought a suitcase to an outdoor painting session. Just in case she found she needed something, she had brought everything. It took her an age to haul the beast to our painting spot (I was expecting to see Sherpas in attendance), by which time she was exhausted. She then spent another twenty minutes digging around trying to find the right bits and set it all up. When finished it looked like a bric-a-brac stall! She was now doubly exhausted – and ten minutes or so later, when I looked across to see how she was progressing, I found that she had given up in frustration and fallen asleep.

We have all overpacked to a degree, but, generally, the more experienced painter will have whittled down his or her equipment to that which is practical and to those items that they actually use.

PAPER

Watercolour paper is specially made for the job. Different papers have different characteristics, and how you paint will influence your choice of paper. It is commonly available in different weights and with three types of surface finish:

Hot-pressed Also called HP, this type of paper has a smooth finish and is my least favourite surface.

Not Short for 'not hot-pressed', this paper is also sometimes known as cold-pressed or CP. It is neither as smooth as HP paper, nor as textured as rough surface paper. This is a popular surface for watercolour with many artists.

Rough This type of paper has a heavier texture or 'tooth', which I prefer due to the way it promotes granulation in certain pigments and because the texture actually becomes part of the painting.

The weight of watercolour paper determines the thickness of the sheet. Paper weights range from relatively thin 200gsm (90lb) paper to heavyweight 640gsm (300lb), though the most commonly used weight for painting is probably 300gsm (140lb), which combines the best of both worlds.

I think paper is the most important of our materials, yet many students choose their paper purely on price. If you use your best paint on cheap, badly-made paper, the result will still be substandard when compared with a work made with quality paper and student paint. The minimum quality paper for a student is probably Langton or Bockingford 300gsm (140lb), and I would go for a rough surface texture.

I use 300gsm (140lb) rough surface paper from Saunders Waterford and Arches for most of my work. I often use Arches 640gsm (300lb) rough surface paper as well, and this is probably my favourite paper on which to paint because of its surface, which is rougher again than the 300gsm (140lb), and the beautiful way it takes washes.

Stretching paper

Paper can be stretched to stop it buckling and distorting when it is wet – this is particularly important for lightweight paper. The paper is soaked with clean water to make it expand and then secured to your painting board so that it cannot shrink back as it dries.

A stretched piece of watercolour paper is a delight to work on and I stretch paper for all my serious work. Every watercolourist has their own way of stretching paper. Here is mine:

1 Soak the paper in a tray of water for approximately five minutes, assuming 300gsm (140lb) paper. Soak heavier-weight paper for longer.
2 After soaking, lift the paper out of the tray and allow the excess water to drain off. Lay the paper flat on your painting board and use kitchen paper to wipe away some more water from the edges to take the tape.
3 Moisten the gumstrip tape by pulling it across the dampened sponge, then press it down firmly, half on the paper and half on the board, all round the edges of the paper.
4 Lay the board flat to dry naturally at room temperature.

WATERCOLOUR PAINT

If we consider the fact that there are three primary colours (red, yellow and blue) and that all other colours are mixed from these, then we can more easily understand the logic of what painters call a 'limited palette' – that is, a small number of colours which you get to know well.

Most experienced artists favour a limited palette as it produces unity in a landscape painting, is easier to use and makes it cheaper to purchase artists' quality paint (as opposed to cheaper students' quality). My palette contains the following colours:

Cobalt violet This adds life to cerulean blue and raw sienna; it also granulates in the first wash.

Cerulean blue My favourite blue. and a well-used colour for my boats.

Cobalt blue My general purpose, all-round blue.

Ultramarine blue I mainly use this to darken colours. In combination with burnt sienna, this blue produces a strong dark.

Ultramarine violet Mixed with raw sienna or burnt sienna, this makes for warmer darks. It works well with Hooker's green too.

Burnt umber A seasonal guest in my palette, I mainly use burnt umber for winter foliage.

Cadmium red A strong and dominant primary colour, cadmium red is best used sparingly to add a splash of colour.

Burnt sienna Useful for warm darks in foliage and, in combination with Hooker's green, great for trees.

Cadmium orange Another good boat colour, this will mute blues (i.e. make them grey), and makes a nice aqua green when combined with cerulean blue.

Hooker's green I use this sparingly, mainly in combination with burnt sienna for tree greens.

Lemon yellow Used mainly for ground greens, this is a useful primary.

Raw sienna A useful all-round colour; this mixes well with blues to create greens.

Light red Used only occasionally; and then only to relieve a boring reliance on burnt sienna.

BRUSHES

I don't treat brushes very well, so I don't buy the most expensive. However, a cheap brush is a near-useless tool for watercolour painting, so I buy mid-range brushes and change them often – though perhaps not as often as I should!

With over thirty years of painting experience behind me, I have gradually refined my brush case to holding just these six staple brushes: two large mops; round sables in sizes 12, 8 and 6; plus a rigger. The round brushes do the bulk of the work, while the mops and rigger are used for especially large areas or small details.

Mop brushes are very large brushes that hold a lot of water. Mine have squirrel hair bristles and are so old I can no longer read who manufactured them. The rigger is a brush with very long, thin bristles. It is used to draw long clean lines.

I prefer sable hair for my round brushes because of their greater capacity for holding water than synthetic bristles.

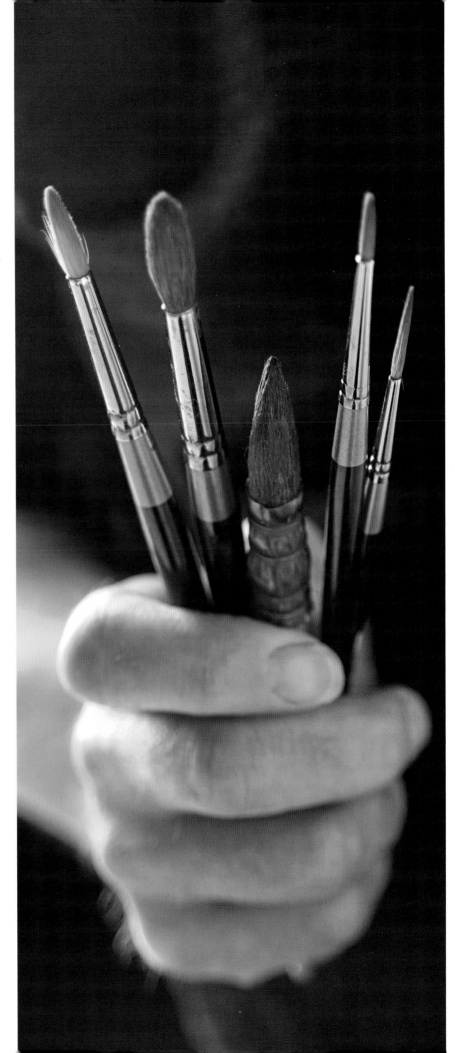

MATERIALS FOR PAINTING IN THE STUDIO

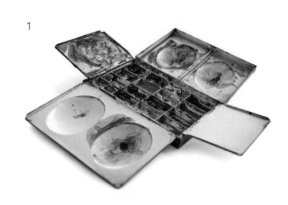

Not everyone is lucky enough to have a dedicated studio, but then not everyone needs a studio. If you only paint occasionally, as a light pastime, then there is no need to set aside a separate space that will hardly ever get used. If you are moderately serious, then having a table where you can leave things set up will be useful. For a professional artist and anyone who paints and frames a fair volume of work, a designated room or studio is an essential part of the set-up.

Whether you use a permanent dedicated space or a temporary place to paint, you will need some additional materials and tools for watercolour painting indoors.

Palette (1) I tend to use a small palette that can be held in the hand for outdoor painting. The interesting thing to note about the palette is that it contains egg-shaped wells to contain puddles of colour (for dry paper work) and angled plates (for stiffer wet-in-wet mixes). It is handmade from a brass sheet and, when clean, is a work of art in its own right. I do not like the way a pool of colour separates to form globules on a plastic palette, but they are lighter to carry (and you do not have to wear a woollen glove to hold the palette in winter, as plastic is warmer than brass).

Putty eraser (2) I try not to use an eraser, as they can damage the surface of the paper. However, in an emergency, a soft putty rubber is a safer bet than a hard plastic one.

Masking fluid and ruling pen (3) This is used sparingly to reserve white paper.

Hairdryer (4) I use a hairdryer in the studio only after very wet washes, and then only when the wash has soaked into the paper and is nearly dry. I try not to overuse my hairdryer because it is harder to put an additional wash on paper that has been warmed up. Also, being bright pink, it is a little embarrassing to bring out at the numerous demonstrations I undertake for art societies. I should like a black turbo model with go-faster stripes, but the second-hand shop only had this one!

Water pot (5) You can never have too big a water pot. I use only a slightly smaller one for outdoors. My water pots are old plastic beakers that I have pierced with a bradawl and threaded string through to enable them to hang from the easel. Ideally, your water pot should be within easy reach. This avoids you having to bend over repeatedly and generally makes your painting flow more smoothly and enjoyably.

Masking tape (6) I use this to protect the gummed tape that I use for stretching the paper from becoming overwet and thus unstuck while applying the initial washes. The resulting white paper left after removal also acts as a frame.

Propelling pencil (7) Unlike a standard pencil, a propelling pencil does not increase in thickness as it wears, which helps to keep your initial line work even and consistent.

White gouache (8) An opaque white paint, this is used very sparingly for the odd highlight here and there.

Kitchen paper (9) This is used to remove excess water from the brush.

Board (10) I use ordinary plasterboard and MDF on which to stretch my paper, thus ensuring a drum-tight surface on which to paint.

My studio

I have had many different studios. My present one allows me to have a number of easels in place and has copious amounts of storage – including drawers, cupboards, and a drawing chest that doubles as a mount cutting surface. It has a roof window for extra daylight, extending the time I have to paint. Most importantly, it is north facing, so there is no direct sunlight.

Some artists like to fill the walls with paintings or other inspirational items, but I prefer to leave them bare, because they reflect more light and are less distracting in an uncluttered state.

TOOLS AND MATERIALS FOR PAINTING OUTSIDE

Watercolour is made for the great outdoors. It is, or should be, a very portable medium that requires a minimum of equipment and is not as messy as other media. Its innate capability for soft diffuse edges make it ideally suited for catching the fleeting effects of light and atmosphere in your painting.

My outdoors kit consists of the following additional items, all of which, with the exception of the bigger easel, fit into a small backpack, leaving me 'hands free' to clamber over obstacles, check the map and, on one memorable occasion, to fight off a bull!

3B pencil (1) We don't require a plethora of pencils. A single 3B pencil will give us a full range of tones from the lightest light to the darkest dark.

Sketchbooks (2) The sketchbook is an invaluable tool. If the weather is too unsettled for painting then I usually sketch. I sometimes put some watercolour washes over the sketches too.

Brush case (3) Brushes kept in a brush case are more easily accessible and less prone to damage than ones buried deep in your painting bag.

Paint pot (4) An old sealable container makes for compact storage of my paint tubes.

Camping stove (5) This is – very carefully – used to gently dry my painting if the weather is very damp.

Camera (6) I always prefer to sketch outdoors, but will use a camera if I get rained off halfway through a painting, or to capture something I spot that is very fleeting.

Easel (7) You will need an easel on which to rest your painting board. I use a lightweight camera stand that I have converted to hold a lightweight piece of plyboard.

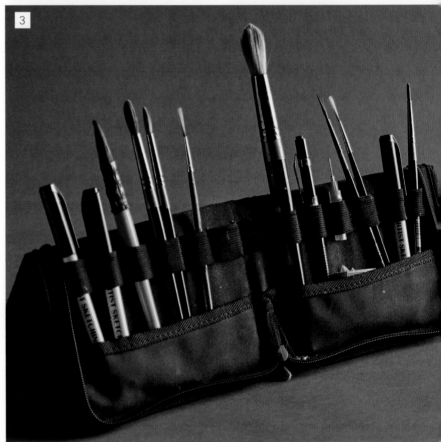

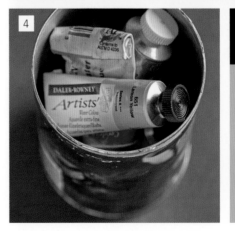

Outdoors comfort

Clothing for outdoor work is very important. It is surprising how soon one will become chilled while stationary. Lightweight but warm outdoor clothing is available to the artist and it is well worth the investment, as nothing stifles the creative juices more than wind chill.

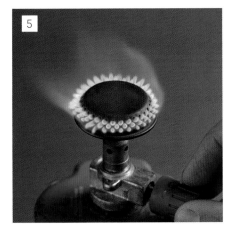

How to respond to onlookers

Painting outside almost inevitably attracts an audience. While a smile and some gentle conversation is not beyond me on a good day, I prefer to work in peace and undisturbed. If you prefer to be left alone, as I do, you might try some of these ideas – though I take no responsibility for those perhaps a little more tongue in cheek than others:

• If painting in a group, send the interloper to another member with the recommendation that they are far better and more sociable than you.
• Put a hat in front of your easel and put money in it. Be warned; one chap who, having 'paid his dues', decided I was the perfect audience for two hours of his structured tuition and criticism, despite his admission that he was "no expert".
• Speak in a foreign language. In my experience, one you make up as you go along is the most effective.
• Wear earphones, the bigger the better. Go for the ones that cover your ears, and shout in reply, as if you have really loud music playing.
• As a last resort, adopt an unkempt appearance and spit or burp at regular intervals and you'll soon find yourself in glorious isolation. Just avoid smelling of alcohol too, or you might find the police coming to give a critique on your work!

On a slightly more charitable note, if you are socially engaged while painting, you can turn your attention to the less demanding areas of the picture and revert to more complicated areas once your 'guests' have departed.

Tip

My wife, Teena, has suggested the advice above is perhaps a little cynical. Her sage advice for getting my audience to depart is to coax them away with pleasantries like 'It has been lovely talking to you, but I really must concentrate on finishing this,' – an improvement on my original draft of 'To be truthful, you're getting on my nerves now.'

I tried her approach once and it did work; though I think I may have spoiled it by piping up with "Drop a few coins in the hat as you leave!"

HOW TO USE WATERCOLOUR

True transparency and luminosity are unique to pure watercolour, and a fresh cleanly painted watercolour is a joy to behold.

The bad news is that in order to use watercolour in this beautifully transparent manner there are rules. Rules are not popular in some of today's trendy artistic circles, but rules there are. The good news is that there are not many, they are not hard to learn and once they are mastered, the rewards are sublime. As with any skill or craft, the ultimate goal is to absorb its technicalities into the subconscious, like driving a car, for example. What is required with painting in general, and watercolour in particular, is the ability to respond to the trials and tribulations of the process with an innate reflex born of knowledge and practice. This may sound like a daunting task, but the purpose of this book is to instill sound technique, passion, enthusiasm and confidence in equal measure.

In this chapter we shall look at the various ways of putting watercolour onto the paper. Time spent on mastering these techniques will be time well spent, as contained in this chapter are the fundamental building blocks of pure, clean watercolour.

Watercolour is alive

One of the most important things about watercolour is that it is 'alive'. What do I mean by this?

If we consider non-waterbased media such as oil paint or pastels, for example, the act of applying the pigment to the surface can take many minutes – or hours if we wish – but because watercolour pigment is suspended in water we must lay our pigment onto the paper before the water evaporates. We have only this window of time and we must work within it (most students are well capable of doing this, if only they would stop fiddling). Failure to do so will result in muddy disturbed colour.

This drying process can be slowed down in many ways: the time of day or year we paint, where we set up our easel and by how much water we use in the painting process, for example – I would never paint a watercolour in full sun on a summer's day or in midday heat. Watercolourists are a little like amphibians or slugs – we like to hang out in moist damp places. It is good to have a watercolourist around the house, as the heating bills will be drastically reduced.

On a more sensible note, if the paint on your palette has to be re wet often once the painting process is underway, then you are on very difficult watercolour ground and it requires some experience to obtain a clean result under these circumstances.

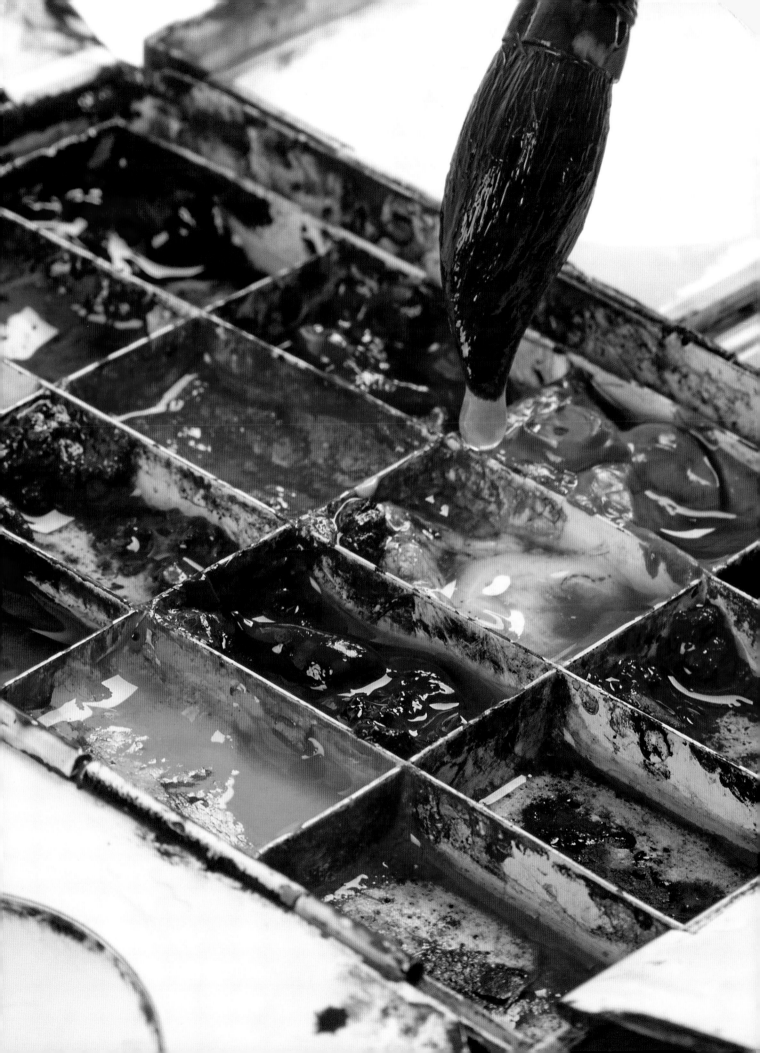

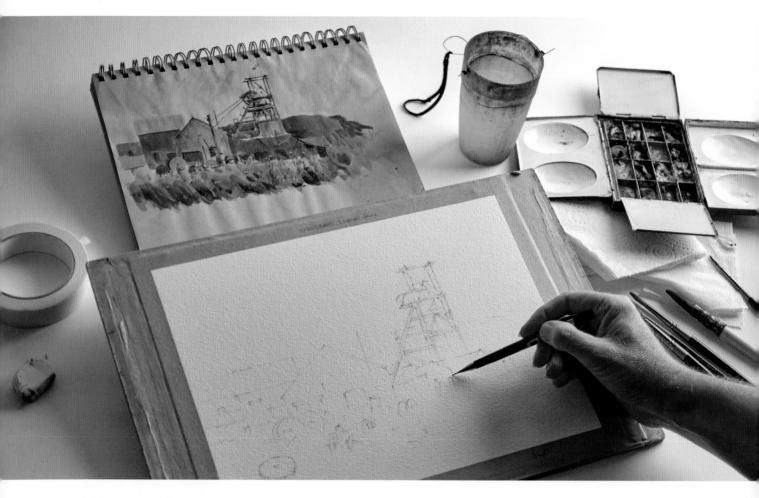

SETTING UP

When painting in pure watercolour procrastination and hesitancy are our enemy. Anything that can assist us in our quest to make accurate positive marks, free from timidity and doubt is worth investing in. This process starts with the correct set-up and preparation of our tools before paint is applied to the paper.

How many times have I seen students digging around in the bottom of their bag for a tube of paint (with a cap that takes a pair of pliers to remove)? How many people have their palette on one side of the painting with the water pot across the picture on the other side? This inevitably leads to dribbling unwanted paint and water across the picture surface. The image above shows an ergonomic set-up that has everything to hand. Notice that the materials are set up together (on the right side as I am right handed), the paints have been pre-wet to soften them ready for painting and the watercolour paper is tilted at approximately thirty degrees from the horizontal.

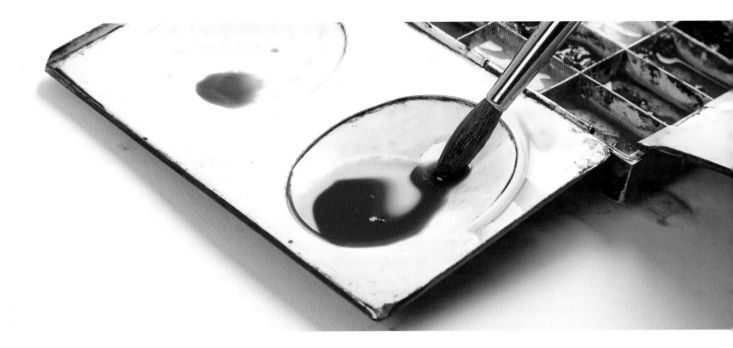

APPLYING WATERCOLOUR

Watercolour has to be applied to the paper in a wet manner. There are two basic ways to achieve this requirement. The paper surface can be pre-wet, in which case we are said to be working 'wet-in-wet', or we can place a puddle of colour (the bead) onto dry paper and draw it downwards in which case we are said to be 'laying a wash'.

PREPARING YOUR PAINT

Watercolour paint should be deposited into a reservoir of clean water already added to a well in your palette. The paints themselves should be pre-wetted in the palette in order to create rich, soft paint into which we can dip a brush. Using a damp brush, take some of this rich, moist colour and mix it into the water in the well of your palette to create a reservoir of fluid paint.

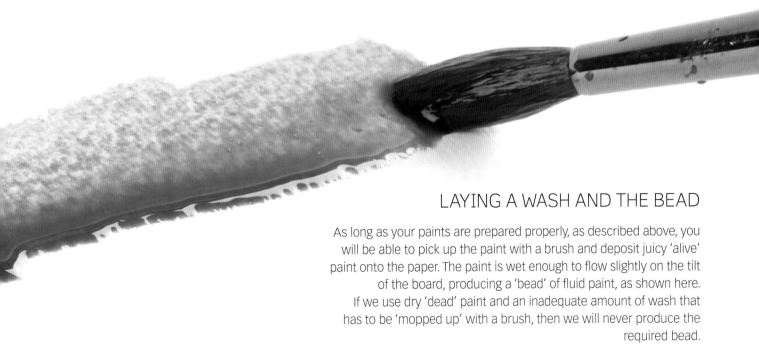

LAYING A WASH AND THE BEAD

As long as your paints are prepared properly, as described above, you will be able to pick up the paint with a brush and deposit juicy 'alive' paint onto the paper. The paint is wet enough to flow slightly on the tilt of the board, producing a 'bead' of fluid paint, as shown here. If we use dry 'dead' paint and an inadequate amount of wash that has to be 'mopped up' with a brush, then we will never produce the required bead.

TAKING A PUDDLE FOR A WALK

Once we have our bead set up, we can start to travel around and through our shapes. I call this 'taking a bead for a walk'. On your walk you can change the bead's colour, density and tone. You can even change the amount of bead – add more liquid for a bigger bead and use less for a smaller bead – but you should always have a bead when laying a wash on dry paper. We can also work 'wet-in-wet' behind the bead, but more on that on pages 30–31.

Once the wash is finished the excess bead can be removed by touching the wash with a brush dried on a tissue. The steps on this page show the process of changing the bead's colour and density.

1 Load your brush with your first colour and apply it to the paper to create a brushstroke. Let the fluid paint gather at the bottom of the stroke and form a bead.

2 Rinse your brush and remove excess water by dabbing it on a tissue. Fill the brush with your second liquid colour and continue the bead down the paper. How much of the original colour travels down with the new colour depends on the size of bead you use.

3 Rinse your brush and add clean water to the bead. See how this makes the paint much lighter in tone and hue.

4 Add thicker (but still juicy) paint to the bead, thus changing its quality once again.

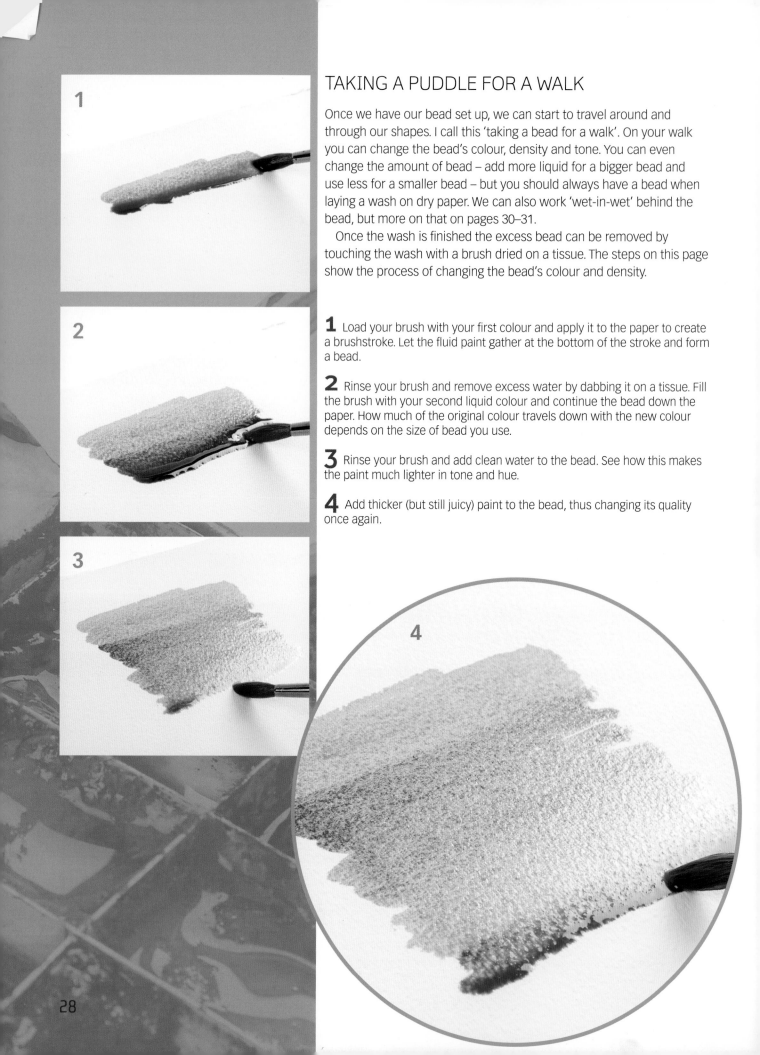

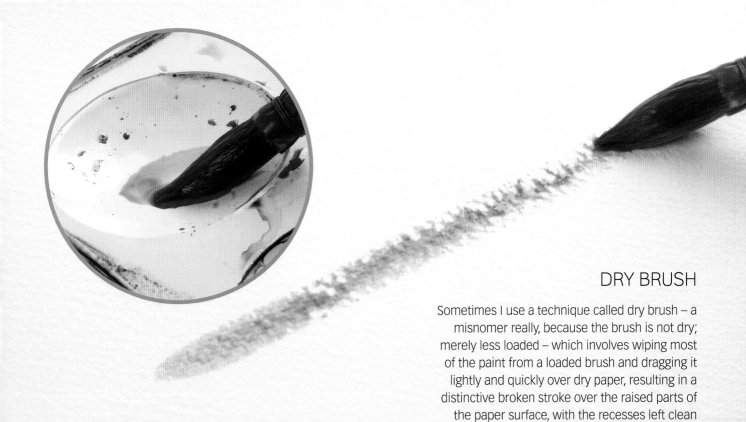

DRY BRUSH

Sometimes I use a technique called dry brush – a misnomer really, because the brush is not dry; merely less loaded – which involves wiping most of the paint from a loaded brush and dragging it lightly and quickly over dry paper, resulting in a distinctive broken stroke over the raised parts of the paper surface, with the recesses left clean and white. I use it to achieve broken edges. The effect works best on rough paper.

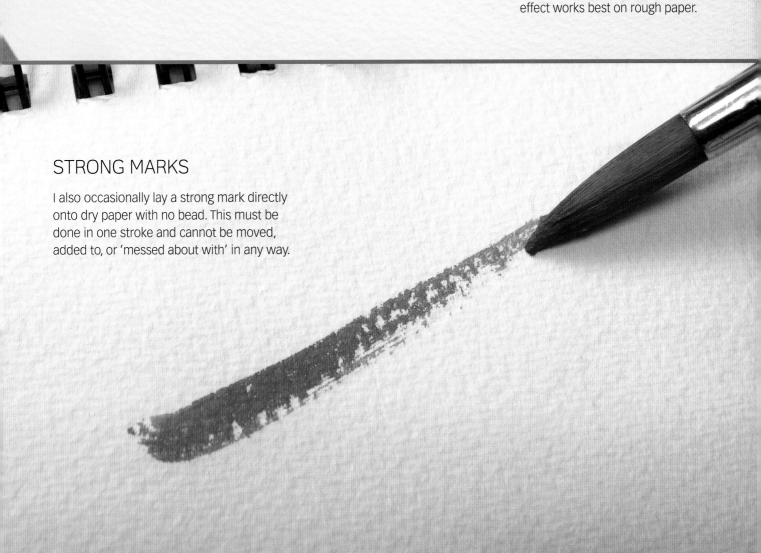

STRONG MARKS

I also occasionally lay a strong mark directly onto dry paper with no bead. This must be done in one stroke and cannot be moved, added to, or 'messed about with' in any way.

29

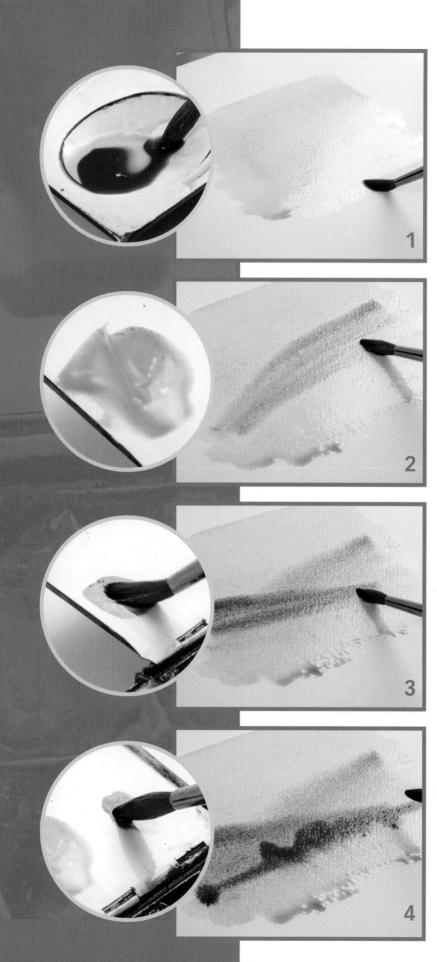

WET-IN-WET

'Wet-in-wet' refers to the process of painting into a surface pre-wetted with either clean water or an existing wet wash. The paint used when painting wet-in-wet is much thicker than that used to lay a wash, and we do not need puddles of paint but richer, stronger pigment.

In the example on this page, I have included small insets of my palette wells, so you can see the sort of thickness of paint with which I am working at each stage.

Two basic considerations to bear in mind when working wet-in-wet are that we can only work on wet and damp paper (the brush marks should be soft-edged) and the brush should always contain less water than the paper, so as the paper turns from wet to damp, our brush must contain richer and richer pigment.

1 Wet an area of your paper with a dilute wash.

2 While the paint remains wet, prepare a slightly stronger mix. Use this to add a few brushstrokes – in this example, some shapes to suggest a distant hillside.

3 Repeat the process with a still-stronger mix for bolder shapes.

4 You can repeat the process as long as the paper remains wet. The stronger the mix, the darker the effect.

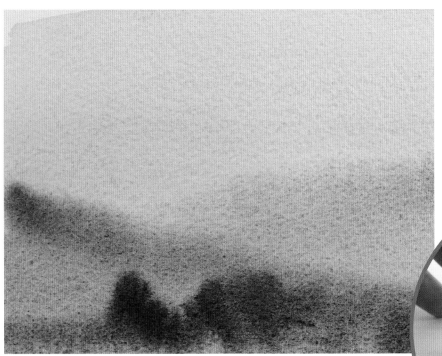

The result

Once you have finished applying the paint, allow the paper to dry completely. As long as you make the marks well before the paper has had time to dry wet-in-wet painting will give you a result with no hard edges evident, as shown to the left.

Paint consistency

The insets on the opposite page show that the dilute paint used for the initial wash was prepared in a well of the palette, while the later stiffer marks were made using paint prepared on the sloping plates at the side of the palette. These stronger mixes do not move or run much, if at all, even if tipped as shown to the right. I call this paint 'stay-putty paint' – as in 'staying put' – and if it does not move on the palette, then it will stay in place on the paper.

VARIEGATED WASH

I call this 'jaggedising' the wash. It means that the bead is laid in a jagged manner rather than a straight line as shown opposite. The result mixes the washes more than a straight bead and can help where we do not want lines of different colour, but a more diffuse mix.

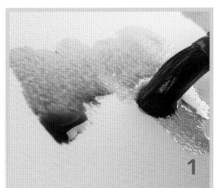

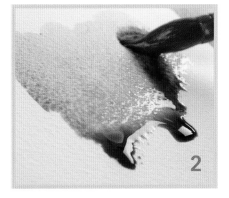

1 Apply the paint to the paper in a jagged manner.

2 Lay the wash below this in the same jagged manner, using the brush on its side, gently touching the paper.

3 While the paint is wet, you can draw a line through the wash with a much stiffer mix of paint for an interesting effect. This is how we work behind the bead.

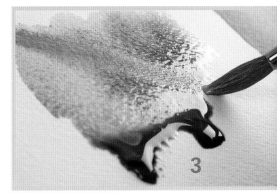

PAINTING *MORNING SUN, FRAMPTON*

This little painting contains all the techniques explained in this chapter. The sky, for example, was a variegated wash on dry paper and while this was still damp the distant trees were placed, wet-in-wet. There is even a dry brush technique that has been used for the foreground hedge. By being able to use the right technique at the right time, we can keep the painting process fresh and spontaneous, thus avoiding muddy, overworked paintings. It does take experience though, so be prepared to put in the practice.

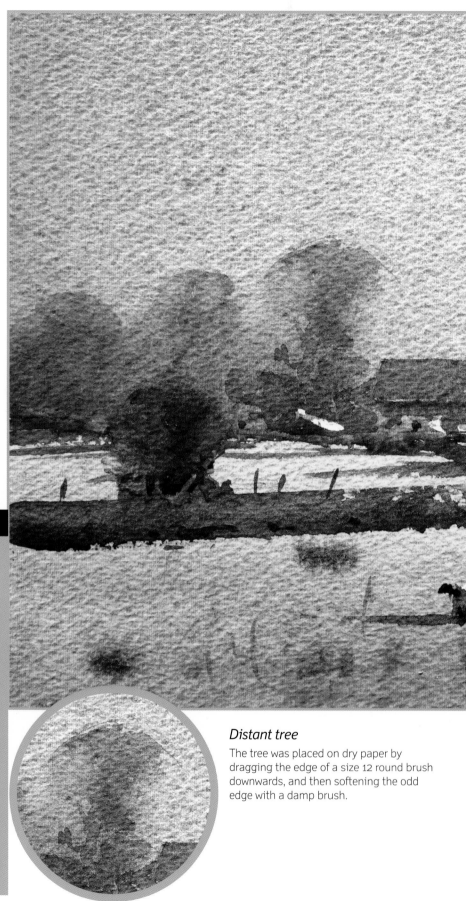

Purity and simplicity

Some may consider this chapter on technique a little brief and will be thinking that there 'must be more to it' and that the author is holding something back. This is not the case; rather these are the fundamental techniques of the pure watercolourist, and they must be practised until they become intuitive.

You must develop the ability to lay washes with beads of various colours and thicknesses, and you must develop the ability to place various thicknesses of paint onto a wet and damp surface. Paint at every opportunity, and once you have attained some proficiency in these elemental techniques you will be able to take some positive steps along the slender tightrope of exhilaration, excitement – and ever near disaster – that is the preserve of the pure watercolour painter.

Distant tree

The tree was placed on dry paper by dragging the edge of a size 12 round brush downwards, and then softening the odd edge with a damp brush.

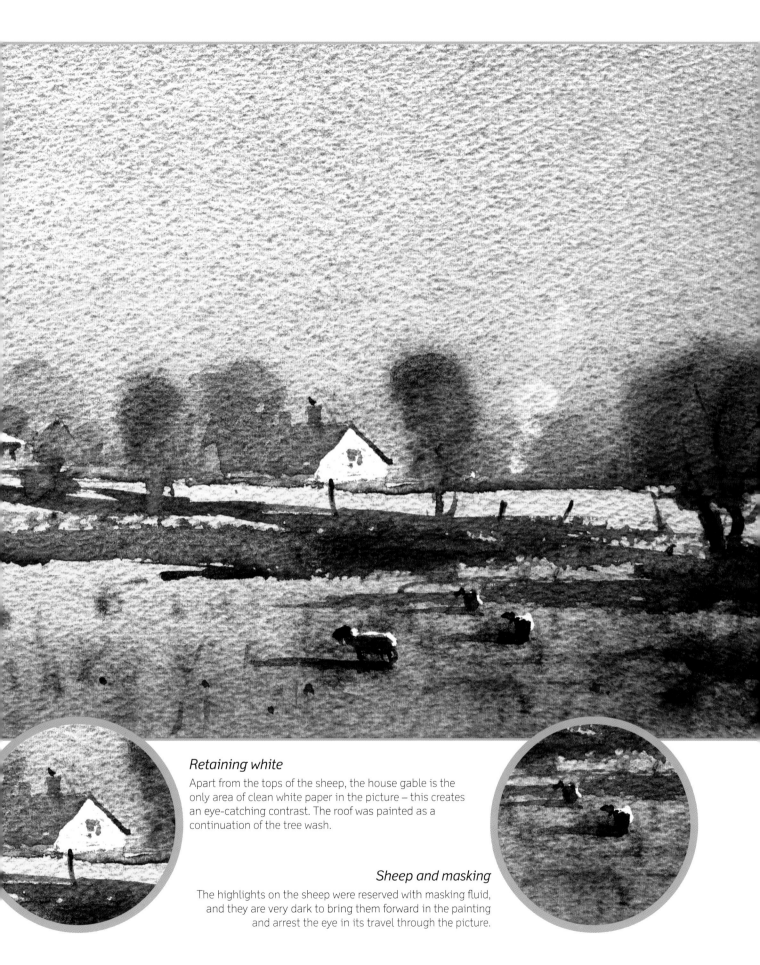

Retaining white

Apart from the tops of the sheep, the house gable is the only area of clean white paper in the picture – this creates an eye-catching contrast. The roof was painted as a continuation of the tree wash.

Sheep and masking

The highlights on the sheep were reserved with masking fluid, and they are very dark to bring them forward in the painting and arrest the eye in its travel through the picture.

PLANNING FOR WATERCOLOUR

If you have ever watched an experienced watercolourist paint you may have noticed the apparent ease – or even wild abandon – of their approach. If the painting starts to misbehave, the artist will simply deliver a few deft strokes or remove some water and things will be redeemed.

This is, of course, the result of years spent honing the core techniques outlined in the previous chapter. It is one thing being able to lay a beautiful clean wash and work wet-in-wet, but to produce a finished watercolour painting of high quality, the experienced artist must add another ingredient to this understanding of technique: planning.

In order to paint a pure, luminous watercolor we have to use the least amount of washes and lay them in the correct order. Failure to plan for this will, all too often, result in too many layers of paint and too much agitation with a brush, resulting in an overworked 'muddy' result.

Planning a watercolour is not difficult, and different artists plan in different ways. Once you have developed your way to plan a painting, you will find that it can be used again and again with only slight variations to best suit the subject. Eventually, it will become your style.

My own way of planning has developed over the years and thus my style has evolved to reflect this. In this chapter we will look at the various aspects of, and the different approaches to, planning a painting. We shall deal with planning in two sections: planning a picture and planning the order of watercolour washes.

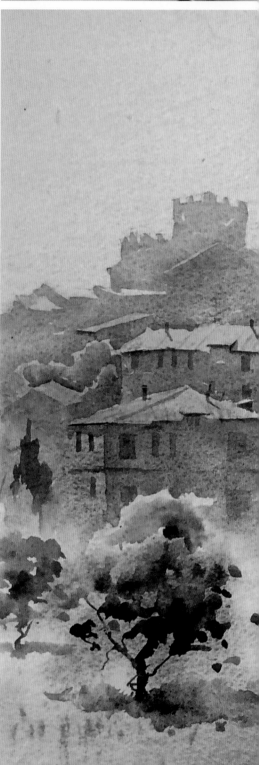

Tuscan Hill Town

I love the romance of these old hill towns in Tuscany, Italy. The campanile towers (bell and clock towers) play a huge role in their appeal. Can you imagine this painting without them? I paint them into the light because I am interested in the atmosphere and profile, not the detail. This painting was completed in three main washes or passes. The sky, rooftops, treetops and foreground were secured in the first top to bottom wash. When this was dry, I painted the walls in one continuous wash, then a third, large wash came through the treeline, leaving only the details to place once it had dried.

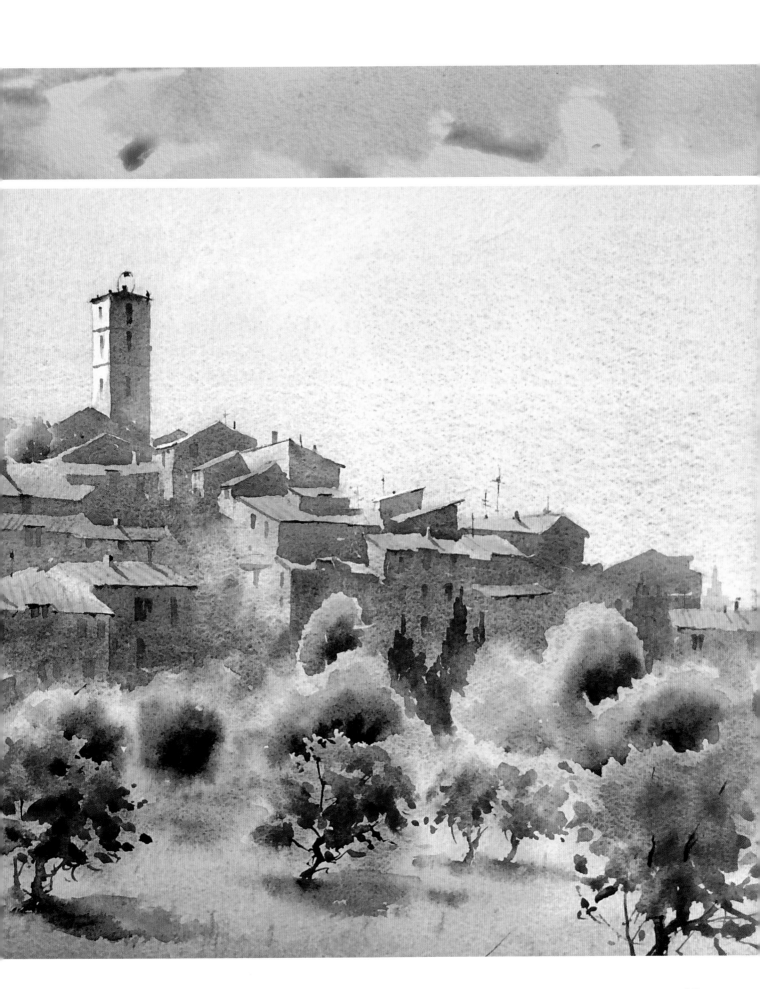

PLANNING YOUR PICTURE

Most novices paint from a photograph and, when they paint, they try to replicate the photograph. However, our task is to paint a watercolour, not a photograph, and before we even begin to plan the washes, we must plan the picture itself. Like many other aspects of painting, planning becomes more and more intuitive the more we do it.

Artists have individual ways of planning a picture, but there will be much common ground based around the rules of composition. The moment I see a scene that I feel may make a good painting, my mind subconsciously goes through a critical process of 'Why?' and 'How?'

WHY?

If I can establish why I am drawn to the scene, then I can establish what exactly I am to paint, or what the painting is to be about. I end up with a sort of title that encompasses the scene. It may be 'sunlight on roofs with tower', or 'wet road and traffic'. This is what the final painting must say to the viewer.

On occasions this title may be hard to pin down. This will be because there are certain aspects of the scene that appeal but also aspects that do not. This is where a sketch becomes a very useful tool for identifying the aspects of the scene that I like. During the sketch I will undoubtedly find out more about 'how' the scene works as well. Pinning down the 'why' aspect really means that you can paint with a purpose, playing things up or pushing things back and simplifying. This method of painting is far more satisfying than merely copying and is also invaluable for keeping focused when painting outdoors.

HOW?

This relates to how I am to portray the title I have identified, and the answer will be contained in the relationship of the big shapes, edges and tones within the scene. I need to establish the most important shapes, edges and tones. Once I have established this, the smaller shapes and other bits can, and should, be omitted or subdued so as to enhance the title. This is doubly important in relation to a watercolour painting that relies on clean washes to make an impact. This aspect of planning is explored in more detail over the following pages.

Start gently

If you are a novice, then the concepts discussed here may be quite alien and indeed, a little intimidating. With time, they will become familiar tools and will greatly ease the task of producing watercolour paintings of merit.

I would suggest starting with subjects or photographs that contain only one or two big shapes. Once you have become adept at composing and planning a watercolour using only a few shapes, then you may start adding more shapes, thus increasing the complexity of subject matter that you are able to simplify.

What this means in real terms is, go for the gable end of the farmhouse and not the whole farm. Sketch and paint a simple boat up against the jetty and not the whole harbour. Contained in this book are some very simple scenes using very few shapes, but they can still make a beautiful watercolour.

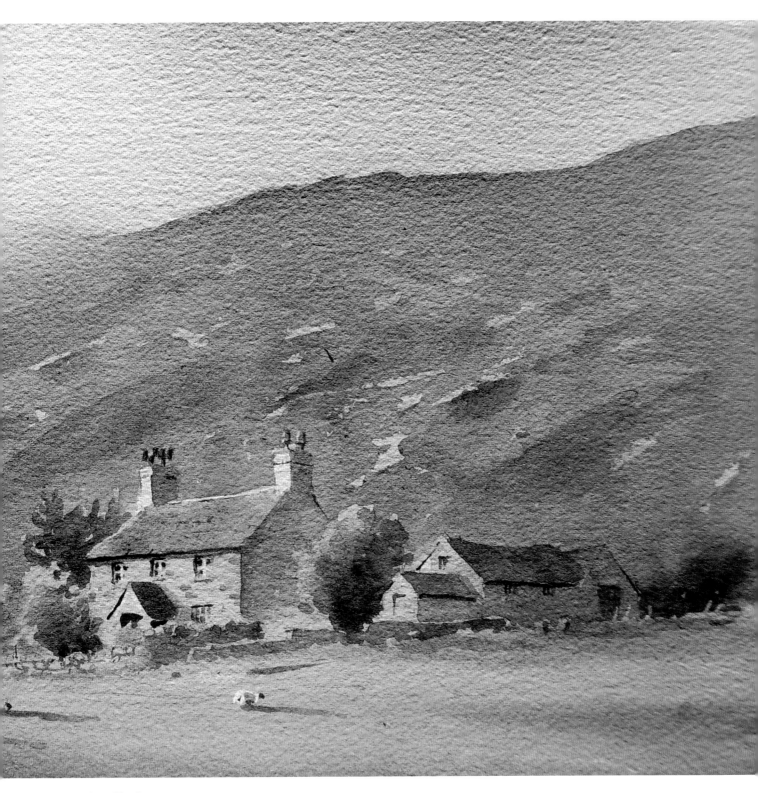

Farm Near Trefan

I am not proud to say that this painting of a farm in North Wales was executed while clad only in my thermal underwear. I was on a campsite – thankfully largely empty – and upon throwing open the campervan door after a chilly night, this is the view that greeted me. It was changing so rapidly that the only course of action was to set up and paint there and then. I am glad I did, it was a lovely morning.

If we want to be able to respond in such a way (you will be pleased to hear painting in one's thermals is entirely optional), then we must study and fully absorb the techniques and discipline of planning. In traditional painting, there are no gimmicks or short cuts – you must know your head to paint your heart.

THE IMPORTANCE OF THE SKETCH

The sketchbook plays a huge role in traditional painting and especially for the pure watercolourist. I have tried to use computer drawing programs and tablets to sketch on, but despite the fact that it is you and a thousand technicians involved in the process, I find it lacks the sensitivity of the humble, low-tech pencil and paper.

When using a pencil and sketchbook, it's all you. I have too many sketchbooks to mention, and if I am in the studio, I will inevitably start the morning by looking through the sketchbooks – not the computer; I have thousands of images on my computer and if I start the morning by browsing through the images for inspiration, then I am usually still there by the afternoon, and feeling very frustrated too.

When you can draw and sketch effectively, you are able to place an emotional idea onto a piece of paper: your idea. So when I use my sketchbooks I am browsing my ideas and not just photographs that are dead in comparison. I may, and often do, look for the relevant photograph to back up the sketch. I will paint directly from the computer, but it has to be a stunning, resolved image and, given my limited camera skills, that is very rare. I am far more likely to produce a sketch from my photograph and then use that as the plan for a painting.

When we sketch, we learn to draw and all good watercolourists can draw. We get to know our subject, what we like about it, how to compose the various shapes and what to include and leave out. If we are not happy with certain aspects of the sketch we can rework the offending passage. It is much better to make mistakes on your sketch than on your watercolour painting. One of the most important things a sketch will provide is a tonal map for a watercolour (the logic of this is explained on pages 42–43). All the lighter areas of your sketch will go in during the first wash and the darker passages in the second.

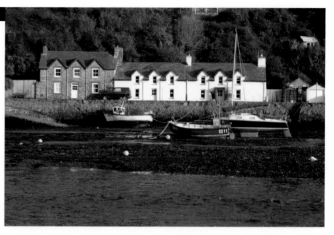

Here is a photograph of Lower Fishguard, near where I live – that's my trusty campervan on the jetty. The sequence here uses it to show you my method for sketching, and I shall explain my reasoning along the way.

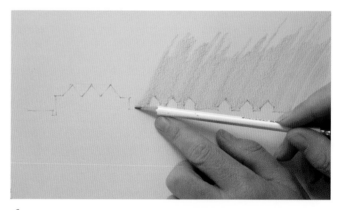

1 I start with one of the dominant horizontals. This is an important line because it defines the white walls of the two cottages. Once this line is drawn, I quickly shade in behind to isolate the white paper. I am basically scribbling and the index finger of my left hand guides the pencil along the line. With practise this is a very quick way to shade large areas.

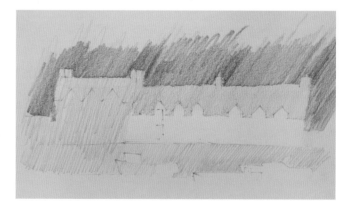

2 The next line to go in is the roofline, and I once again scribble in a darker shade to pull out the roofs below. I place two windows to get the approximate position of the harbour wall and then draw in the top of the wall. Another horizontal traces the base of the wall and travels up over the boats. I can now hatch a tone into the wall and the big shapes have all been stated. I can now work into the shapes to add enough detail to make them 'read' properly.

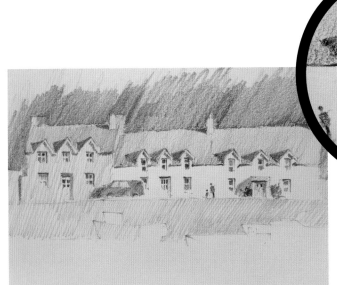

3 The shadows and windows were placed next. Notice how only the shadow side of the window is indicated (see inset). I am careful to vary the weight on the pencil so that the windows are not all the same. I have also put in some figures – and my van, of course.

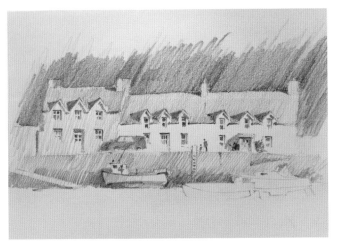

4 I move to the harbour wall itself and darken its base before beginning work on the boats. You may have noticed by now that I do not work in outlines but edges. It is a process of placing darker tones against lighter tones. I am looking to find edges and loose edges. I find what I wish the viewer to look at and lose areas that I wish to leave quiet and understated.

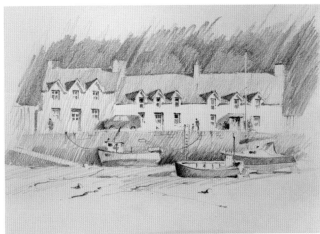

5 The boats are added next. After this, it is time to step back and appraise what needs to be pulled out and developed with further detail. Do any areas require further work? What bits and pieces are to be included?

The finished sketch

To finish, I decided to put some shading and ropes to indicate the harbour floor. Dark accents were also added to some shadows, windows and the tops of masts using a black pen for the extreme dark tones.

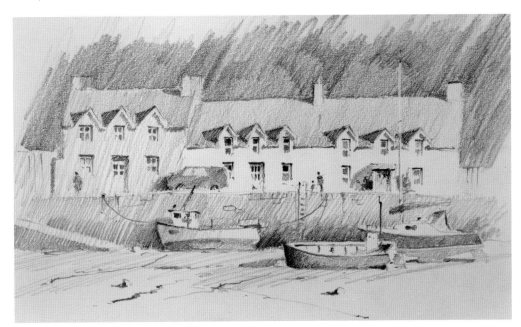

SKETCH AND THE CAMERA

The camera is an invaluable tool for the artist but this useful servant often becomes the master. The novice will try desperately to draw and paint every part of the photograph. All creativity is lost and a tight copy is the best that can be hoped for. Better to paint the reason for taking the photograph in the first place, whether it be the light on the roofs, wet streets or a particular impression of hazy light. A photograph should be used, not copied. It should be an aid for a composition, not a substitute for the composition.

A better use for the photograph is in the production of studies. Take photographs of sheep, cows, boats and any thing that lets your painting down. From these images you can then produce pencil studies – like those shown to the left – to help you improve their rendering in your paintings. You can also use the photographs to produce studies in watercolour.

For some artists the camera has replaced the sketchbook. I would much rather sketch or paint on site than take a photograph, and a sketch can be produced in a surprisingly short time. If I must work from a photograph, and I often do, then I will first produce a sketch. While doing the sketch I will give it a title (i.e. the reason for taking the photograph) and try to make sure that the finished sketch represents this title in a stronger fashion than the photograph.

The power of the pencil

Being able to draw gives the artist a huge advantage in traditional art. If you can draw well your understanding of how to use composition, shape, edges and tones increases dramatically. You will never be able to fully utilise a photograph's potential unless you can draw well.

IDENTIFY WHAT IS IMPORTANT

The eye is very adept at recognising objects and groups of objects by their profiles. Once the brain has received this information it is satisfied and moves on to the next shape. I sometimes ask my students what colour shoes I have on or how many buttons there are on my shirt. Inevitably, they do not know, because they focus only on what is important – that is, that the tutor has turned up. In a similar way, if I wish you to see a mountain, why paint all the rocks when a profile will suffice?

The big shapes in a landscape are such things as sky, land and sea. If we place these effectively with good tonal differences, then even if they are soft-edged, the viewer will be able to tell them apart. It is the relationship of the big shapes in a painting that dictate the mood and atmosphere; smaller shapes add accents and charm, but they must be handled with restraint or over-busyness will kill the message.

When working out what to include in your landscape work, try to find horizontals that travel across a landscape, things such as rooflines etc. Draw a line over the top of traffic or a harbour full of boats and your brain will instantly make up the rest of the shapes. Take a look at the paintings in this book to see where I have merged different objects into one big shape.

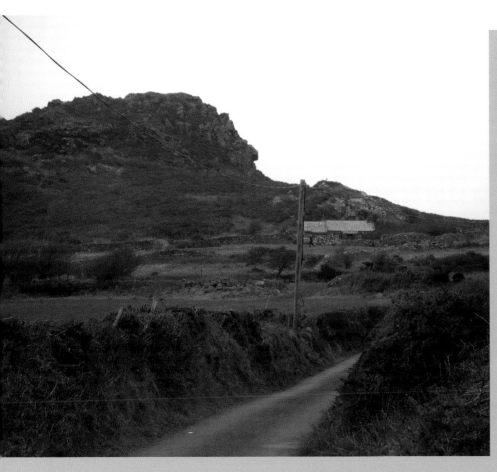

FROM PHOTOGRAPH TO SKETCH

Compare the source photograph with the sketch shown here. Notice how the big shapes and tones are relatively true to the photograph, but many smaller details have been altered or omitted to make a more successful and pleasing composition. In particular, I have cropped in on a small section, eliminating a lot of extraneous detail and allowing the cottage to stand out as a focal point.

The main thing that attracted my eye here was the lightness of the cottage roof, and I have tried to show this in the sketch. I also liked the way the hill added drama so I have used and exaggerated this shape while reducing the detail. I loved the windblown trees and walls too, so these went in as a single shape. The foreground lane has been left out but could have been used, along with the telegraph poles. Perhaps there is more than one sketch possible here.

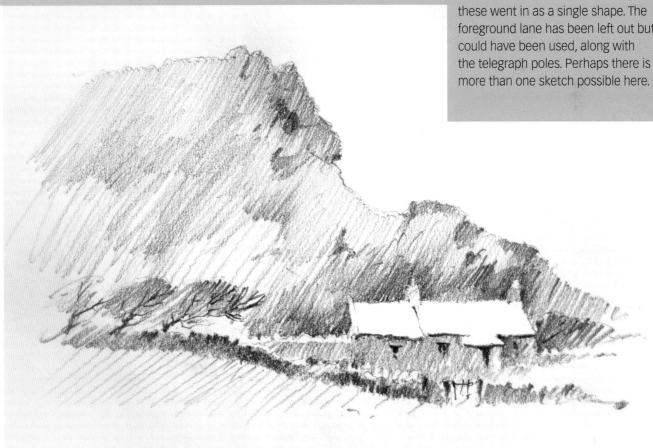

THREE STAGES OF PAINTING

To produce a clean luminous watercolour, we must apply as few layers of paint as we can. Aim for one layer of paint wherever possible, with a second wash over certain parts of the painting and final touches for windows, fenceposts and so forth kept to a minimum. These washes need to be applied with the deftest touch of which the artist is capable. Our aim should be to place the least number of washes in as few layers as possible with the minimum amount of brushwork.

When making a plan, the fact that watercolour is painted from light to dark must be at the forefront of our thoughts. The lighter washes must go onto the paper first, with the darker passages added beside or on top of these washes once they have dried.

For my own part, I tend to work in three stages: first, I apply an overall wash or a 'ghost wash'. By the end of this first wash, the lighter passages have been placed at the required strength of hue and tone and the darker passages have been hinted at. Once dry, I then superimpose the darker second washes on top of this ghost wash, trying to keep it as linked up as possible while softening edges I do not want. Finally, the details are added.

FIRST WASH

This is an overall wash and covers the whole of the paper (with the exception of any white paper I require). It is either laid onto the wet paper or brought down from top to bottom in a big bead. Even on wet paper, I travel from top to bottom, as it is the best way to control a wash.

The job of the first wash is to place a soft impression of the image onto the paper. It will vary in both colour and tone, but its edge quality will always be soft. Areas that are to stay as this first wash have to be placed at the right strength and tone. Areas that are to take a second wash (usually because they are darker in tone) are placed as strong as I can get them at this stage.

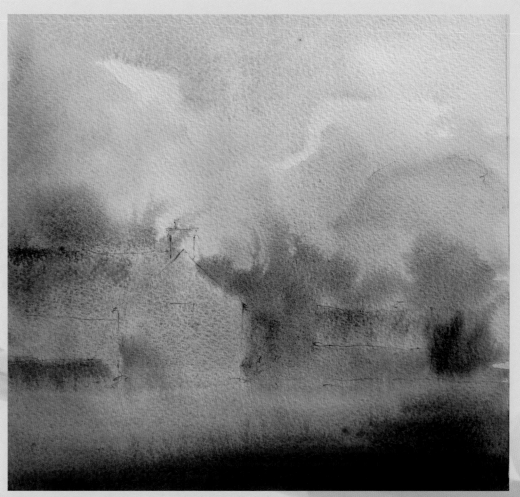
The painting after the first wash.

SECOND WASHES

Once the first wash is completely dry I place the darker areas as second washes. Second washes are placed next to the lighter areas that I wish to maintain as first wash, and their job is to provide edges and make the first washes stand out. I sometimes pre-dampen the paper in certain places for a soft edge. I do not always paint actual objects with these second washes, but try to join areas into bigger shapes as this makes the painting less busy. I subconsciously use an acronym – BTEC – before I place a second wash because it helps clarify my intent:

B – Brushwork Where am I to start the wash and how will I travel it through its shape?

T – Tone What depth of tone is the wash to be and will its tone vary?

E – Edge Will the wash be hard-edged, or will I need to soften certain edges?

C – Colour What colour is the wash? Will the colour vary?

Whether outdoors or in the studio, this approach makes things easier to evaluate; these deliberations might otherwise render my hair even greyer than its existing state!

DETAIL WASHES

To call these washes is a misnomer really, as this third stage usually consists of details and accents – a window or figure for example. Even then I try not to paint the whole shape as a hard-edged 'cut-out', as it were.

Sometimes, however, I will glaze over an area that is too light or does not contain enough hue (strength of colour). I make sure the paper is absolutely dry before I do this as the risk of lifting and muddying the second wash is a frightening prospect this late in the game.

The finished painting, with second and detail washes added.

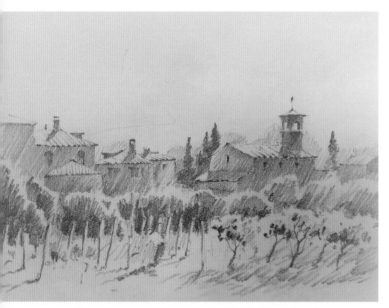

FROM SKETCH TO PAINTING

Let's take a look at how I applied the method described on the previous pages to a more complex scene. The sketch to the left shows a Tuscan village I stumbled upon while driving to another location.

Producing the sketch allowed me to plan the painting. It is what I call a composite sketch due to the fact that the olive trees were actually on the other side of the road – I moved them in front of the village to replace the bare earth that was actually there.

I also learned that it would be good to keep the sky, the roofs, the tree tops and the foreground as first wash because they are the lightest elements within the scene.

STARTING TO PAINT

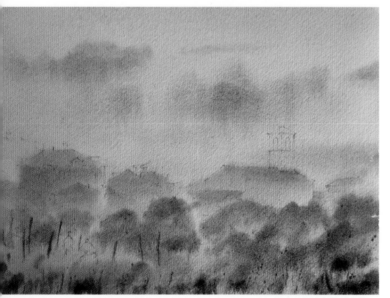

Start by dampening the paper and putting in a 'ghost wash' from top to bottom. The shapes do not run wild – they are placed with paint that varies in its viscosity from medium to very rich paint. With the exception of the sky, never use paint so thin that it would form a bead if it were placed on dry paper. We require stronger, richer marks for the land shapes and thin, watery paint will never achieve this.

The paint is used at thicker consistencies towards the bottom of the paper, in order to bring this area forward and establish an illusion of aerial recession. All this must be completed within the drying time of the paper, which will vary according to the temperature of your studio.

DEVELOPING THE PAINTING

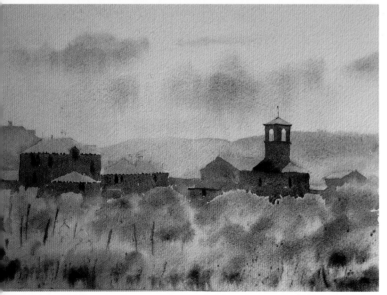

Once the paper is completely dry the second washes can be applied. Remember, as these are to be placed on dry paper, a bead of colour is needed. Your priorities at this stage are to get the tone of each wash right first time; to join shapes; and, wherever possible, to place second wash next to first wash. If it is impossible to avoid placing second wash next to second wash make the tone of each as different as possible.

In this stage, add distant shapes behind the roofs. The job of this shape is to show the light on the roofs. When this wash is dry, work a second wash over the tower and run it down through the building walls. The job of this wash is to show the light on the roofs and the light tops of the trees.

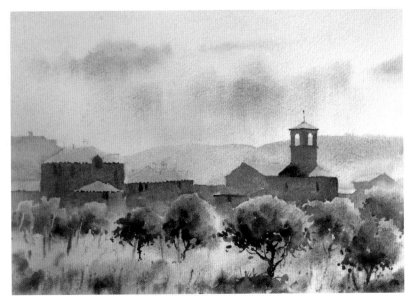

REFINING THE SHAPES

Once dried, dampen the tops of the trees with clean water then place a second wash over the trees. This will cause the area to appear to drift back to first wash before it reaches the tree tops. This is how I get light rims around the treetops. Note how the bases of the trees now have a purpose too – it is to make the ground glow.

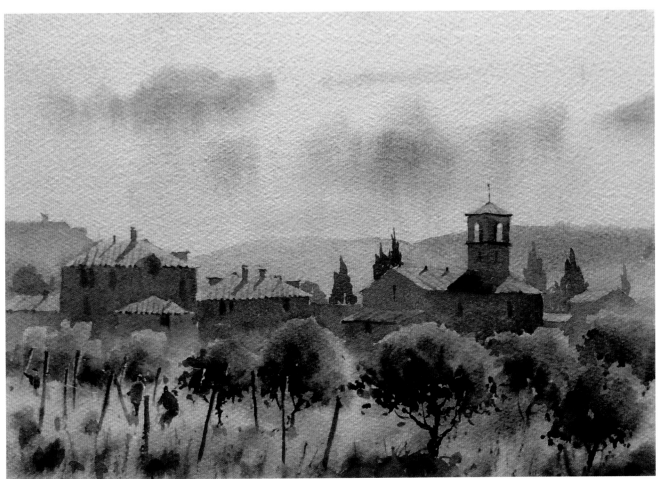

Tuscan Village

ADDING DETAILS AND FINISHING

With the atmosphere of the scene set by the big washes, it is now time to make these shapes even more 'readable' and interesting by adding bits of detail such as cypress trees, chimneys, people and the posts in the foreground. This has the effect of 'populating' the painting and adds significantly to the final impact.

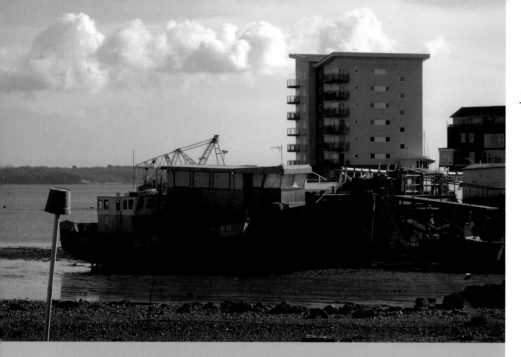

FROM PHOTOGRAPH TO PAINTING

I was instantly drawn to the boat jumble on the foreshore, so I knew the title had to be 'boat jumble' or some such thing. I also thought the backdrop was pretty ugly and that it would need changing or playing down. With this in mind I set about the sketch.

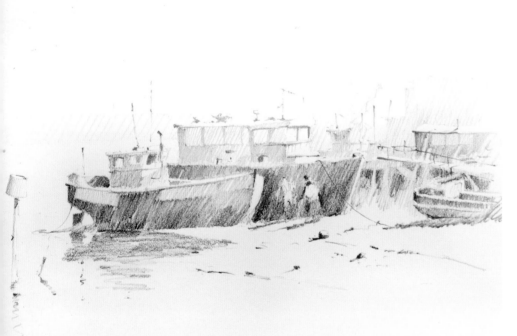

PRODUCING A SKETCH

Start by placing the backdrop as one flat shape. Break up the straight edge on the right side of the tower by adding more balconies.

Draw in the focal point – the boats – using lots of dark/light contrast to draw the eye; then add the sheds, cranes and other structures in the midground. These were selectively placed to aid the composition – don't feel you have to include everything in the photograph. Equally, don't be afraid to add something in – I decided the hull of the rear boat was too empty, so I placed some lighter figures on the foreshore to break up its shape.

STARTING TO PAINT

The purpose of the first wash is to cover the paper and set warms and cools. With this painting, a lot of the midground will eventually be covered with the lit boat/rooftops, handrails and similar details. For this reason, the midground area is relatively complex in this painting – and the first wash reflects this.

The foreshore will remain as first wash so hit it rich and strong with this in mind. Place all the brushwork directly, with no fiddling, using the side of the brush.

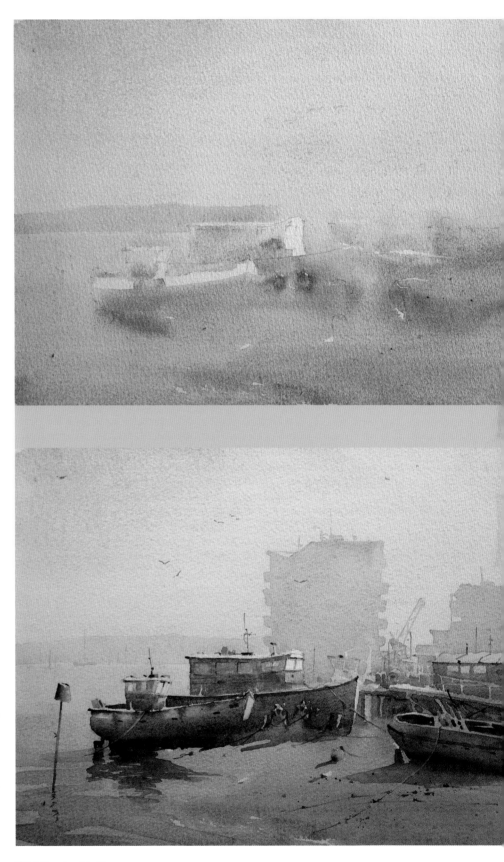

SECOND WASHES

Once the first wash is completely dry you can place the second washes. Here, the distance was flattened as per the sketch, and I used it for aerial perspective and to show up the light roofs of the boats. This was achieved by keeping the wash blue enough and light enough to look distant, but yet dark enough to show up the very pale roof colours.

As I painted through the midground I tried to keep the wash linked up by treating the objects as one shape and travelling my bead from top to bottom, while varying the colour and viscosity of the paint contained in the bead. Finally, having set the big shapes it was time for the details, highlights and accents that bring such a scene alive.

Old Boats, Hythe

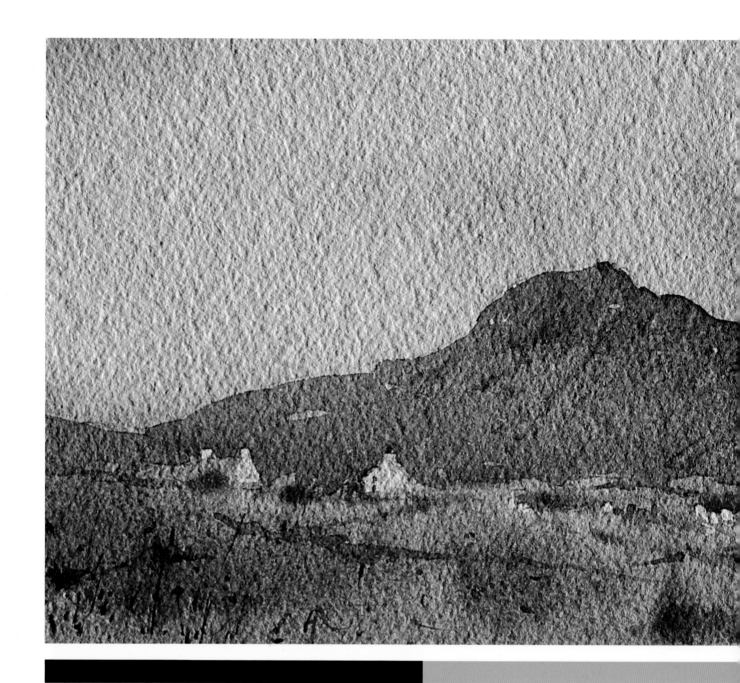

SEEING THE WORLD IN WASHES

It is true that being an artist changes the way that one sees the world. Painting in pure watercolour has its own effect on one's vision. I now see the world in washes and have long-suffering non-painting friends who look at me perplexed while we wait at a traffic light and I blurt out "Is that a second wash or a first wash?" and "Ooh, that's a ruddy good dark."

The fact of the matter is that you have got to see the world through the eyes of the painting medium you are using (even if that occasionally means annoying your friends), and if painting time is not available, then we can

paint in our mind by practising the way we see a scene. Whenever you have a quiet moment, try to look at the scene before you and to break it down into first and second washes; to identify the lightest light and darkest darks and which edges are soft and hard.

Not only is this good for our watercolour planning but it stops us looking at our mobile phone and keeps us interested in the real world. My daughters believe that I keep my distance when driving so that I can check the sky for buzzards (I have my name and website written on my van, so avoid me at all costs).

Carn Llidi

This is a small painting on 640gsm (300lb) rough paper. I always use a rough surface as I love to see the texture of the paper showing through. It was carried out in just two washes: an overall wash for the sky and foreground and, once dry, another wash for the hill and bushes.

Discipline and enjoyment

The contents of this chapter may appear a little hardnosed to those who regard painting as a light, intuitive process. "Surely," they might object, "all this planning will kill the spontaneity of painting?" They miss the point. It is only by totally absorbing the information (along with the technical aspects of how to apply watercolour) that we can be free to concentrate on the very difficult job of putting our feelings onto paper. Watercolour is a cruel taskmaster and if we are hindered by a lack of knowledge and technical skill, then the chances of getting the brushes to do what the heart and head want is remote indeed.

Across the Grand Canal

I have been to Venice three times and have not yet been inside a building. I simply find the streets too interesting. To wait around queuing to go into the many (admittedly wonderful) churches and other buildings is a physical impossibility for me when there is so much to paint.

This wonderful view of Venice was painted in a 'sky/land' or 'sky/water' type of overall wash. This simply means that you paint the sky and land first, then, once this is dry, the shapes that stand on the land are painted. It means that the bulk of a painting such as this can be produced with two or three main washes. We should always follow the 'big shapes first' principle in both our painting and drawing. If these shapes work then they will set the atmosphere and adding the details will be like icing a well-made cake.

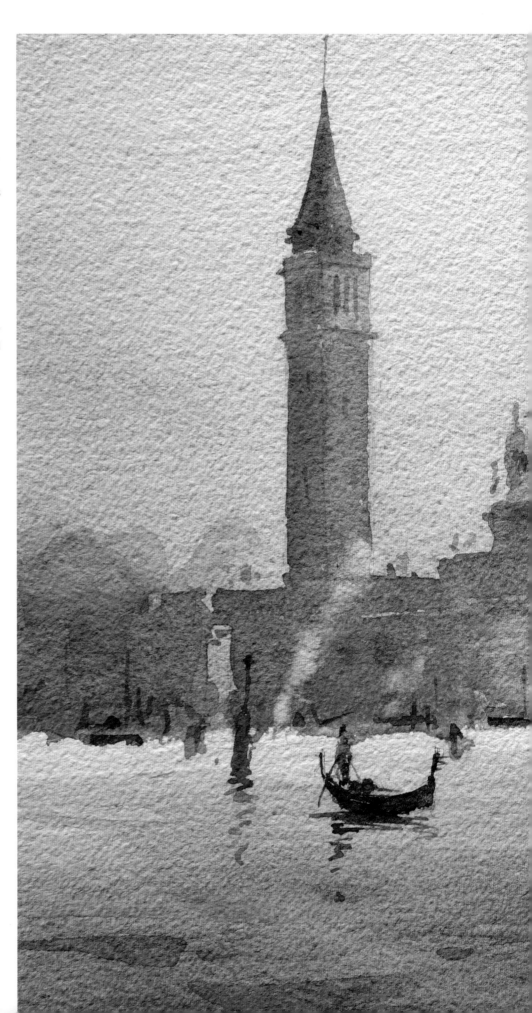

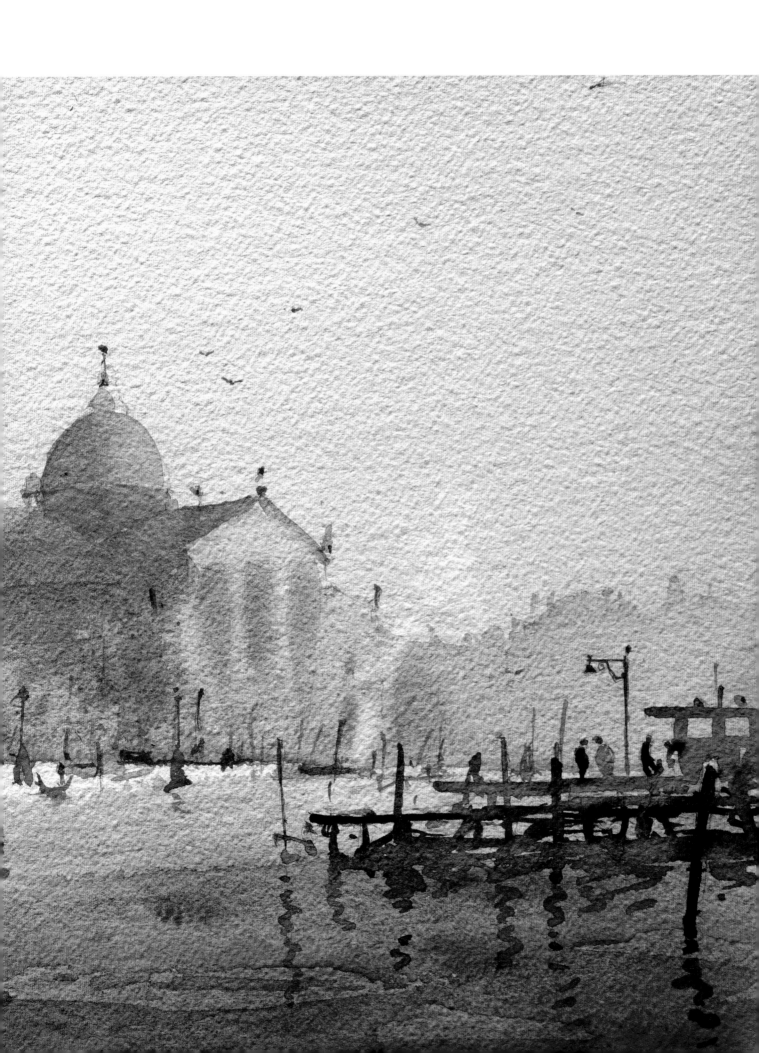

PAINTING INSIDE

AND OUT

A landscape painter has two places of work. One, the great outdoors, is often harsh, changeable and challenging, but also alive and sublime in its immediacy. The other, the studio, is a controlled, perhaps even air-conditioned arena where magic and mischief are conjured from various forms of source material, but beware: it can also become too staid and comfortable. The set-up and the work produced in each will call on different methods and require very different approaches from the artist.

THE STUDIO

The studio is where I do most of my larger 'set piece' paintings. It is where I review my sketches, photographs and paintings completed on trips away and it is where I refine and alter weather, mood and even the shape of the landscape itself. I sometimes think of this as painting with my brain. (My wife says this is why I struggle in the studio!)

The studio can be a hub of creativity, but only if properly utilised. I have learned the hard way not to start the day looking through photographs at the computer. The sheer volume of unresolved material will result in a lost day and a grumpy artist too. I start by looking through my sketchbooks and when I find something promising I may look for the relevant photograph to back up the sketch. Even this act can swallow up valuable painting time, and on good days none of the above will happen because I will have been focussed the evening before and will hit the studio running.

OUTDOORS

When painting on site, I work with my eyes first and foremost, as opposed to my brain. Outdoor painting is a form of creative, humane hunting, where subjects are stalked and quickly appraised as food for the brush. Even when a good subject is spotted there is no guarantee of success, but your skills increase with experience. The aim is to catch the atmosphere of the scene in front of you, with the hope that the image will travel through you and then out onto the painting. It is important to realise that it is not copying, it is translating. The end result should say more than what is in front of me.

There are, of course, practical considerations to painting outside. I will always aim to paint the mood of the day, for example: there is no point standing outside on a sunny day and trying to paint rain. Warm clothing is often essential, and just standing behind a hedge or wall to break the wind can drastically affect the outcome of the painting. On warm days it may be useful to paint under the shade of some trees or simply to get out early or late in the day.

The outdoors is where the real learning is undertaken and it has twice the thrill of studio work. Without constant outdoor work your landscape painting will become stale and contrived.

My studio

I try to keep the studio clean and orderly, but inevitably chaos encroaches. When it starts to inhibit my ability to work, I will attack the debris with gusto until long-lost surfaces and areas of floor begin to reappear.

I once did the splits while stepping back from the easel due to a rogue piece of paper on a shiny laminate floor! On the plus side, while I was down there I found two brushes that had been 'missing, presumed lost' for some time.

MAKING THE CHOICE

For this artist, regular exposure to the great outdoors is an essential requirement in maintaining my sharpness as a painter. However, whether you choose to paint outdoors or indoors is ultimately up to you. The decision will be influenced by factors such as your painting experience, the complexity of the subject or the practicality of setting up on site. Most artists will take a mixed approach – sometimes working outside and sometimes in the studio.

Even if you only choose to sketch outdoors, then you are practising your 'hunting' skills of composition, simplification and choosing a suitable viewpoint.

Choosing your own subject matter from life is the surest way of finding out who you are as a painter. As an illustration, I was once sketching a magnificent winter oak tree when I noticed another artist standing right up to the trunk. It turned out that she just loved the texture of the bark. Consequently, her painting had a strong focus on the rich texture, while the broader atmosphere of the area occupied and informed my own work.

It is a mistake to feel that an outdoor painting must be completed entirely on location. Sometimes – due to changes in the weather for example – I will return home to finish a painting in the studio using photographs, a sketch or simply making up and placing any finishing touches that I think will improve the message of the painting.

1 The best view is always from the middle of the road.

2 Any object that can move will do so as you are painting it.

3 Everyone has a relative who paints (inevitably, better than you).

4 If the painting is a terrible failure, then busloads of people with such relatives will appear.

5 If the painting is turning out to be an absolute cracking success, no living thing capable of admiring it will be within ten miles of your easel.

6 "I'll go back tomorrow." A statement which invariably means a housing estate or some other such thing will have sprung up overnight and rendered the view totally useless.

7 Bird poo is a surprisingly accurate substance.

8 Horses are very creative beasts and will pinch your equipment for their own use (or they will eat it!).

9 "I just asked a man and he said the tide was going out." (Yes, it will… but only after it has come in first!)

10 "It's bound to brighten up"; "It will lift"; "It will clear" … It won't.

A small painting made on site can be used along with photographic reference to produce a large set-piece studio painting; or as a 'mood indicator' to help turn a sketch of another scene into a painting with the same mood.

I enjoy both outdoor and studio work. Together, they feed the creative juices in many different ways.

Opposite:
Polperro Corner
Sometimes in my pursuit for the atmosphere of the day, I overwork an on-site painting and spoil its transparency. Such work is not a waste – this studio painting is a larger, refined version of a small on-site painting that had become overworked and muddy.

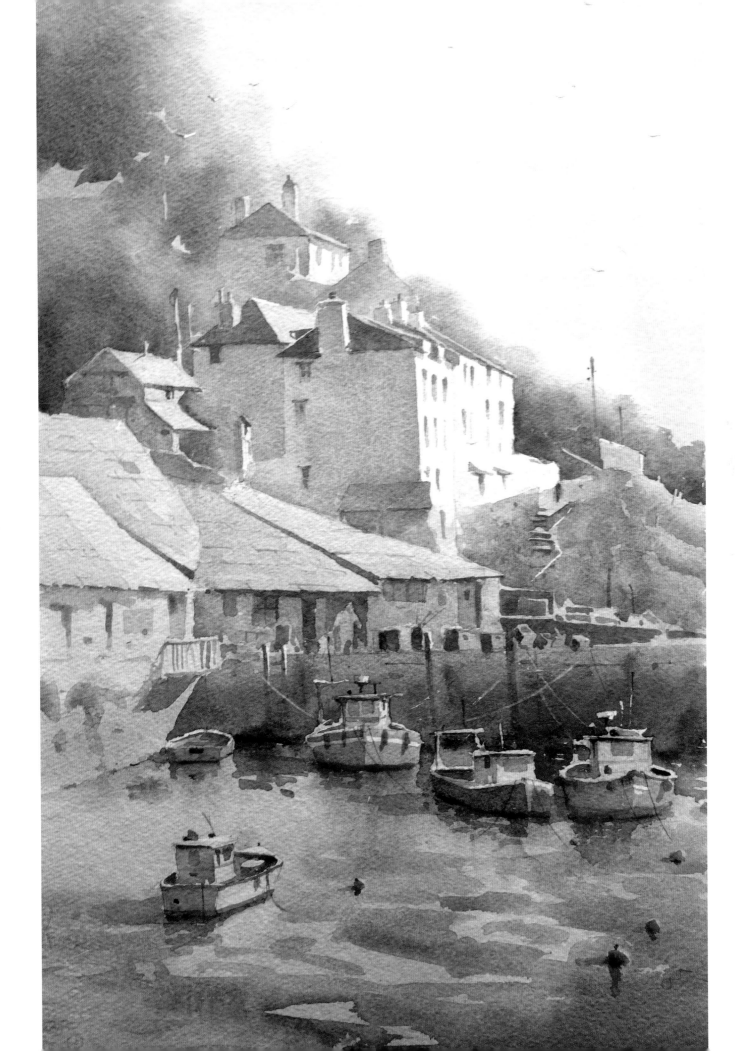

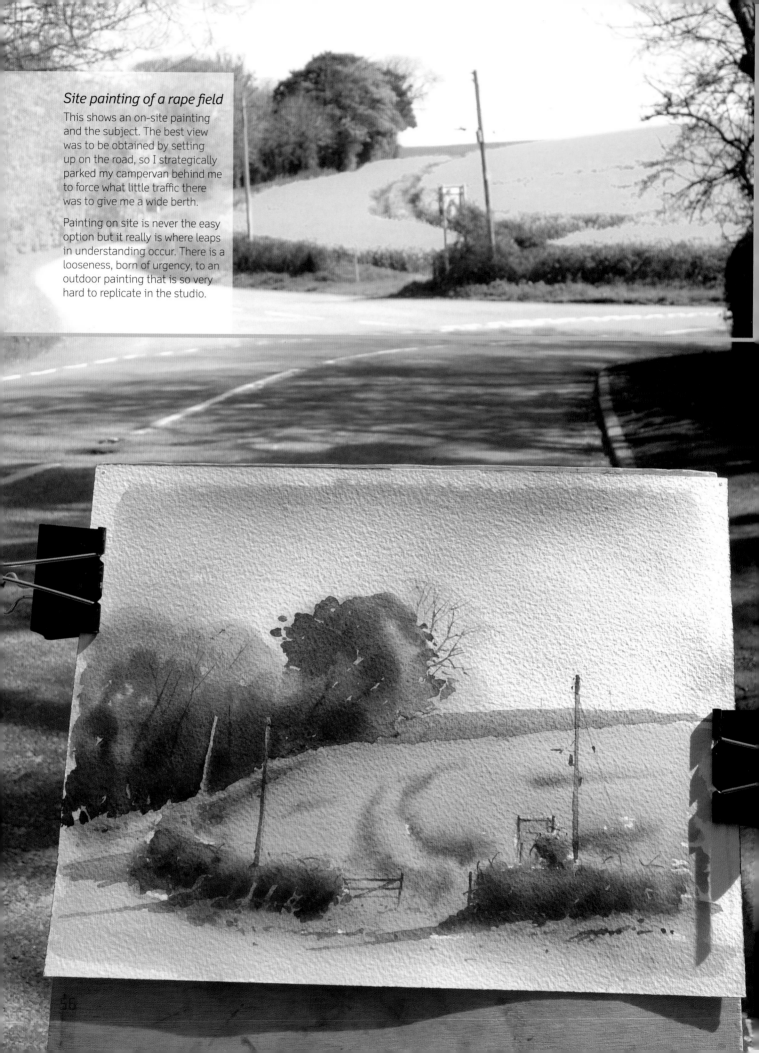

Site painting of a rape field

This shows an on-site painting and the subject. The best view was to be obtained by setting up on the road, so I strategically parked my campervan behind me to force what little traffic there was to give me a wide berth.

Painting on site is never the easy option but it really is where leaps in understanding occur. There is a looseness, born of urgency, to an outdoor painting that is so very hard to replicate in the studio.

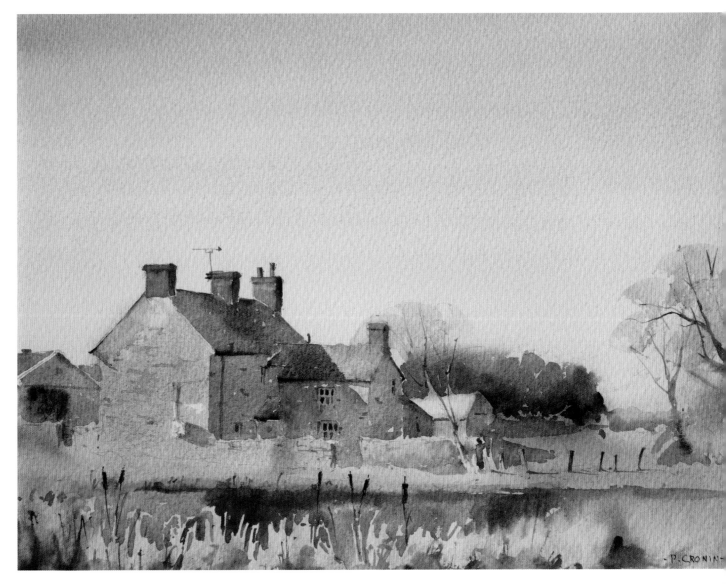

PAINTING *POOL FARM*

I did not have to go more than a mile or two from my home to find this old
village pond. It's a well-known painting spot in the area, and on this crisp winter's
morning it made a lovely subject.

Painting outdoors on such days is a pleasure indeed, as the watercolour
washes will stay wet for ages. This gives the inexperienced much more time to
study and adjust washes before they start to dry. I love painting during the cooler
months as I find the landscape much more interesting then, than when it is
cloaked in summer greens.

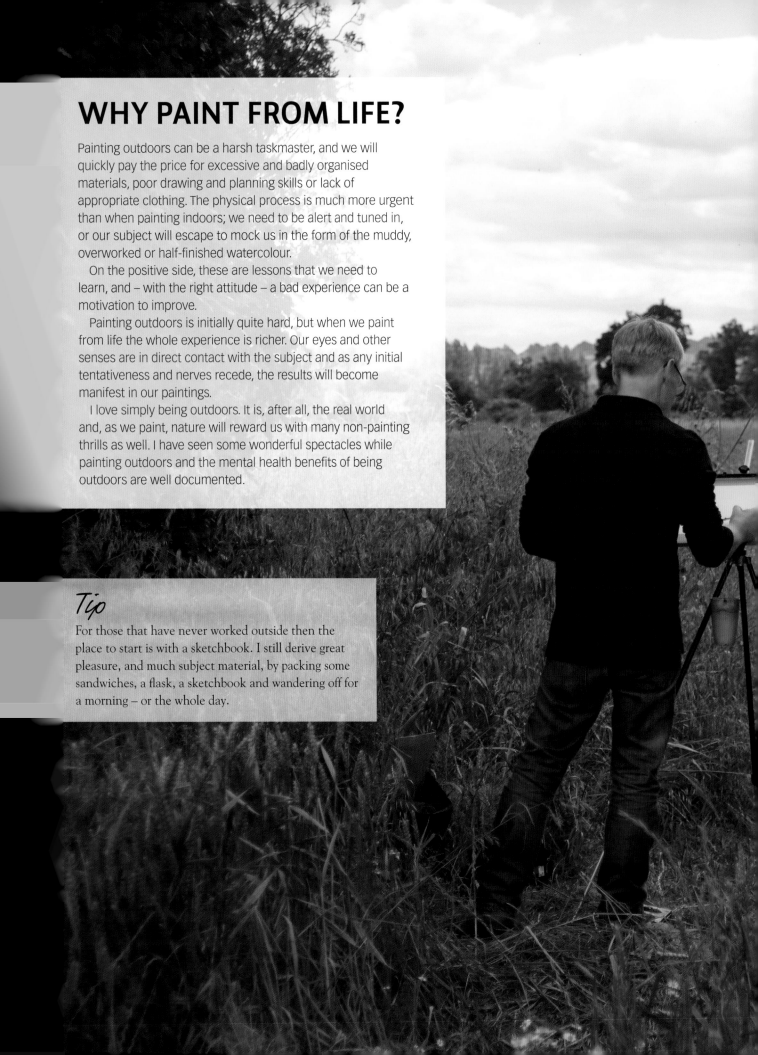

WHY PAINT FROM LIFE?

Painting outdoors can be a harsh taskmaster, and we will quickly pay the price for excessive and badly organised materials, poor drawing and planning skills or lack of appropriate clothing. The physical process is much more urgent than when painting indoors; we need to be alert and tuned in, or our subject will escape to mock us in the form of the muddy, overworked or half-finished watercolour.

On the positive side, these are lessons that we need to learn, and – with the right attitude – a bad experience can be a motivation to improve.

Painting outdoors is initially quite hard, but when we paint from life the whole experience is richer. Our eyes and other senses are in direct contact with the subject and as any initial tentativeness and nerves recede, the results will become manifest in our paintings.

I love simply being outdoors. It is, after all, the real world and, as we paint, nature will reward us with many non-painting thrills as well. I have seen some wonderful spectacles while painting outdoors and the mental health benefits of being outdoors are well documented.

Tip

For those that have never worked outside then the place to start is with a sketchbook. I still derive great pleasure, and much subject material, by packing some sandwiches, a flask, a sketchbook and wandering off for a morning – or the whole day.

TURNING THE WORLD INTO WASHES:
HOW TO WORK FROM LIFE

In the chapter on planning for watercolour (pages 34–41) I said that we should see the world in washes. Working from life can be seen as 'turning the real world into washes', because that is what we must do. The 'real world' consists of many hundreds or thousands of different individual objects, and we must combine them into shapes which we then paint with as few washes as we can.

I generally try to combine distant shapes and shapes that I want to appear as 'quieter' in the painting, so these areas will have less shapes, while the focal point – which should be eye-catching – will have more. This is in tune with how we actually view things, rather than the hyper-analysed study we make when we paint an area – when painting, we become more aware of details than we would be if it we were viewing in the context of the whole vista.

I often squint at the scene and will not start painting until I have worked out a basic plan of how the washes will fit together. I seek out the lightest areas and make a mental note that these must be placed at their full strength in the first overall wash, while the darks can be hinted at. I take some time to appraise the midground because this is often the busiest area wash-wise, and I need to get as much first wash here as possible. If I am on form, this planning will be complete by the time I have set up the painting gear, then I am eagerly away, starting to paint. At other times I will stand or sit patiently waiting for a solution to arrive. Sometimes the rain or an angry farmer arrives sooner and the hunt is over before it has begun.

Generally the whole process takes approximately an hour to an hour and a half. Any longer and the sun will have travelled too far or the weather will have changed and the 'feel' of the scene is gone. On very flat days more time could be spent, but personally I feel that this leads to overworking and the energy that is so important in outdoor painting is lost.

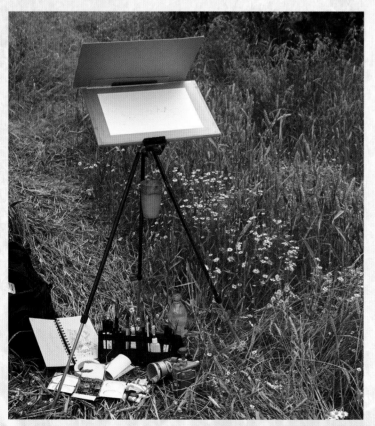

My kit

As described on page 22, when painting outdoors we may have to adapt, add to – and take from – our materials in order to suit working in the field. It is worth having a bag pre-packed with your tools and equipment ready to go, or at least pinning a list of what you will need to the studio wall, as forgetting an essential piece of kit is surprisingly easy to do. Teena says that if I adopted the same thorough approach to food shopping, my culinary adventures might not be so hazardous for the family.

My kit, shown here, shows what I take with me. The most obvious addition to my studio set-up is the lightweight easel. Some people can paint on their lap, but I need to be further away from the painting board, not trapped underneath it. The sunscreen that attaches to the easel and the water pot that hangs from it are also shown in position.

I always use the same palette, whether painting indoors or outdoors. It has a thumb ring underneath so that it sits firmly on the hand. Others may have a larger indoor palette and a smaller outdoor item with perhaps a more limited range of colours.

The only other additional items in my rucksack are a plastic bottle to carry water and an old camping stove and lighter to dry the painting on very damp days.

OAST HOUSES

This was painted on a very hot day. Not being from Kent, the part of the UK where these buildings – designed to dry hops as part of the brewing process – are most common, I found the old oast houses of great interest, and this was an attempt to get something down on paper, in conditions that were really too hot: the editor, photographer and I would have been better off sitting outside the local hostelry with a cold beverage.

Despite the difficulties of the heat, I was not displeased with the result and was inspired to paint another studio version once I returned home. Compare the on-site painting opposite with the studio version on pages 72–73.

You will need

Large mop brush

Size 12, 8 and 6 round sable brushes

Rigger brush

33 x 23cm (13 x 9in) Saunders Waterford 300gsm (140lb) Rough surface watercolour paper, stretched on a board

Masking fluid and ruling pen

My usual palette of colours (see page 18)

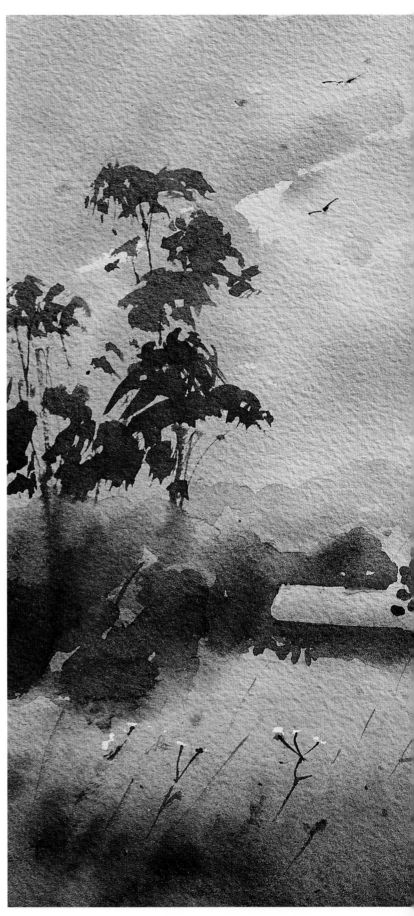

The finished painting

Techniques, not tools

The list of materials and colours I use – and the similar lists with the other projects –are starting points, not the be-all and end-all. The most important thing is how you put the paint on the paper, not the exact brush you use.

My advice is to adhere to the methods outlined in the steps that follow, but use the materials with which you are most comfortable.

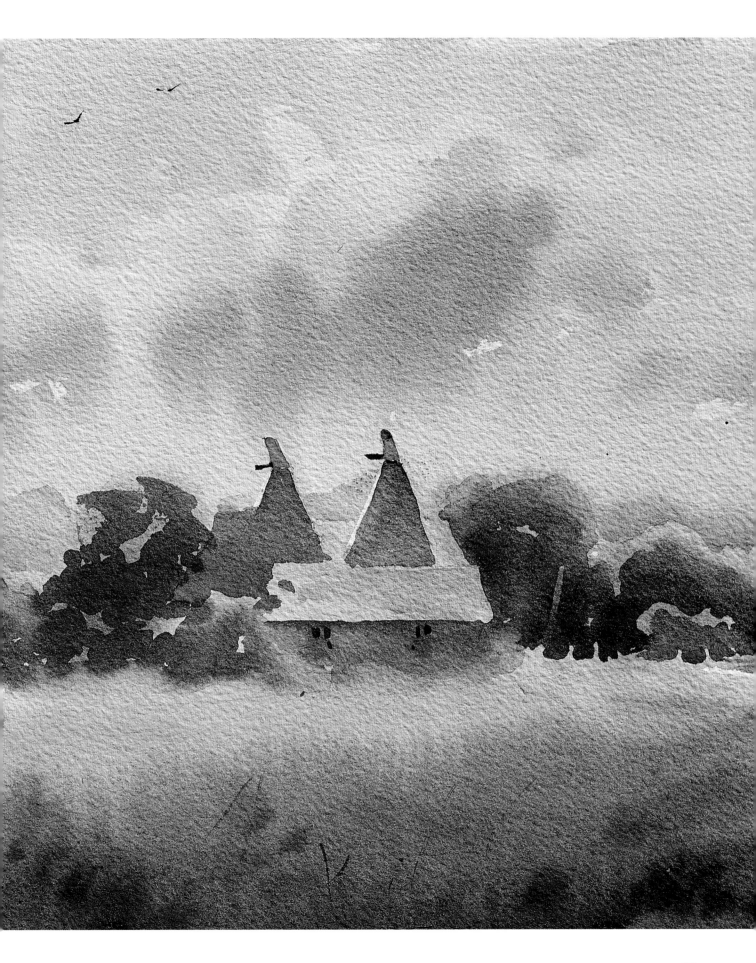

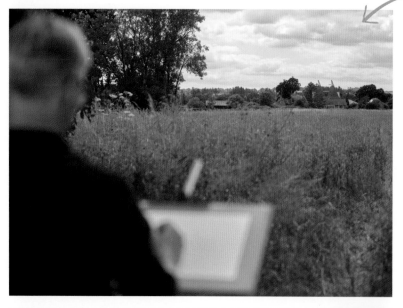

SKETCHING AND PREPARATION

It is important when working on site to recognise and respond to the urgency of the situation. This does not mean adopting a hurried or slapdash approach, but more a process of honing things down.

Have equipment that is uncomplicated, easy to assemble and allows you to work efficiently by having everything at hand.

Before you set up, wet your paints so that when you come to start they are alive and moist. Do not draw more than you need – remember, it's the big shapes that are important, the smaller shapes can be 'drawn' with the brush.

Don't waste set-up time: you should be analysing the whys and hows as soon as you see a scene. The exposure and time constraints mean outdoor painting is a very different beast to the rather leisurely pursuit of indoor painting, and this is why it feeds and enhances the indoor process.

Preparation

Having identified the scene, I work quickly to set up my easel and get the sketch down with my pencil. Use the ruling pen to apply a little masking fluid to the left-hand sides of the oast house roofs.

FIRST STAGE

The aim of this stage is to lay in, from top to bottom, one continuous wash of varying strength and colour to form a kind of ghost image.

The sky will be complete and the foreground will require very little work after this stage. For this particular painting I had to work very quickly due to the accelerated drying time caused by the very hot day. Adapting to these challenges is part of the enjoyment.

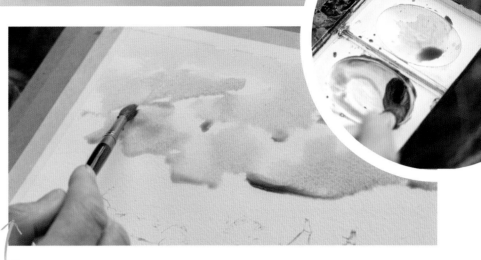

1 Use a mop brush to place water into the top of the sky to form random cloud shapes. Colour these by feeding dilute cobalt blue into the wet areas. This will leave a nice bead that will wait while you form the clouds with a size 10 sable brush and a wash of cobalt blue and cadmium red. The underside of the sky is then brought down to the horizon with a bead of cerulean blue.

Keep referring to the scene in front of you as you work.

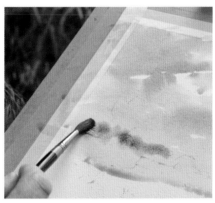

2 While the paint is still wet, use the size 10 sable to apply a thicker mixture of cobalt blue with a touch of burnt umber to form the distant treeline.

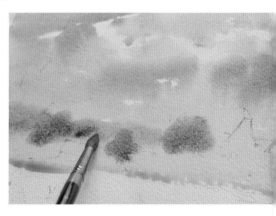

3 Add a still thicker mix of Hooker's green and burnt sienna to form nearer trees.

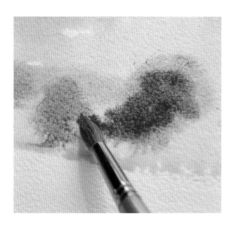

4 At this stage the trees can be darkened by adding ultramarine blue to the mix. Remember this must be done rapidly while the surface is still wet and alive.

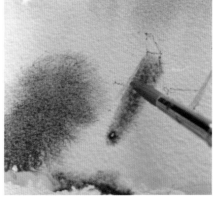

5 The buildings go in next, with a mix of ultramarine blue and burnt sienna. Keep the paint fairly stiff.

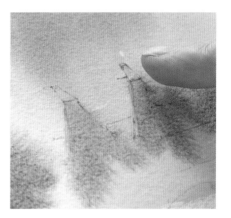

6 Place the colour inside the shape as it will spread a little. If it passes outside your line, a little flick with the side of your finger will arrest its travel.

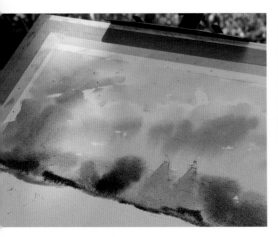

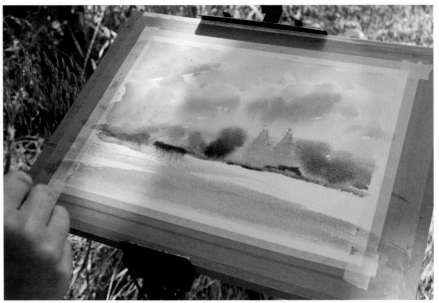

7 Using a strong mix of ultramarine blue and burnt umber, place the hedgerows.

8 With a big mop brush and a mix of cadmium yellow and cadmium red, quickly place in the field and let it connect to the remainder of the bead in the hedgerows.

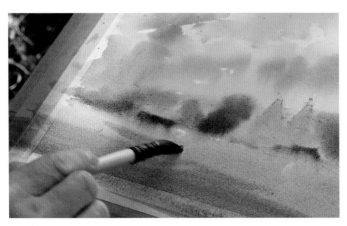

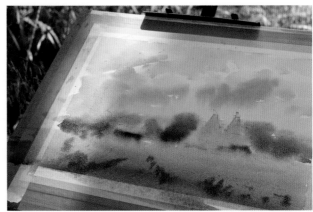

9 Working quickly with a stronger versions of the same green and yellow-orange mixes, strengthen the field in the foreground.

10 Add still richer, stiffer marks with a size 8 round to add texture to the field.

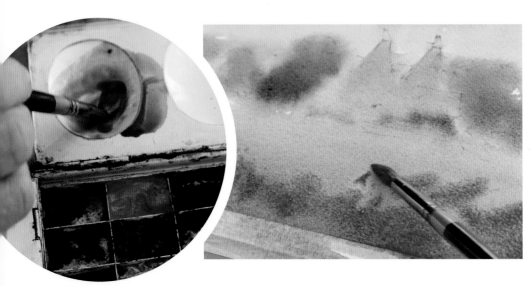

11 Place the thickest, richest marks in the foreground, but be economical in their use – too many will make the painting look cluttered and busy.

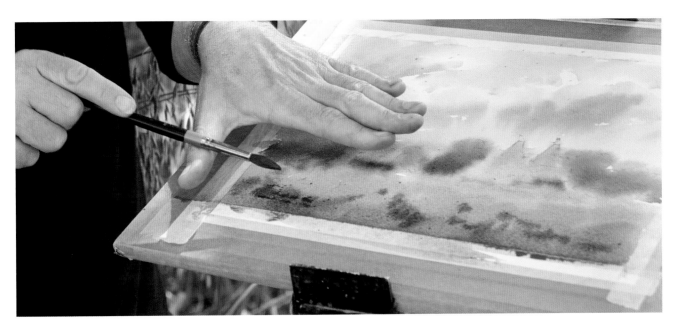

12 Shield the area above the field with your hand, holding it a little way above the surface as shown, then tap the loaded brush against your thumb to spatter small droplets of paint onto the field for texture.

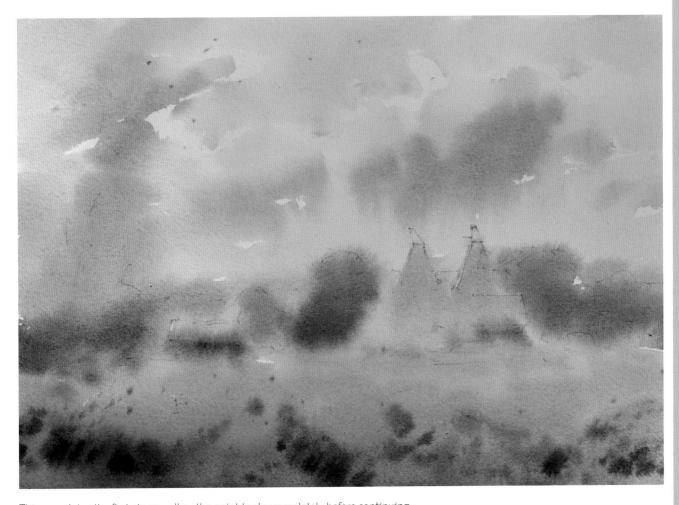

This completes the first stage – allow the paint to dry completely before continuing.

SECOND STAGE

After the wash of the first stage has dried, the painting will appear flat, so we want to add a sense of distance by adding contrast – in tone, colour and shape – between the foreground and background. This is what we will concentrate on in this second stage.

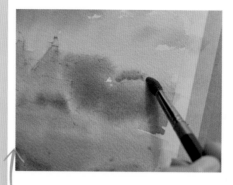 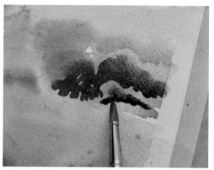

1 To increase the impression of distance, dampen the sky above the trees on the right-hand side with clean water, then add some more trees with a mix of cobalt blue and a touch of cadmium red, using a size 6 sable brush. This also gives the tree in front a highlighted top.

2 Strengthen the dark trees nearer the front of the painting by dampening the area, avoiding the top where the foreground trees meet the distant blue-green trees, then touching in a mix of Hooker's green and burnt umber. Leave gaps of clean paper to create shape.

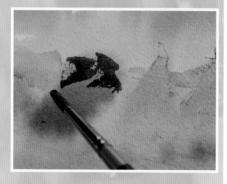 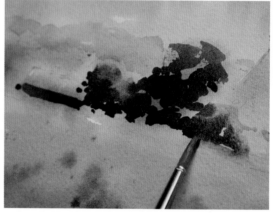

4 Work down the trees with the tip of the brush to create texture, leaving gaps of the first wash showing through. Paint the hedgerow at the same time.

3 Use a stiff (i.e. a less fluid) mix of the same colours to paint over the trees to the left of the oast houses. Use a dry brush technique; lightly drawing a barely loaded brush over the dry surface to pick up the texture of the paper.

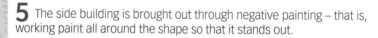

5 The side building is brought out through negative painting – that is, working paint all around the shape so that it stands out.

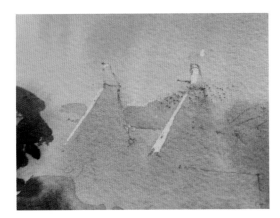

6 Allow the painting to dry completely – on a sunny day, this shouldn't take too long at all! Use a clean finger to rub away the masking fluid from the oast house roofs.

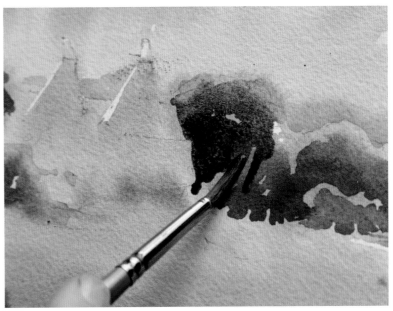

7 Use the size 8 brush to paint the remaining midground areas with the same combination of Hooker's green and burnt umber. The detail above shows me working around a telegraph pole with the negative painting technique. Details like these help to create realism.

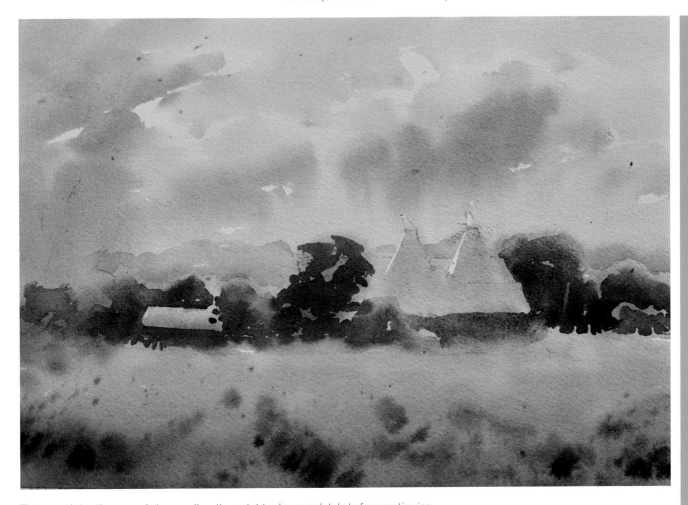

This completes the second stage – allow the paint to dry completely before continuing.

THIRD STAGE

One of the perils of working outdoors is that the light is shifting. Not only do you have to work quickly, but the sun can move enough to fall directly onto your painting, which can be dazzling and dramatically reduce the drying time available to you.

To the left is shown my solution – a simple plywood sunshade that fits securely on my easel. Your sunshade should be rigid and lightweight – but not so light that it blows away.

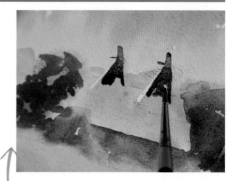

1 The hard-edged shapes can now be placed; paint the oast house roofs with a mix of ultramarine blue and burnt sienna using a size 5 brush.

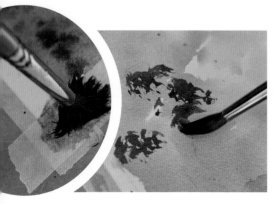

2 For the larger left-hand tree, push an old size 10 brush downward on the edge of the board to splay the bristles (see inset). This can be used to give an interesting broken edge to the mix of Hooker's green, burnt sienna and ultramarine blue.

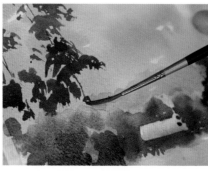

3 Using a rigger, use the same mixture to portray some branches between the foliage. This must be done while the foliage is still wet.

4 Still using the rigger, paint the windows with a strong mix of ultramarine blue and burnt sienna.

5 Don't forget the birds, which are painted with the same mix. Do try not to go overboard with the rigger – it's a surprisingly dangerous brush.

6 Add some texture to the lower roof using some dilute burnt sienna on a size 6 brush.

7 To place a cloud shadow over the foreground, gently lay clean water over the top of the foreground using a mop brush.

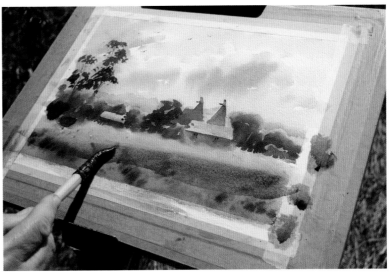

8 Using a fairly strong (but still with a bead) wash of ultramarine violet, lay in the shadow with a minimum of fuss.

9 Strengthen the foreground shadow with a wet-in-wet application of ultramarine violet and ultramarine blue. Use only one stroke here – any more will risk lifting the underwash.

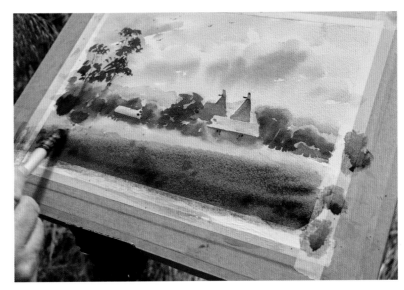

10 Drop a small amount of clean water on top of the shadow. This should run down into the violet and form the impression of grasses.

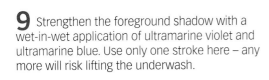

Tip

I pushed my luck here, so this stage is optional, and will depend on whether your paint has dried or remains alive and workable.

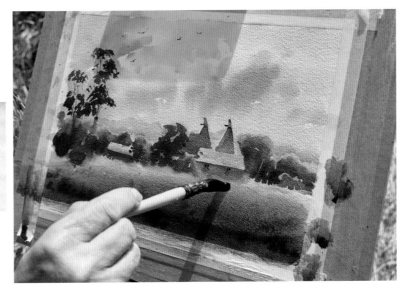

11 Spatter some cadmium red paint into the field to suggest poppies – notice how my hand protects the painting above the field.

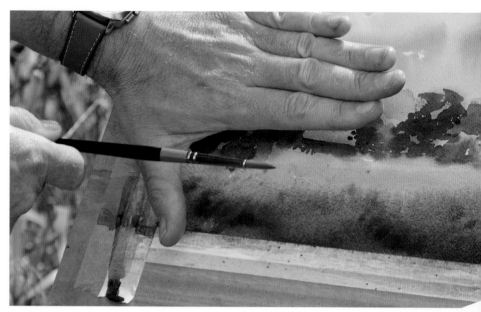

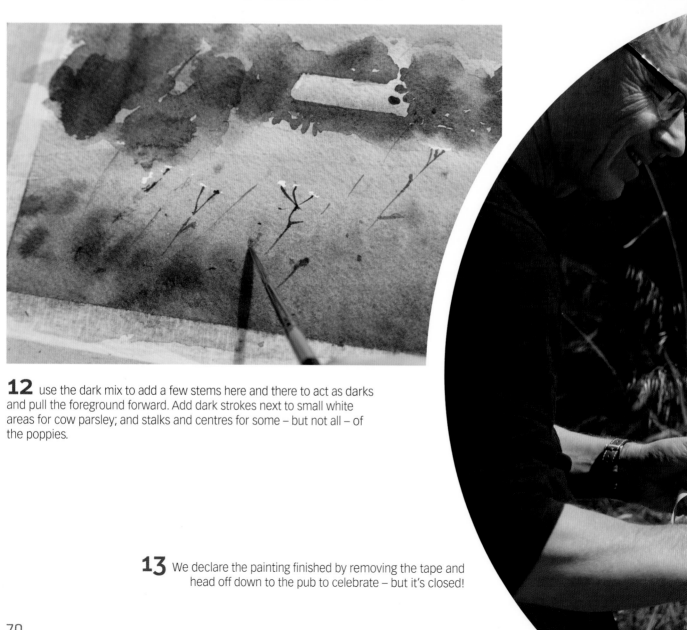

12 use the dark mix to add a few stems here and there to act as darks and pull the foreground forward. Add dark strokes next to small white areas for cow parsley; and stalks and centres for some – but not all – of the poppies.

13 We declare the painting finished by removing the tape and head off down to the pub to celebrate – but it's closed!

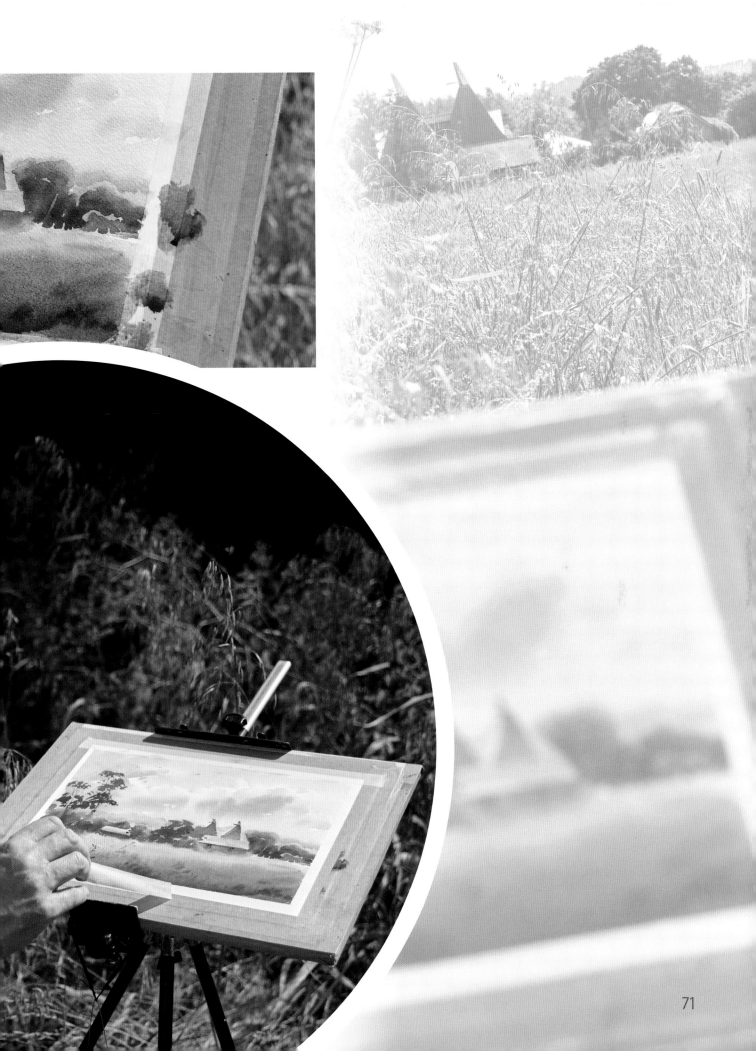

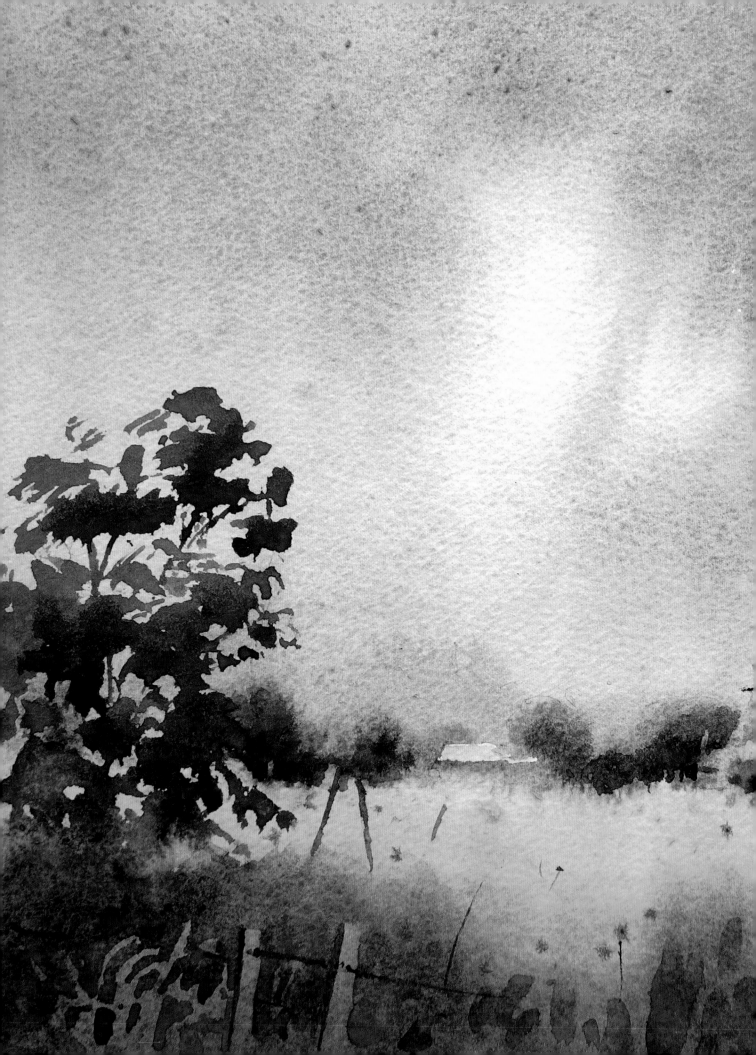

FROM SITE TO STUDIO

After completing a site painting, I usually take it home and assess it the following day. When removed from the actual subject, the painting ceases to compete with its origin and takes on a life of its own. Sometimes I will place a glaze (a thin wash) over areas, or put a few additional marks here and there. I may decide to leave well alone.

The success rate of site paintings must not be judged in the form of frameable paintings. You are taking home a lot more than a finished painting. The studio failures sting me to a far greater degree than on-site failures. I view a studio failure as wasted time, but if I fail on site then I have still had a richer experience – often I have been with friends, in great scenery, I have learned and I have a created a reference that can be used as a studio painting.

Oast Houses, Kent

Compare this painting, made later in my studio, with the one worked on site. The first thing to appreciate is that the washes are cleaner because I was not fighting the hot sun. The result is softer and thus more atmospheric. The format and composition has also been altered slightly: the studio version is square, which provides more intimacy; while the oast houses have been pushed further into the distance.

All of these decisions came about after careful self-critique of the original painting. We must learn to be our own sternest critic.

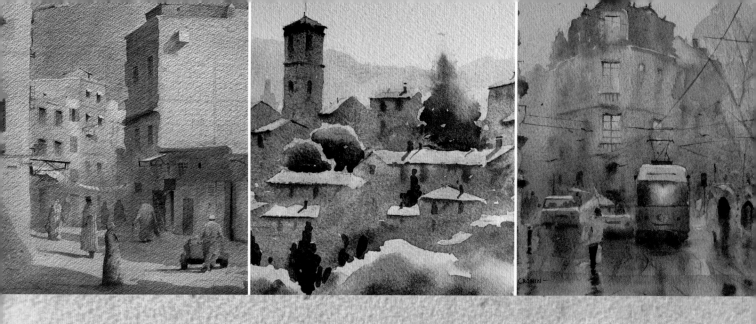

CREATING

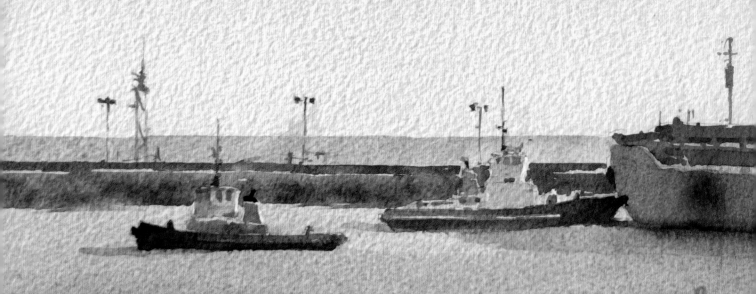

WATERCOLOURS

with Light and Luminosity

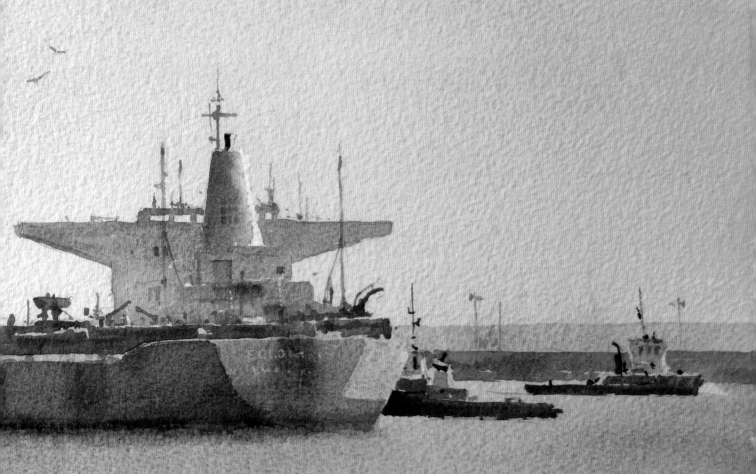

LIGHT AND WATERCOLOUR

When I am out and about, whether in a city or the countryside, I can't help but notice how many people are now totally disengaged with the natural world. Earphones in, looking at their mobile phones, they are deep in thought or otherwise distracted. It's sad, because humans evolved senses to interact with and respond to each other and their surroundings.

If you go out, breathe the air, listen to the sounds and actually look at the world we live in, you'll find it quite an interesting place. Imagine standing in the same spot, town or country, from dawn till dusk (though if we're doing it from dawn till dusk we had best sit). The smells, the sounds and the sights would change all through the day, sometimes subtly, sometimes dramatically, but change they would. If you were able to stay at the same place all year (most of us can do this, it's called our home) then the changes would be seasonal too. It is these changes that provide landscape painters with a lifetime's inspiration.

When one first starts to paint, it is often as much as we can do to get the shapes to look right, and this is what most novices concentrate on; painting the objects they see accurately. As progress is made, the painter starts to realise that these objects change according to such things as time of day, light and weather. This is why this book contains no chapters on specifics like buildings, trees or skies. We must recognise that a building seen in mist will be very different when viewed in sunlight and is painted with a completely different combination of shapes, edges, colours and tones. Therefore the key to achieving different moods in one's work is to study how the different weathers, seasons and times of day affect the relationship of shapes, edges, colours and tones within a painting. These are said to produce different 'atmospheres' and the final part of this book deals with the ultimate challenge for the watercolour landscape painter: how to produce paintings that represent these atmospheres using pure transparent washes. We shall look too, at how our painting plan must vary to take account of the mood of each painting.

For clarity we have used titles such as sun, rain, snow and mist. They can – and do – of course combine, and this is where it gets really exciting. We can get sunlit showers or misty snow and so forth (where I live in South Wales, we can get all the above together in the same day!). So as well as demonstrations the chapter also contains other paintings attempting to show a portion of the immense variety of moods the great outdoors has to offer.

Back Street, Marrakesh

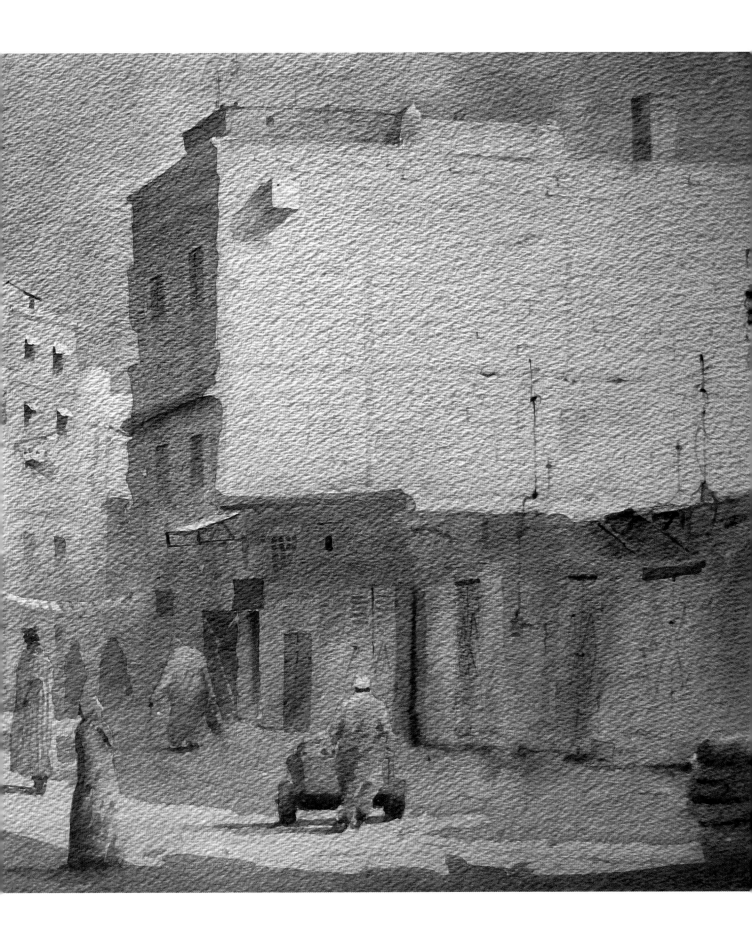

WEATHER AND ATMOSPHERE

The effects of light, season and weather on a given subject are infinitely varied. There is, of course, no 'magic formula' and no substitute for actual study, brush in hand, in front of nature itself.

However, some basic guidelines can be offered. I use the acronym 'SECT' – which stands for 'shapes, edges, colours, tones' to help me focus on how these four important elements are affected by different weather conditions. The table below attempts to identify and summarise the main themes, each of which are explored in more detail on the following pages.

CONDITIONS	SHAPES	EDGES	COLOURS	TONES	WASHES
Bright sunlight	Lots of identifiable shapes and clear separation between them all.	Predominantly sharp crisp edges in the foreground, softening with recession owing to increased haze in the air.	The most colourful of all conditions, but surfaces can shine so brightly that they appear white.	Strong tonal contrast to foreground and midground. Quite pronounced aerial recession possible on more hazy days.	Aim to get all sunlit areas stated in the first wash and handle shadows with a superimposed second wash.
Evening sun	The number of apparent separate shapes will decrease with the failing light.	The number of edges will decrease, but lots of hard edges remain, aside from those affected by aerial recession.	The sky often colours up while land shapes will lose saturation.	Strong tonal contrast but tones start to fuse and present themselves in the form of lengthening shadows.	Handled in a similar way to bright sunlight, as described above.
Looking into the sun	Shapes will fuse together even more than evening sun, thus giving fewer separate shapes and more profiles.	The number of hard edges will decrease further but profiles against the sky are predominantly hard edged.	Colour will decrease markedly and can become very limited.	Strong tonal contrast but tones within large shapes will fuse more to give less shape and colour. Aerial recession between shapes will ensure a good tonal range.	Start this type of subject with a sky/land wash and place the darker vertical shapes as a second wash.
Rain	Shapes will fuse together even more, thus giving less separate shapes and more profiles, which are often lost and found.	The number of hard edges will decrease but profiles against the sky can be hard-edged, particularly after rain as any dust will be cleared from the air. Lots of soft fused edges too.	Colour will often markedly decreases and thus require a limited palette but if the sun is also present strong local colour is possible.	Strong tonal contrast is possible but tones within and between large shapes predominantly fuse more to give a closer-toned composition.	Place horizontals such as roofs, roads as first wash and superimpose verticals with a second wash. Soften these at their bases to form reflections.
Mist and fog	Shapes fuse together, sometimes presenting very little separation at all. Profiles are very often lost and found.	Predominantly very soft and fused, though capable of a hard staccato edge too, especially in the foreground.	Very limited palette but colour will creep in as mist turns to haze.	Predominantly close-toned, but pronounced aerial recession is possible. Full tonal range will be present due to strength of foreground elements.	Aim to place most of the painting in the first wash, working as it dries. Once dry, tease and soften away any hard edges as required.
Snow	A great variety – shapes will be numerous as per sunlight, right through to fused if in mist.	Edges vary from numerous as per sunlight, right through to fused if in mist.	Snow obviously limits colour, but scenes are not colourless.	Tonal contrast will again vary according to weather conditions.	Surprisingly little white paper is required for snow. Use a sky/land first wash, then state darker verticals as second wash.

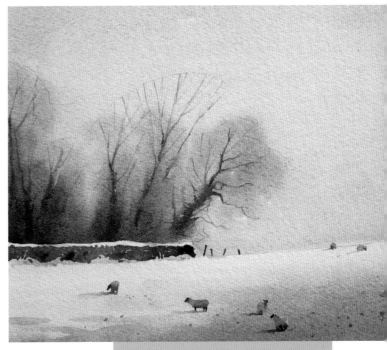

CHANGING WEATHER

It is the subtle play of tone and edge that can imbue a painting with a given atmosphere. If we stop to think, it is obvious that we cannot portray mist by placing hard-edges everywhere or by having strong tonal contrasts all over the painting, for example.

If you only ever paint the objects in a landscape, then you will never achieve atmosphere in your work. As we have repeatedly stated within these pages, we need to see the world as shapes, edges, colours and tones. If you observe these accurately it will have surprising results on your work. Remember too that the best place to observe the landscape is actually in it.

The paintings above, all of the same scene, were painted during the winter months, so you will notice that the overall colour palette is very similar. The difference between them is that each is an example of the scene in different weather conditions. Clockwise from top left, they are sunshine, mist, snow and rain.

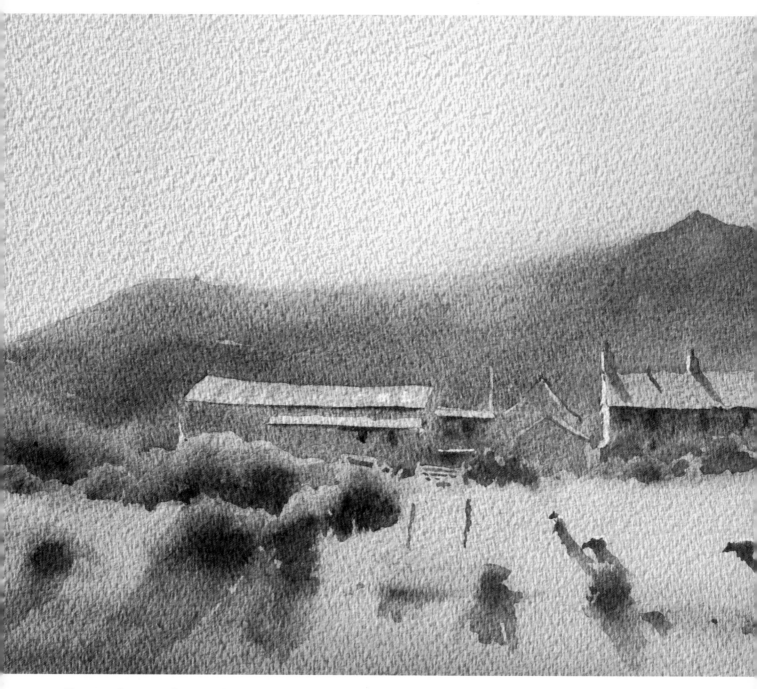

Evening Sun near St David's, Pembrokeshire

This was spotted by chance as I was heading home after tutoring some students. Usually when you spot things like this there is nowhere to park, but I managed to squash the campervan onto the roadside verge and carry out a quick sketch. The painting was carried out in two main passes: the sky and the meadow, then when this was dry, I painted the whole mid ground as one wash. I was quite pleased with the result.

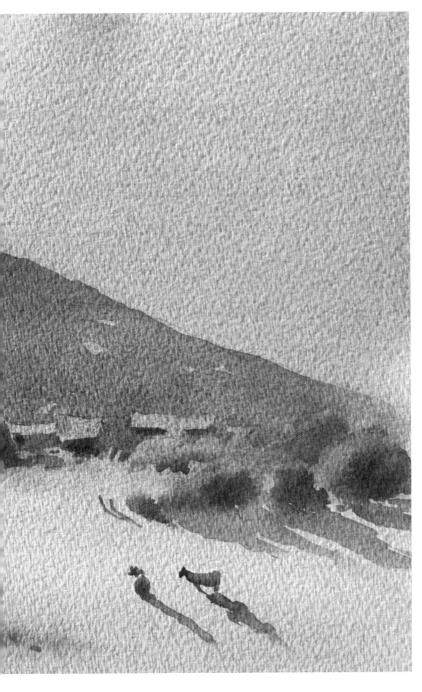

SUNLIGHT

Sun is the giver of life (and sunburn). It gives form and shape to the landscape and lifts the spirit. Sunlight offers the painter oodles of tone and sharp, cut edges. There is an abundance of colour too, and for the novice painter it is probably the most painted weather effect.

There is a plethora of sunlit conditions, varying with the season and time of day. Morning sunlight requires a different approach to midday, for example, and the evening another approach again. Painting at the beginning and end of the day is beneficial due to the fact that there is less heat and more drama, due to haze or long shadows.

When painting in sunlight, we need to consider our position in relation to the sun: whether we are painting into the light, across the light or down the light. Painting down the light – that is, with the light directly behind us – can make for a colourful painting but it is likely to be flat, owing to the fact that there will be no shadows to help with form. I like a good proportion of my cityscapes to be across or – better still – into the light, because this causes shapes to become fused, which lends itself to a less busy painting.

In my sunlit paintings I try to place all the sunlit surfaces with the first wash and hint at the shadow areas. The second wash will largely be for the shadows and near foreground.

Painting on site in strong, direct sun and midday heat is not good practise in any media, as direct sun onto the painting surface is blinding to the artist. It will doom any on-site attempt at pure watercolour to failure, so in hot sunny weather the watercolourist needs a way to slow the drying rate by shading the work and thus lowering the temperature. Shade can be achieved via an umbrella or by sitting under tree cover, which has the advantage of damper, cooler air too.

While abroad in the Mediterranean, I was once able to paint a street scene at midday by setting up in an air conditioned shop window (thus providing traditional art, installation art and performance art in one fell swoop!). My more orthodox approach would be to paint early, with a pen and wash approach as the day heats up, and start again late in the day.

INTO THE SUN

This demonstration aims to portray the atmosphere of looking into the sun as it sits high overhead. If the sun was lower then the house walls would be darker. Watercolour-wise, it is a case of isolating first washes with darker second washes, thus giving the impression of light. Remember also that looking into the light, shapes fuse, an effect that is evident here.

I have quite an affinity with this light effect and if you look through the book you will find may other paintings where I have used the method outlined in this demonstration to achieve this mood. The colours used here lean heavily on raw and burnt sienna to capture that Mediterranean warmth. Again, don't fixate on the specific colours and brushes: remember my earlier point that it's not the tools you use, it's the technique that counts.

You will need

Large mop brush
Size 12, 8 and 6 sable round brushes
Rigger brush
33 x 23cm (13 x 9in) Arches 300gsm (140lb) Rough surface watercolour paper, stretched on a board
My usual palette of colours (see page 18)

Tip

When painting bright sunlight, a light-surfaced watercolour paper is important. Although the Arches paper I used for this project is not pure white, it has a lighter surface than the Saunders Waterford paper that I usually use, which is a bit too cream in colour for this sunlit scene.

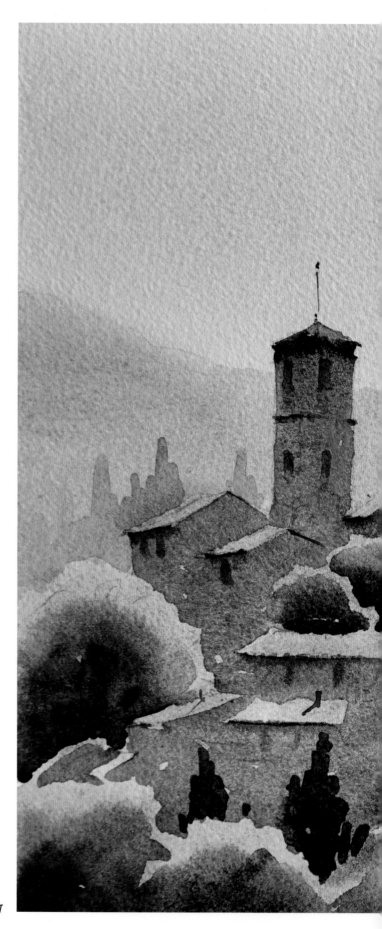

The finished painting

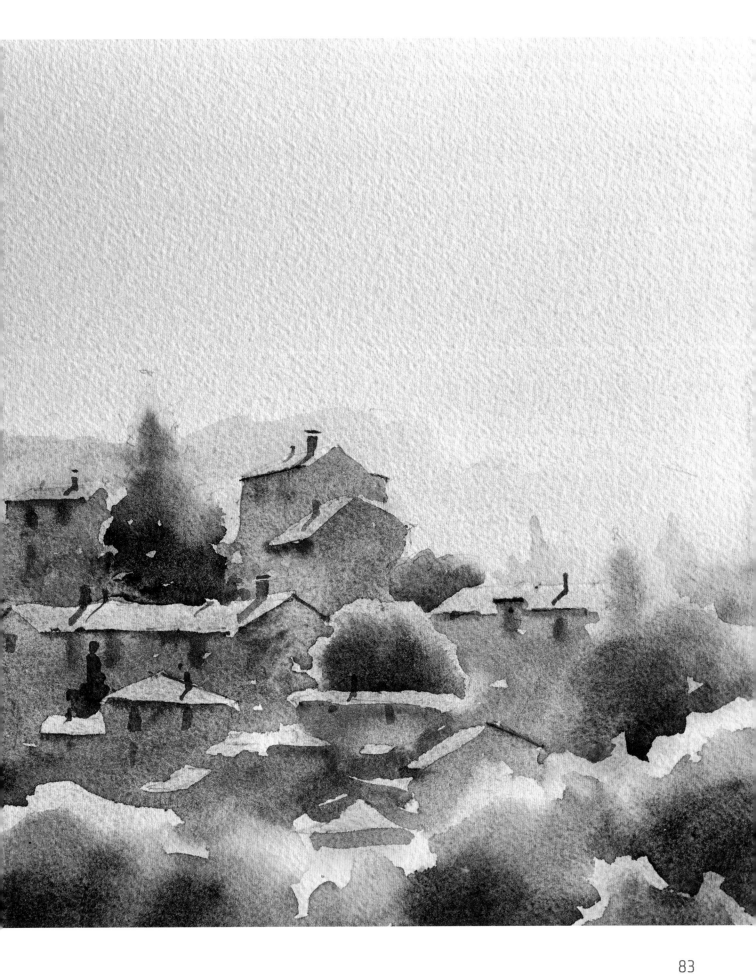

THE SKETCH

The sketch was a combination of three photographs due to the fact that the field in front of the village was actually ploughed and bare. I wanted to see if a vineyard or olive grove would work best as a foreground.

I often do sketches such as this to test the best composition of shapes and tones. This sketch portrays a light effect that I am often drawn to, which is into the sun with brightly-lit roofs; this is what the watercolour will be about.

FIRST STAGE

Watercolour is painted from light to dark. The sketch dictates that the sky, roofs, treetops and foreground will stay as first wash, with a second wash placed over the walls and trees once this initial wash is dry. During the execution of this first stage the paper has to be wet at the top for the sky and damp at the bottom for the foreground colours. It is wise to use the biggest brushes that you feel confident to wield. Also important is the use of stiffer paint (ie. more pigment, less water) for the initial land shapes, to allow the sky to start to recede at this early stage.

The aim at this point is to produce a soft impression of the scene with no hard edges evident.

1 Paint a wet-into-wet sky using cobalt violet, cadmium orange, and cerulean blue using diagonal strokes of the mop brush. Use the brush on its side (as opposed to the tip), in order to place the pigment as quickly as possible

2 Pick up the board and tip it gently to encourage the paint to mix and merge on the surface.

3 Re-wet the brush and draw the wash down to the bottom of the paper.

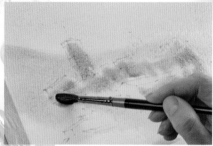

4 Working wet-in-wet, add mountains using the size 10 round brush, cobalt violet and cobalt blue; then use raw sienna and burnt sienna wet-in-wet to add the buildings.

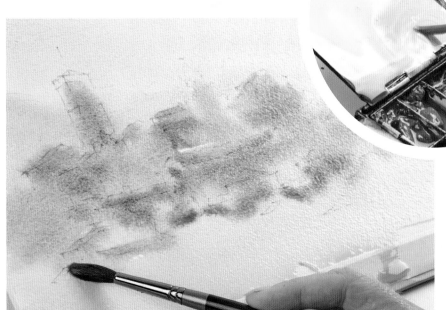

5 Still working wet-in-wet, establish some basic foliage with lemon yellow.

6 While all the initial washes remain wet, add scribbly marks of cadmium orange and cadmium red for roofs with the size 3 round. Pick up neutral mixes from the palette (see inset) for variety.

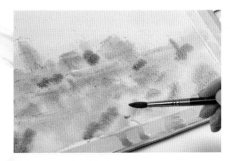

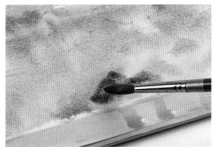

7 Add a mix of French ultramarine and lemon yellow wet-in-wet for shadows and darks in the foliage.

8 Reinforce the darks with a mix of burnt sienna and Hooker's green.

This completes the first stage – allow the paint to dry completely before continuing.

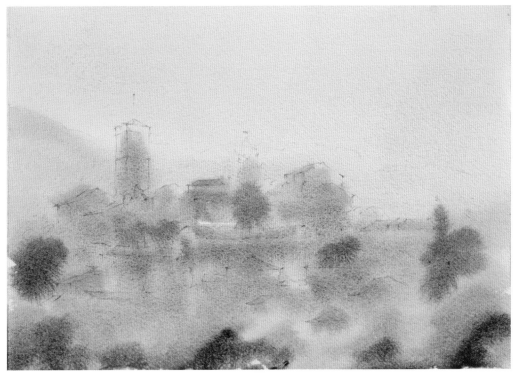

SECOND STAGE

Once the first overall wash is completely dry, the background hill and distant buildings can be added. This wash is used to establish a hard edge to most of the rooftops, which are to remain as the first wash.

In this stage, we soften off the top of the hill on the right-hand side with a damp brush and note how the wash varies in tone as it travels across the paper. Remember that every time you are working on dry paper, you should be using a juicy bead of liquid colour.

Also at this stage, a strong mid- to dark-toned wash is used to vary the both tone and colour of the building to make the resulting shapes more interesting. Windows are dropped into the damp wash with stiff 'stay putty' paint and the final job is to soften away parts of the bottom edge above the trees.

1 Soften the top of the mountain using a wet mop brush.

2 Strengthen the background mountain with a cobalt violet and cobalt blue mix. Work over the tower and around the foreground shapes.

3 Using a damp brush, introduce more water to the mix as you work to the right. This will both vary the tone and soften the effect in the background.

4 Soften and dissolve the edges of the background buildings by drawing the wet bead over them. Avoid the edges of the foliage, to keep them more crisp.

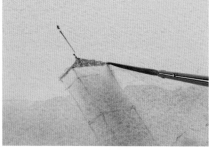

5 Start to define the edges of the buildings. Beginning at the top of the tower, using the rigger to apply a mix of cerulean blue and Hooker's green.

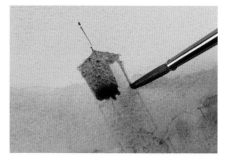

6 Switch to the size 8 round brush and build the tone on the tower up using a dark mix of raw sienna, ultramarine violet and a little ultramarine blue.

7 Work wet-in-wet to build the darks on the background buildings, being careful to leave the roofs clean and dry. Add raw sienna at the edge of the dark mix in the well (see inset), allowing the colour to bleed in for variety. This can be done with cerulean blue, too.

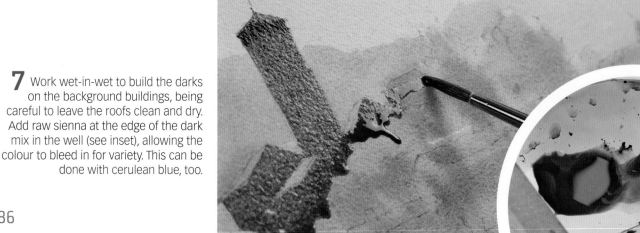

8 As you work around the buildings, you will likely end up with more than one active bead – this is fine; it ensures the colours are shared across the area.

9 Continue building the darks towards the foreground. Vary the brush if necessary for tight areas and soften the edges using a clean wet brush.

10 In the foreground, use negative painting to suggest rooftops; boxing them in with darks that join the main dark area. Near the very bottom, leave the dark area more jagged to suggest intervening foliage.

11 When the gloss has disappeared from the wash, but before it dries completely, use the rigger to add details such as shadows beneath the roofs and windows with a strong dark mix.

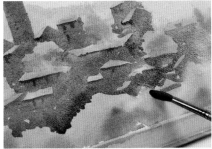

12 Continue applying dark details across the painting, then use a damp size 10 round brush to soften some of the hard edges at the bottom of the darks areas before they dry.

This completes the second stage – allow the paint to dry completely before continuing.

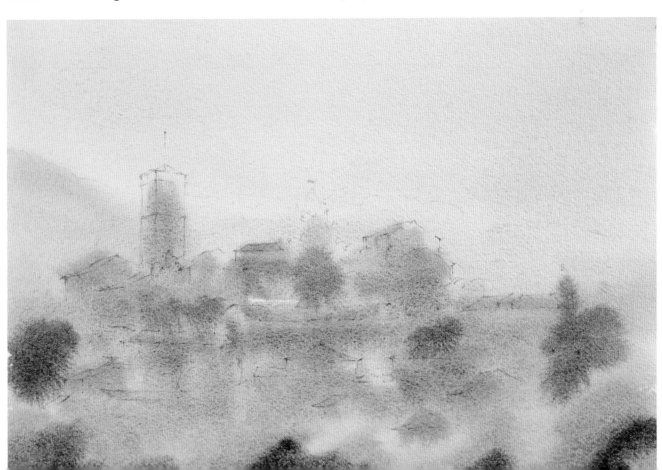

THIRD STAGE

Once the painting has dried once more, it is time to start on the trees. These shapes are to be 'lost and found', which is achieved by selectively dampening areas of the paper to lose some of the hard edges and by allowing one tree to merge with another.

The top of each tree section is wetted with a damp brush and a green mix is then applied. While this remains wet, a stiffer darker mark is added for the base of the trees, which are then softened into the ground.

Once each clump of trees is dry, repeat the process for the next clump of trees, and so on, until the foreground area is complete.

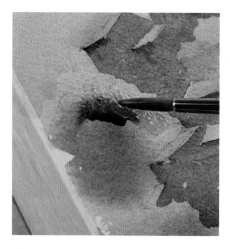

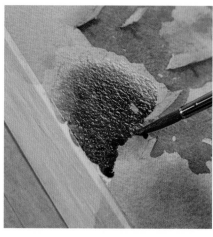

1 Wet a section of trees with clean water, then set up a bead of Hooker's green, cerulean blue, ultramarine blue and lemon yellow within the area.

2 Without rinsing the brush, add dark areas wet-in-wet using a mix of ultramarine blue and burnt sienna.

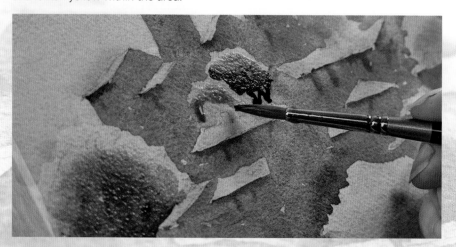

3 Continue building up the other tree areas. Add shaping to some of the tree areas by taking the dark mix across it, leaving a light edge midway through. This suggests the area is made up of multiple separate trees or bushes.

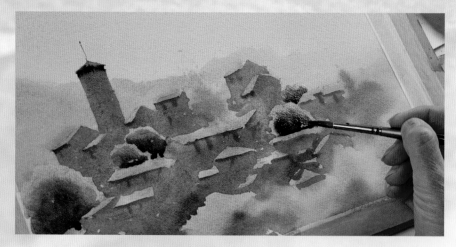

4 Emphasise some of the rooftops by creating hard lines at the bases of foliage areas in the midground, so that the terracotta red of the light first wash stands out due to the contrast.

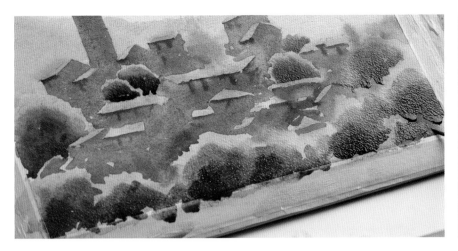

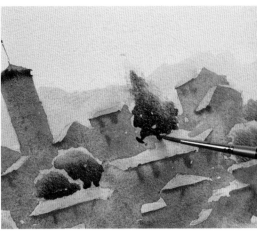

5 For the foreground foliage, make the individual trees larger and use your strongest darks here.

6 The central tree is important in terms of composition, but don't be intimidated by it – treat it just like the others.

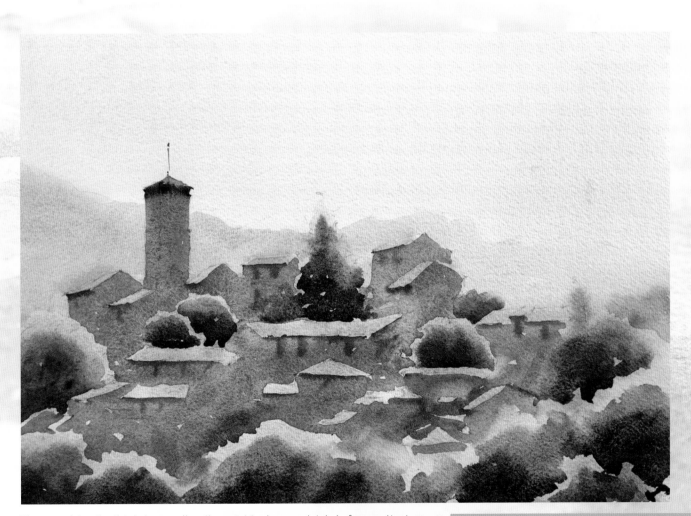

This completes the third stage – allow the paint to dry completely before continuing.

FINAL STAGE

With the light effect (the purpose of the painting, remember) already set, the painting requires only a few final details such as distant trees, sticks, people and chimneys to bring it to completion.

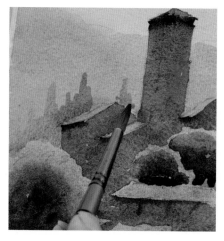

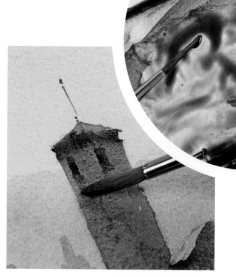

1 Add cypress trees in the background using a size 6 brush and dilute French ultramarine.

2 Add touches of a strong dark mix (ultramarine blue and burnt sienna) to the tower with the tip of the brush, then soften them with clean water.

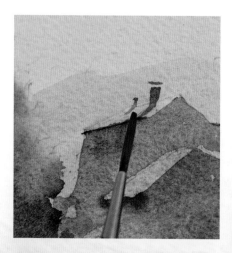

3 Switch to the rigger for finer marks on the other buildings, using the dark mix to add further details. Chimneys can be suggested with small vertical strokes; and offer good opportunities for suggesting light by adding shadows along the line of the roof.

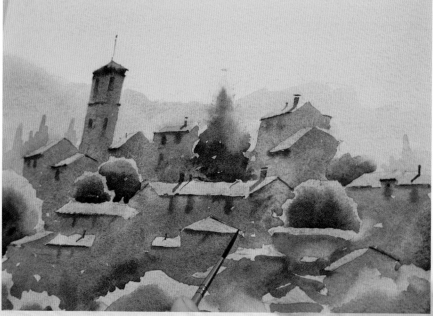

4 Keep the direction of the shadows consistent across the whole painting – the direction of cast shadows may vary depending on what surface they are falling on, but they will always face away from the light source – in this case, at the top right.

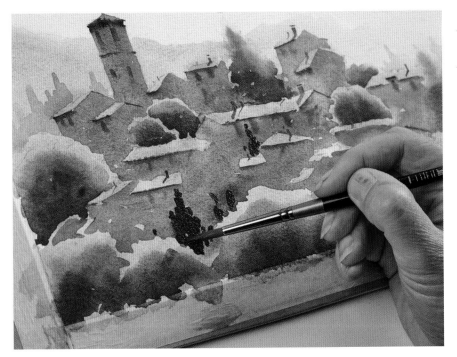

5 Make a strong dark green from Hooker's green, ultramarine blue and burnt sienna and add cypress trees in the foreground, using the tip of the size 8 round brush.

6 Allow the painting to dry, then carefully remove the masking tape to reveal the clean border. The finished painting can be seen on pages 82–83.

PAINTING *ABERAERON*

The light is in front and to the right-hand side of this painting of the port settlement of Aberaeron. This is often a format that inspires me, as it means that all the verticals will be in shade and almost all the horizontals are lit, which allows the placement of all the horizontals in the first wash.

In terms of the act of painting, it follows a very similar plan to the Tuscan painting on the previous pages. Once dry, the continuous second wash describes the background, house fronts, bushes and bank that nicely sandwich the first washes of the roofs and grass, thus allowing for a simple but effective painting plan. All that remained after this was to place the boats, windows and water with minimal fuss.

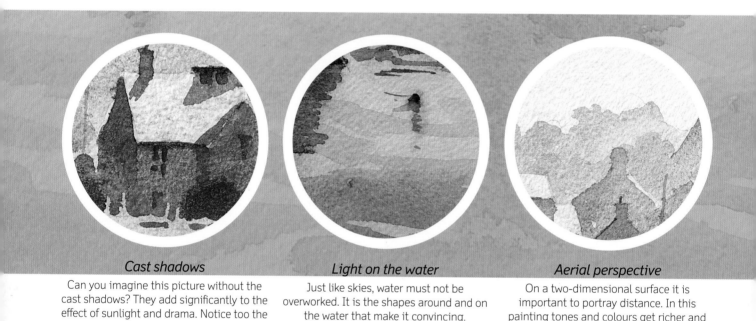

Cast shadows

Can you imagine this picture without the cast shadows? They add significantly to the effect of sunlight and drama. Notice too the posts at the base of the buildings, which break up an otherwise boring edge.

Light on the water

Just like skies, water must not be overworked. It is the shapes around and on the water that make it convincing.

Aerial perspective

On a two-dimensional surface it is important to portray distance. In this painting tones and colours get richer and stronger as they get nearer the foreground. By contrast, the distant trees and buildings are soft blue-tinged silhouettes.

Troublesome birds

One of the perils of this coastal village is the seagulls. They regularly dive-bomb people and will snatch food from your hand. It appears that they cannot tell a paintbrush from a food item as I have often been harassed while painting here, too.

Their natural inquisitiveness and total lack of toilet manners render them a major hazard for the coastal painter. The absolute nightmare scenario here is when a family on holiday gather around to watch you paint, while munching away at food that is being constantly attacked by the seagulls, that then attracts a cat that attracts some dogs... well, you get the picture.

PAINTING *BOAT REPAIR*

I like this simple little painting. I knew the summer trees would be a challenge, but they were important as a dark to pull out the brightly-sunlit cottages; I painted them in a similar manner to the trees in the Tuscan painting demonstration earlier.

The rest of the shapes are mostly white paper with bits of second wash giving form to the underlying first washes. I call this process 'teasing edges', because that is exactly what is done. An edge is laid (on dry paper obviously) and then the remaining wash is softened back into the existing first wash with a damp brush and a deft touch. This helps to create a 'lost and found' effect, where shapes are found and then lost back into the overall wash of the painting.

Combining shapes
The hull of the boat was painted in the same wash as the tree. It is important to take note of such things while planning your paintings, or you will end up with too many shapes and a busy painting.

Soft background
Soft, diffuse changes of colour and tone stop the trees from being too flat but keep them in the background.

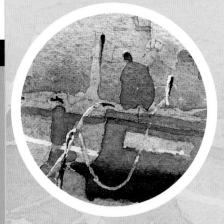

The focal point
I wanted to arrest the attention of the viewer here, so there is detail and – of course – the eye-catching figure.

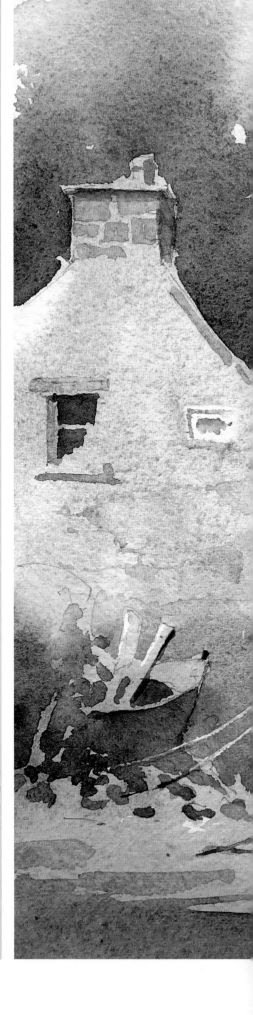

Peace and quiet

One doesn't always have to paint the grand and dramatic. Often it's the unexpected that hits the heart. Quiet little corners like the subject here always appeal to me. They are a compelling snapshot of a given moment and mood.

It was necessary to set upon a steep muddy bank to paint this scene and – predictably – I quickly became unstuck, sliding down the bank and into the shallows. As a result, while the resulting painting was clean and fresh, the artist ended up dirty and smelling of river mud.

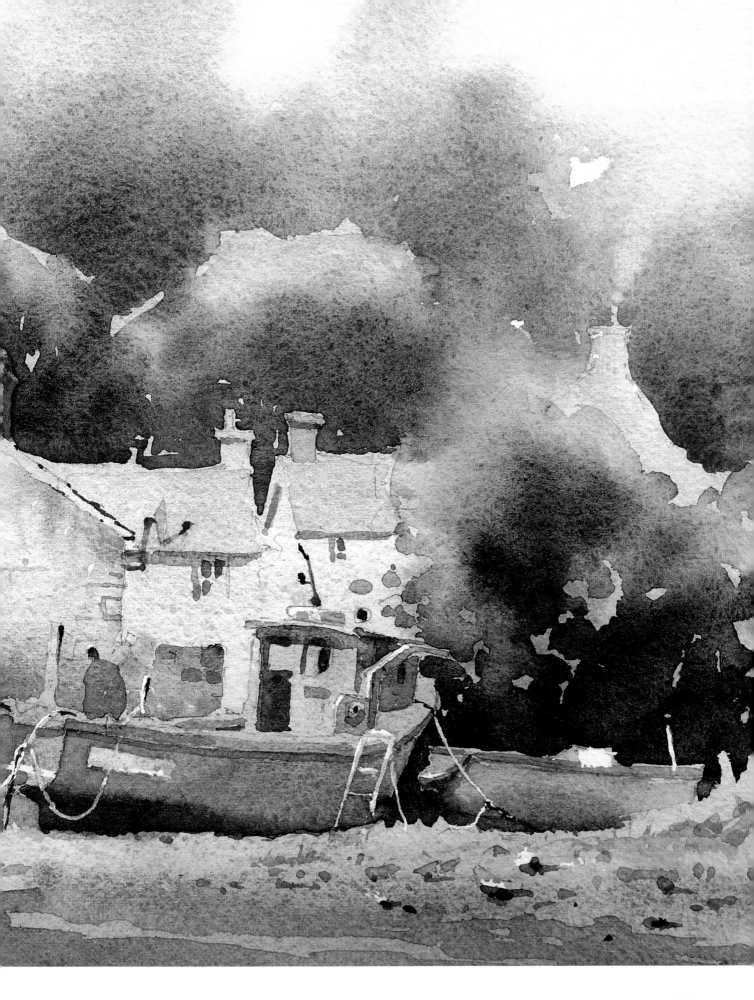

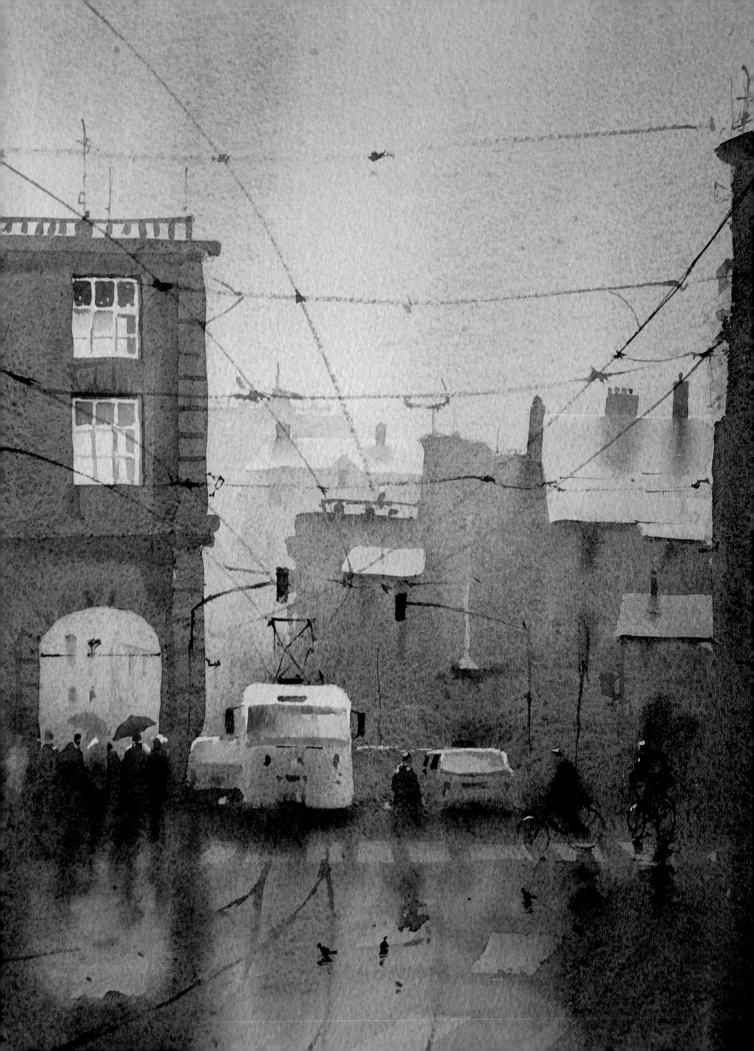

RAIN AND STORMS

I rarely see rain painted in exhibitions; the default mood is sun, which is safe and bright and happy. Lots of people are grumpy about rain, but I find it quite beautiful. It is not just the fact that land without rain is arid and desolate, but the way in which rainfall affects the landscape from a pictorial point of view. Verticals become darker and inclined, while horizontal surfaces shine. Like mist and haze, it closes down the landscape, unifies and mystifies our world.

When painting rainfall with the overall wash method, the shining hard and horizontal surfaces will be the first wash as they will be the lightest parts of the painting, while most of the vertical surfaces will be second wash. Watercolour is made for rain, as it has a tendency towards soft, diffuse edges and it will of course run – often seemingly of its own free will – without being prodded and pushed around.

The act of painting outdoors on a wet day is a wonderful and rewarding experience, as the paint takes an age to even start to dry – in fact, this is how I learned to paint wet-in-wet. Obviously to paint rain outdoors, we need to get ourselves out of the rain. This can be achieved by using old farm buildings or, if you are in a town, asking a kindly shop owner. Some sort of shelter is essential if the rain is constant. If I can position it conveniently, I often paint from my campervan. Failing this, I have a large fishing umbrella that I can stake out and paint underneath. On days that are merely showery, I take an old carrier bag along with me: in the event of a shower, I quickly pop the bag over the top of the easel. If a wash is still wet, then I turn the painting board over first.

From a practical point of view, once you have got the paint on the paper, the other useful thing is to have a means of drying the painting. I either use the cooker in the campervan, or a small camping stove that fits into my painting bag to warm the piece – for obvious reasons, this requires you to take care!

Opposite:
Prague Rain
Compare this with the painting of Aberaeron on page 93. They both use the device of light roofs, but each portrays very different weather effects. In *Aberaeron* the light roofs are surrounded by lots of hard edges and colour while here we have a very limited palette and an abundance of soft edges, giving a totally different atmosphere.

SUN AND SHOWER

This scene of Brecon, Wales, was about both sun and rain. The challenge of this scene is to portray the harder edged, strongly contrasting areas in the sunlight with the softer, more diffuse effects of the rain. As always, the solutions are to be found in close observation of the different shapes, edges and tones involved.

In this project, we aim to achieve a lot in the first wash of this painting, with the result that only three main second washes are used later: the sky, the distant buildings on the right-hand side, and the nearer building on the left-hand side. Notice how the sharp hard-edged roof area contrasts with the soft diffuse street.

This painting is unusual in the fact that the sky is finished in the second wash, rather than the first, as is usual in landscape painting. Such decisions have to be made when planning the washes.

You will need

23 x 33cm (9 x 13in) Saunders Waterford 300gsm (140lb) Rough surface watercolour paper, stretched on a board

Large mop brush

Size 12, 8 and 6 sable round brushes

Rigger brush

My usual palette of colours (see page 18)

Masking fluid and ruling pen

My inspiration

Teena was in a meeting and I was mooching about on a freezing cold day – at one point even I was driven into a café by the chill.

The day turned to a spate of sun showers with a terrific effect on the atmosphere and I managed to pull off a sketch between the showers of hail.

Opposite:
The finished painting

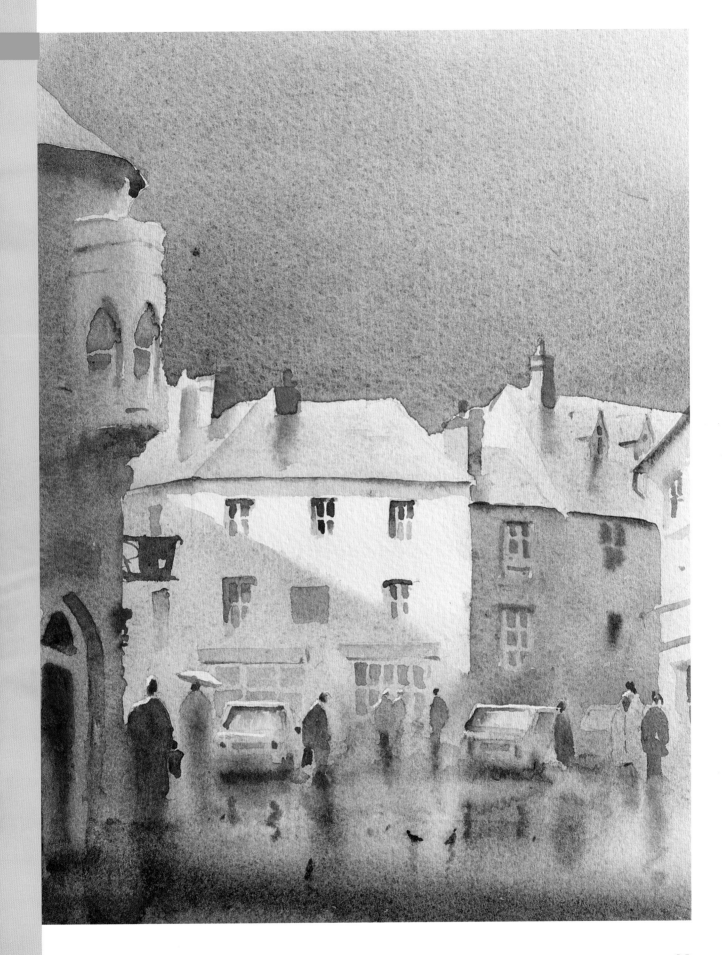

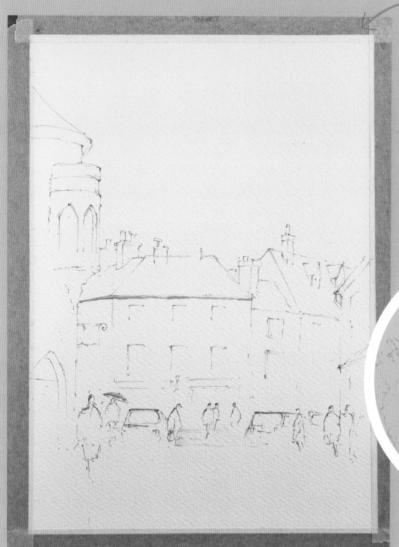

THE SKETCH

The initial sketch was made using a propelling pencil, and secured to the painting board with gummed tape. Use a ruling pen to apply masking fluid as shown, then run masking tape around the edge of the painting area to create a clean border.

Note the long horizontal line of masking fluid – shown in the inset – that runs below the roofline of the central building. This will act as a barrier for the washes.

FIRST STAGE

Usually the sky is virtually completed in the first stage, but this painting is an exception. Because the roofs should be light and have hard edges in the finished painting, the sky needs to be kept light in the first overall wash and the roofs left as one layer (first wash).

Note as well, that the main building is left as white paper. This enables you to place the shadow as first wash while setting the scene for the people and traffic in the wetness below.

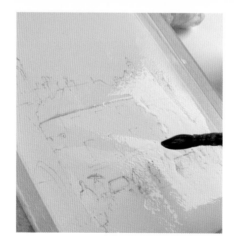

1 Use a mop brush to wet the whole surface of the paper except for the central house – wet this only under the shadow.

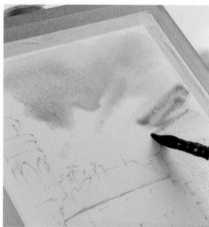

2 Use the mop brush to apply raw sienna and ultramarine blue for a dilute sky. Work right over the roof tops and the right-hand side.

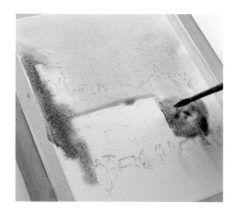

3 Change to the size 8 round brush. Working wet-in-wet, add light red on the left-hand side, then ultramarine violet and burnt sienna on the right-hand side.

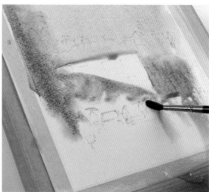

4 Add raw sienna on the left-hand side, then establish the shadow on the central house with a mix of ultramarine blue and cobalt violet.

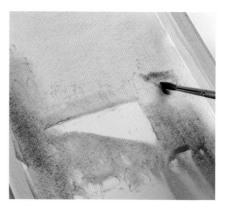

5 Add cerulean blue to the central roof (above the masking fluid line), then ultramarine blue and cobalt violet on the right-hand roof.

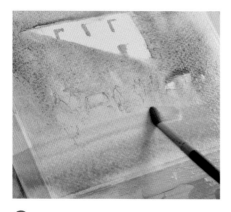

6 Still using the ultramarine blue and cobalt violet mix, use the tip of the brush to suggest shadows in the windows, then the side of the brush to establish the road with horizontal strokes.

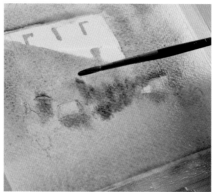

7 Switch to cerulean blue and add the cars wet-in-wet, and use light short strokes of ultramarine violet to blur the horizon at street level.

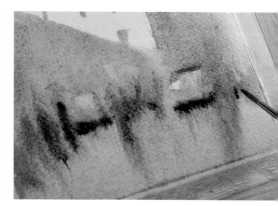

8 Tip the board up more steeply and add silhouetted figures using raw sienna and ultramarine violet. The angle will encourage the paint to run down rather than sideways, ensuring the figures remain relatively slender.

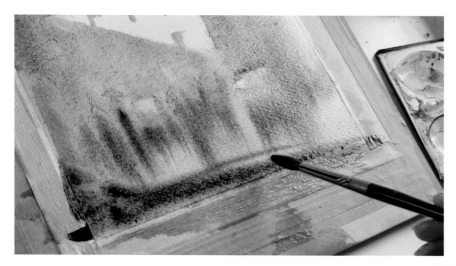

This completes the first stage – allow the paint to dry completely before continuing.

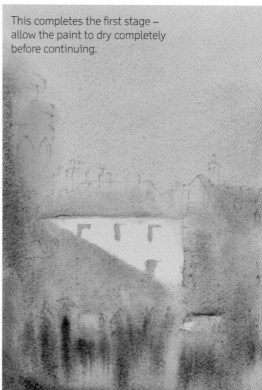

9 Use a stronger dark mix of ultramarine blue and burnt sienna in the foreground, tip the board near vertical to let the paint flow, then lay it back down at a shallow angle and add a strong band of ultramarine blue at the base.

SECOND STAGE

As usual, this stage is primarily concerned with achieving tone, hard edges and some detail. The white house needs to be set up as the focal point, so some hard edges are placed against its shape at this stage.

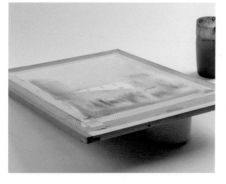

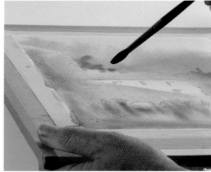

1 Tip the painting backwards so that water will flow away from the roofline, then re-wet the sky using the mop brush and clean water.

2 Drop a deep mix of ultramarine violet and ultramarine blue into the sky using a size 8 round brush, and let it bleed upwards from the roofline.

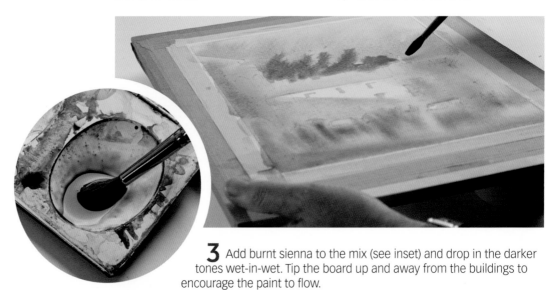

3 Add burnt sienna to the mix (see inset) and drop in the darker tones wet-in-wet. Tip the board up and away from the buildings to encourage the paint to flow.

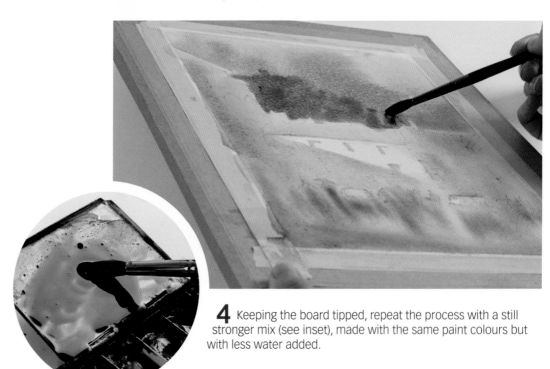

4 Keeping the board tipped, repeat the process with a still stronger mix (see inset), made with the same paint colours but with less water added.

5 Set the board down and correct any edges, by using a dry size 6 round brush to draw up any beads that form. This will prevent them running down over the lower part of the painting. Allow to dry completely.

6 Use a clean dry finger to remove the masking fluid from the roofline.

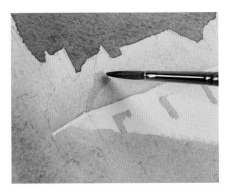

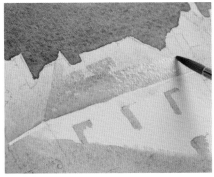

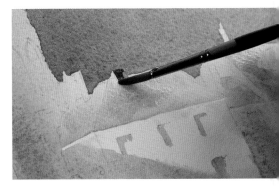

7 Make a dilute mix of cerulean blue and cadmium red and start a bead on the central roof.

8 Draw the mix across the roof, adding occasional hints of the two pure colours for variety. Dilute it away as you reach the right-hand side using clean water.

9 Paint the right-hand roof in the same way, then add a chimney with a mix of raw sienna and ultramarine violet, touching in the paint with the size 8 round brush.

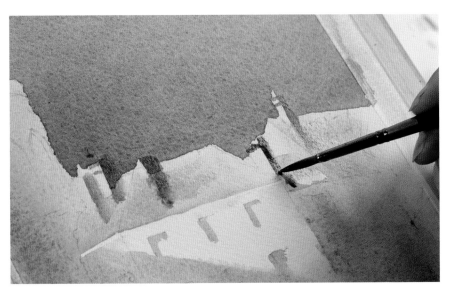

10 Draw the colour down into the wet roof, then add the other chimneys and roof details with the same mix.

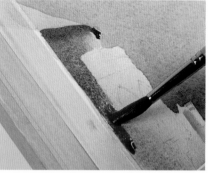
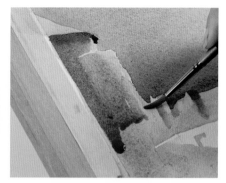

11 Add dark mix of ultramarine blue and burnt sienna (see inset), and use it to paint the shadow below the rooftop.

12 Touch a size 10 brush loaded with a mix of light red and raw sienna to the dark mix and draw the paint down the side of the tower.

13 Use the size 6 brush to draw a very dilute mix of ultramarine blue and cobalt violet across the tower, in order to create the curved effect.

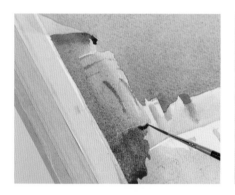
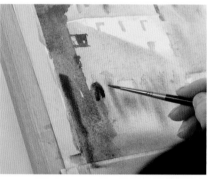

14 Change to the rigger to add dilute touches of the dark mix for detail, such as the arches.

15 Swap between the size 6 brush to draw the wet paint on the tower itself down to the ground level, and the rigger to develop further details like the signpost and figure, using the dark mix.

Detail of the figure once dry.

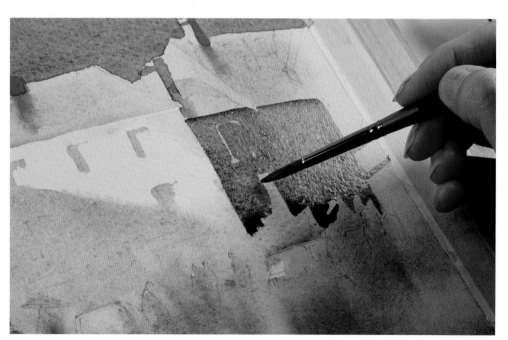

16 Build up the right-hand side of the painting using the colours established earlier – raw sienna, light red, ultramarine violet and ultramarine blue, together with strong darks to strengthen and darken the tone.

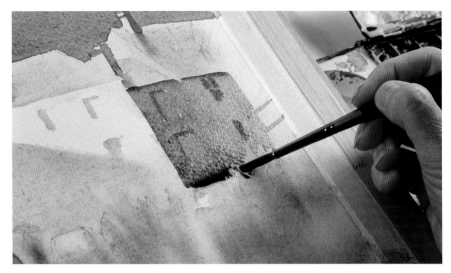

17 Continue drawing the paint down to the top of the car in front of the right-hand building. If necessary, draw away excess paint by touching a clean, dry brush to the bead.

This completes the second stage – allow the paint to dry completely before continuing.

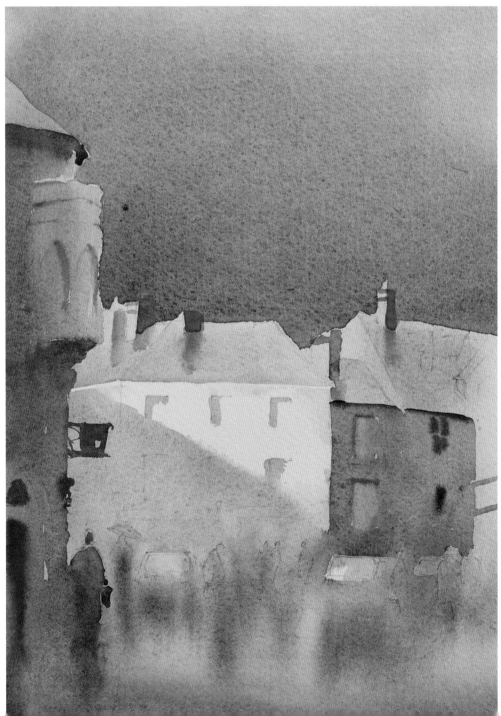

THIRD STAGE

The smaller shapes, such as windows and people, need to be placed now, as well as the wet road, which pushes home the notion that it is a wet, rainy day.

It is important not to overplay the figures and cars as the viewer's eye should find the white house first and strongly-placed figures will detract from this.

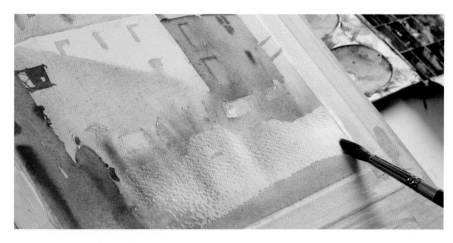

1 Working from the bottom of the paper to the base of the distant figures' feet, wet the foreground with clean water.

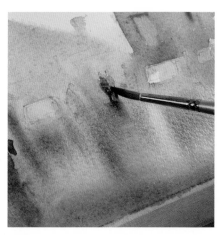

2 Working one at a time, use the size 6 brush to touch in the figures using the existing mixes on your palette.

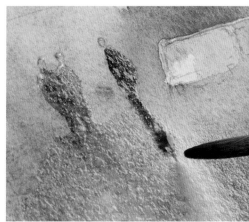

3 As you finish each figure, draw the excess colour into the wet area and let it dissolve away.

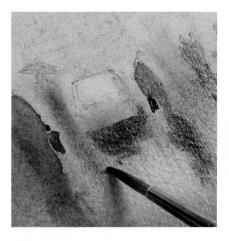

4 Add darks below the cars, again letting it bleed into the wet area.

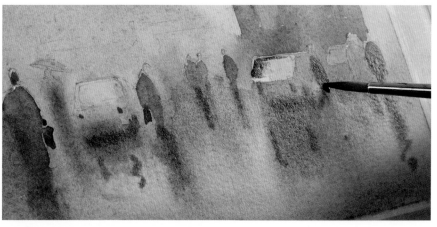

5 Still using the size 6 round brush, touch in the brake lights with light red and add short scribbled marks below each one as reflections. Use a dilute version of the dark mix on your palette to add other details on the cars.

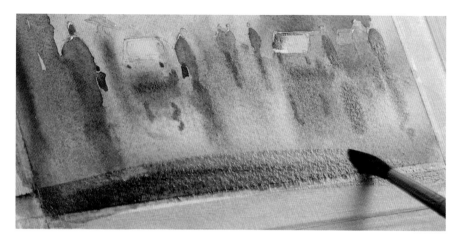 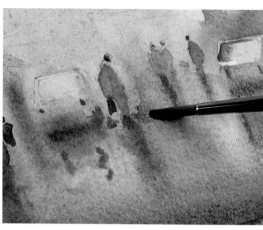

6 Swap to the size 10 round brush and add large dark strokes across the bottom of the painting with a dark mix of ultramarine blue, ultramarine violet and burnt sienna.

7 While the area remains wet, use the size 6 to apply a small amount of the dilute dark mix to the pavement level, to establish the ground.

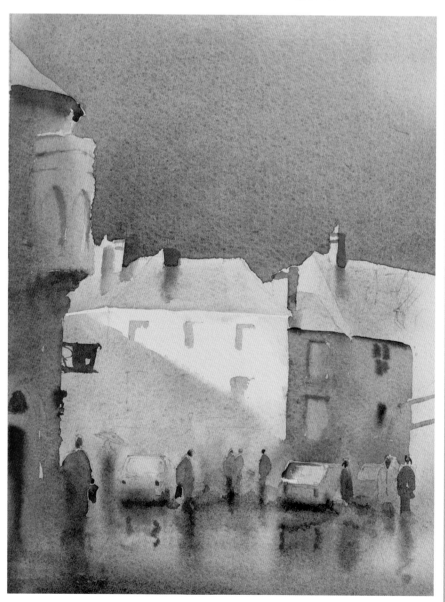

This completes the third stage – allow the paint to dry completely before continuing.

FINAL STAGE

This stage is where we add, refine and establish the specific details that give the painting human interest and create a sense of narrative and atmosphere.

1 Use a clean finger to gently remove the remaining masking fluid.

2 Using the size 3 round brush and a dilute dark mix of ultramarine blue and burnt sienna, add the window panes on the right-hand side. These can be relatively dark.

3 Use the same mix to add the distant figure with the umbrella. Leave a lighter gap between the figure and the figure in the foreground.

4 Develop details on the cars with the same dilute mix and brush. Add shadows to the top and left of the rear windscreens, and suggest number plates with neat horizontal strokes – you need only suggest these, rather than go into detail.

5 Strengthen and reinforce the shadows on the tower, working within the areas established earlier, and leaving fine gaps between the earlier marks and the new ones.

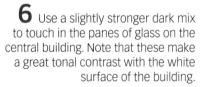

6 Use a slightly stronger dark mix to touch in the panes of glass on the central building. Note that these make a great tonal contrast with the white surface of the building.

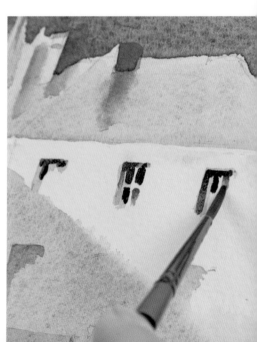

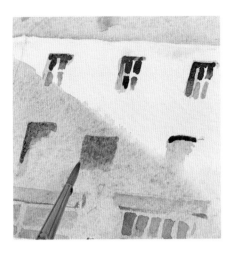

7 Use raw sienna to add the shop sign.

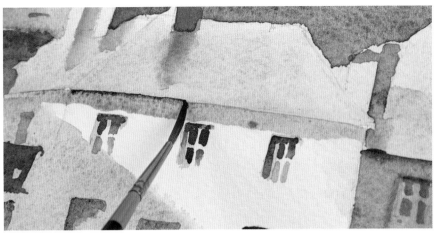

8 Draw a dilute mix of ultramarine violet and ultramarine blue under the roof of the central building. Before it dries completely, run a fine line of the dark mix (ultramarine blue and burnt sienna) along the roofline.

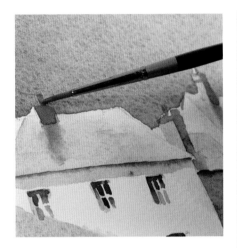

9 Add chimney pots with light red.

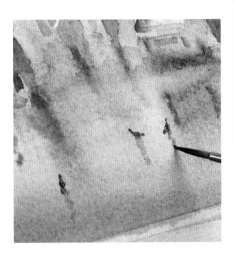

10 Use the dilute dark mix to add some foreground details like these pigeons. Don't forget to add shadows.

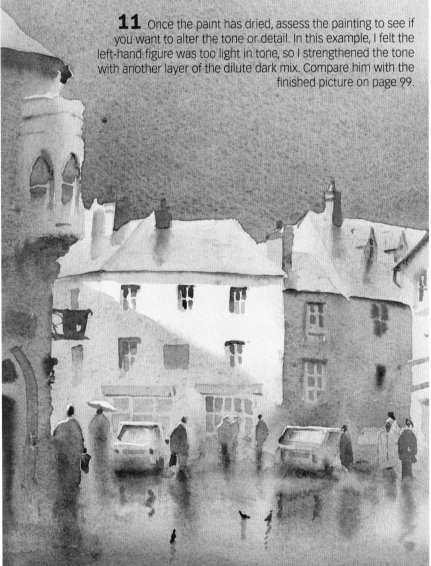

11 Once the paint has dried, assess the painting to see if you want to alter the tone or detail. In this example, I felt the left-hand figure was too light in tone, so I strengthened the tone with another layer of the dilute dark mix. Compare him with the finished picture on page 99.

PAINTING *GHENT RAIN*

On occasion, my wife speaks at various conferences around the world. I tag along and am cast onto the streets to loiter and look, as is the lot of an artist that hates shopping. This painting came from a sketch carried out with a water soluble pencil from the shelter of a doorway on one such trip.

I actually prefer cities in the rain. Buildings appear to fuse into unified masses, while traffic and people flow along beneath in a river of spray and melancholy. I am often the only one smiling at the glory of the day – what's wrong with people?

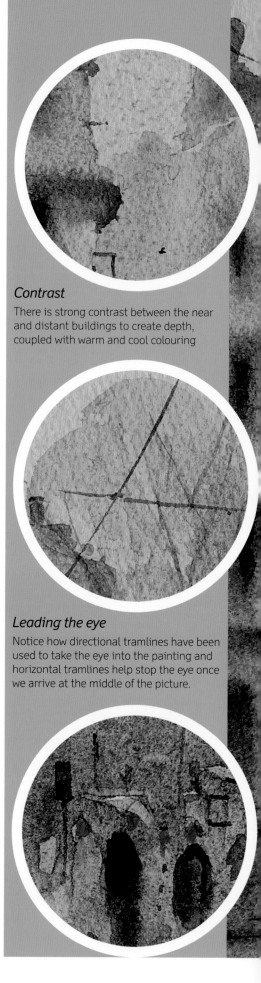

Contrast
There is strong contrast between the near and distant buildings to create depth, coupled with warm and cool colouring

Leading the eye
Notice how directional tramlines have been used to take the eye into the painting and horizontal tramlines help stop the eye once we arrive at the middle of the picture.

Softness
At street level everything is kept soft and diffuse, either by painting onto damp paper or by softening off with a damp brush. This must be carried out deftly or you will muddy areas of the picture.

Undercover painting

My old fishing umbrella invokes many memories for me. It is big enough for two artists to sit under and has a skirt half way round that drops down to the ground and can be pegged into position.

It means that I can paint outside on rainy days and with my camping stove I can dry the painting too.

I have shared my umbrella with some of the best British watercolourists and many other painting friends too. Once or twice it has been shared with total strangers, taking shelter while waiting for a cloud burst to clear. Sitting under its canopy, waiting for a wash to soak into the paper enough to dry it with the stove, many conversations on life, watercolour and the state of the world have been held. Strangers don't stay strangers for long on such occasions.

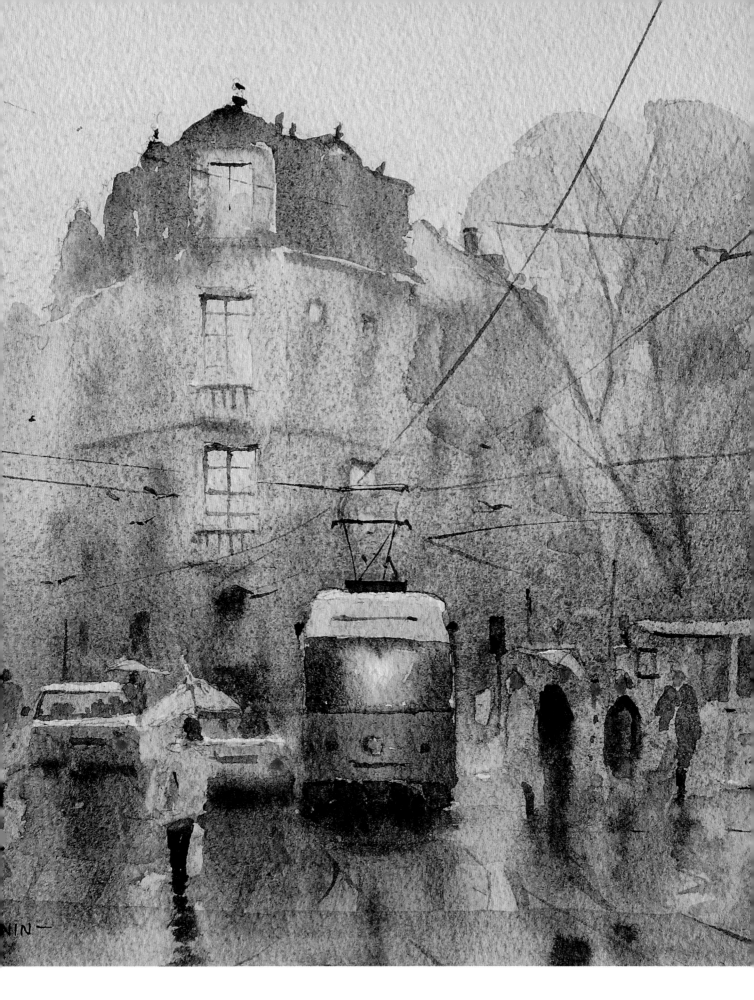

SNOW

Of all the atmospheric phenomena that our planet throws at us snow is probably the strangest. Everything becomes calm, clean and quiet with strong colour wiped from the land unless it can penetrate its fluffy blanket. Edges can be soft or crisp, tones close or strong, depending on the lighting conditions.

In watercolour, snow is handled much like water: it is best treated very simply, with the other shapes in the painting indicating the fact that the snow is snow. The vertical shapes such as walls and trees play a big role in this by adding colour and forming negative shapes. Observation will also tell us that snow is very rarely white but subtle shades of reflected colour from the sky and surrounding objects.

Generally, the bulk of the snow will be first wash with the bulk of the verticals once again second wash.

Painting snow outdoors can be pleasurable, given good conditions and the right clothing, but it is often uncomfortable or near impossible with limbs threatening to catch frostbite, and worse still, washes freezing on the paper. Again the campervan and fishing umbrella help, but be prepared to sketch too. I often use pencil and wash for sketching snow as it is relatively quick and I generally use only one layer of paint over the pencil lines, which act as tone, so the drying time is not such an issue.

Transformative snow

As a child I was brought up on a large housing estate. I had a small 'box' room as my bedroom and remember one winter's evening sitting with the light off on the end of my bed with my back against the wall. I had a view along the whole of the empty, quiet street and the deep snow had covered everything. The street lamps were catching the falling snow in orange haloes and my battered old street was transformed into a magical, special land... ah, the wonder of snow.

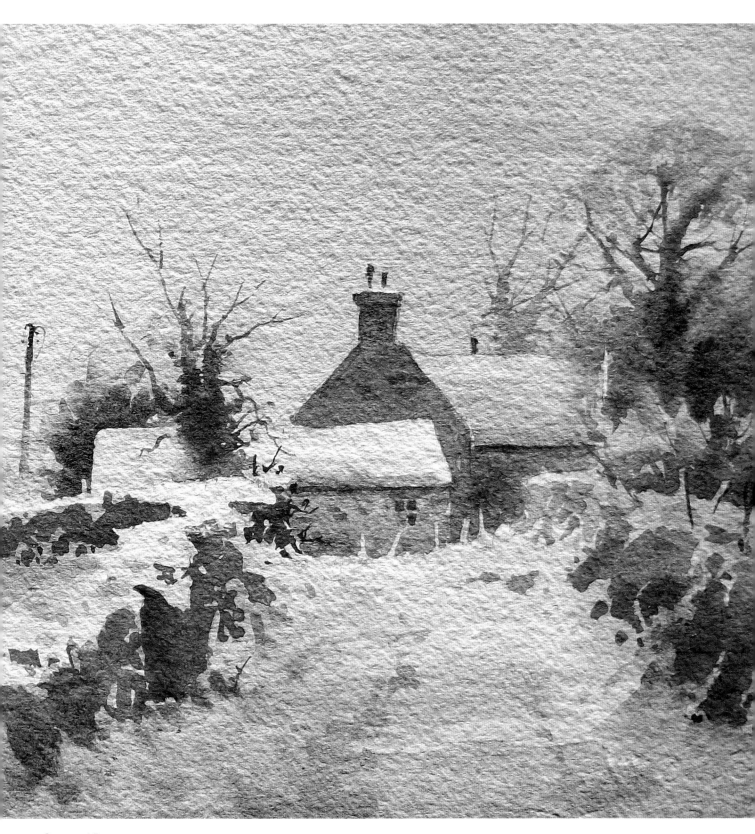

Snowed In

Every time it snows I take my campervan out, slipping and sliding through the local lanes. It can be a bit fraught at times, but the results are worth it. I will either paint from the van or, more likely, carry out as many pencil and wash paintings as I can, to obtain as much source material as possible. It always amazes me how little white paper a snow scene contains and how important the introduction of a little colour, in the form of trees, hedgerows and so forth, is to the eventual success of the painting.

EARLY MORNING SNOW

The scene is based on a juxtaposition of warm and cool areas. It was drawn from one of a number of sketches I completed during a snowy trip around my home. There was quite a chill wind blowing, so all the sketching that day was from the relative warmth of my campervan. Despite the cold day that inspired it, this painting – like many snow scenes – includes a surprising amount of warmth.

As a watercolour, it is very simple in that the sky and land remain as the first wash with the background, midground and foreground shadows painted as second washes. As you progress in your technical and creative skills, the number of stages required to execute a given painting will decrease.

Fiddling and overbusyness spoil the natural luminosity of watercolour, and this will be especially evident in snow scenes: this project will offer you vital practice in keeping things clean.

You will need

33 x 23cm (13 x 9in) Arches 300gsm (140lb) Rough surface watercolour paper, stretched on a board
Large mop brush
Size 12, 8 and 6 sable round brushes
Rigger brush
My usual palette of colours (see page 18)
Masking fluid and ruling pen

The finished painting

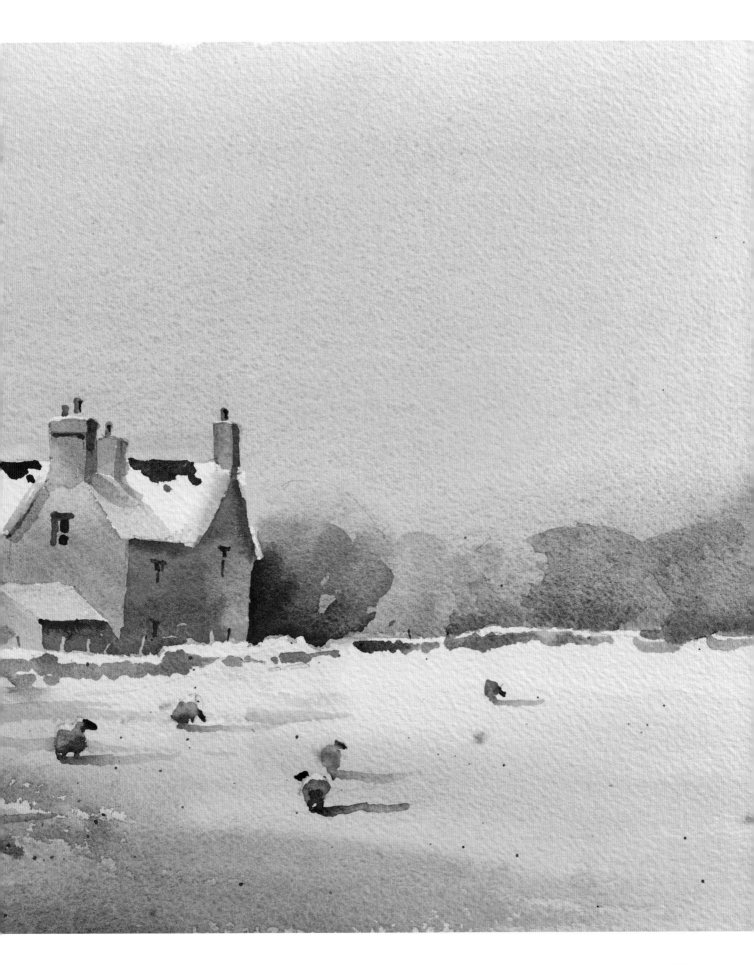

THE SKETCH

Always sketch with the lightest lines you can, this way there will be no need to rub out, thus damaging the paper. Once you are sure of the shapes you can place some stronger lines to secure the design.

It is good practice to draw as little on the paper as you can. Generally speaking pencil work decreases as your confidence grows. If you feel compelled to use an eraser, a soft putty eraser is best.

FIRST STAGE

The first stage should secure the atmosphere. Once again, colour should be placed where you intend the second washes to go. This makes the second washes much easier, as it gives you something to start with and build upon. It also allows you to leave gaps in the second wash, an essential requirement where you intend to have a large area of second wash. Without these gaps, a large area of second wash can appear flat and slab-like.

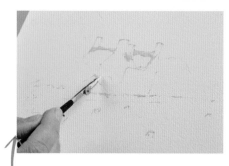

1 Use a ruling pen to add masking fluid to the ridgeline of the roof and along the top of the hedge in places.

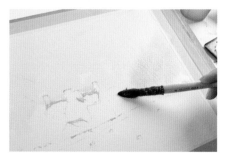

2 Using the mop brush and clean water, wet the sky down to the horizon on the right; wet the area up to the building, but leave the building itself dry; then work slightly over the tree on the left-hand side.

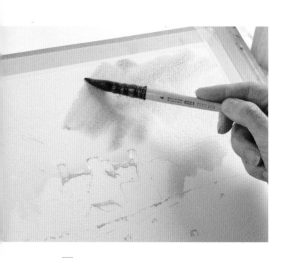

3 Start to build up the sky using raw sienna on the top right, adding dilute cadmium red to the mix as you work towards the left.

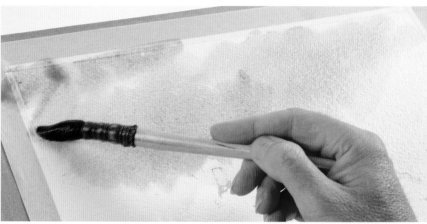

4 Continue working across the sky, towards the top left, adding dilute paint wet-in-wet. Introduce ultramarine violet roughly halfway across, and cobalt blue at the far left-hand side.

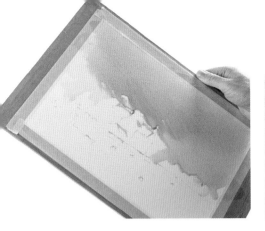

5 Pick up the board and tip and tilt it to encourage the colours to merge.

6 Set the painting back down and use a clean dry size 6 brush to draw up the bead that forms on the horizon at the lower right.

7 While the paint remains wet, add strength to the distant hill with a little dilute ultramarine violet.

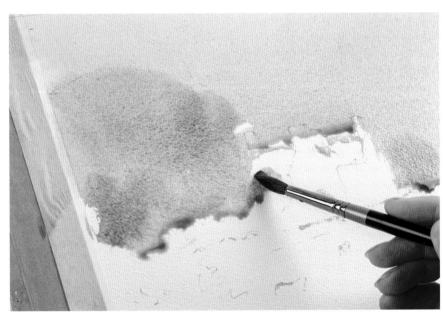

8 Establish the copse on the left-hand side by applying a mix of raw sienna and ultramarine violet with the mop brush.

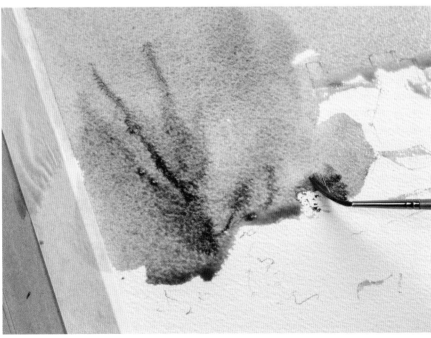

9 Change to the rigger and add burnt sienna wet-in-wet to suggest the trunk and branches of the tree.

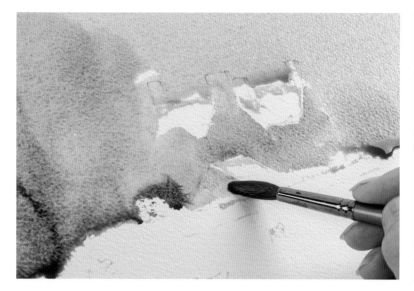

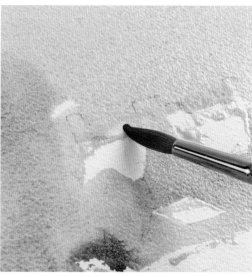

10 Change back to the size 10 brush. Avoiding the roof areas, paint the buildings using cobalt violet, raw sienna and a little of the dark mix (ultramarine blue and burnt sienna).

11 If necessary, rinse and dry your brush, then use it to remove the bead on the roof.

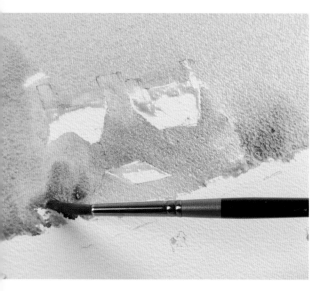

12 Add dilute dark touches on either side of the house.

13 Wet the field using the mop brush and clean water, leaving a clean strip of dry paper on the right-hand horizon.

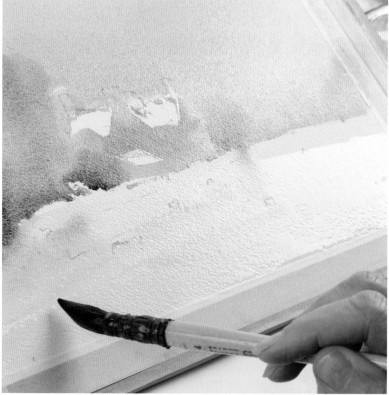

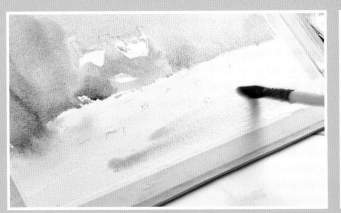
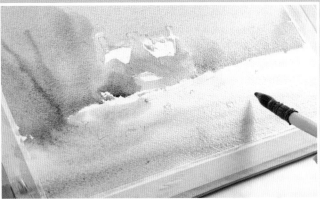

14 Using the mop, add successive strokes of raw sienna, ultramarine violet and ultramarine blue to the foreground, concentrating the violet and blue in the lower left-hand side.

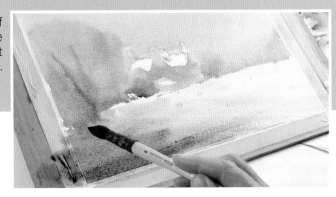

This completes the first stage – allow the paint to dry completely before continuing.

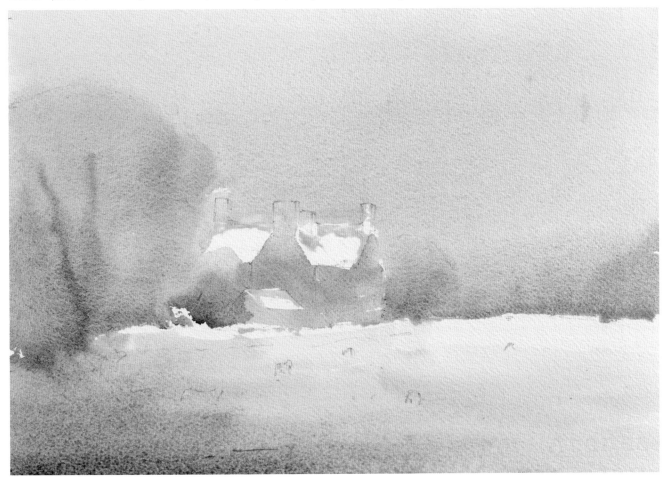

SECOND STAGE

Here we add strength and tone – and thus recession – by placing some of the shapes on the land and strengthening the foreground.

At this stage, everything is kept to big shapes, the details will come later.

1 Remove the masking fluid by rubbing it away gently with a clean finger.

2 Paint the distant pale trees on the right-hand side using ultramarine blue and ultramarine violet. Use the side of the size 6 brush, allowing it to split. This will help to create texture.

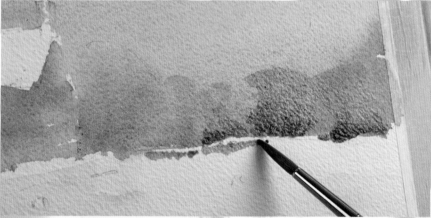

3 Add a slightly darker mix of cobalt violet and raw sienna at the base, working wet-in-wet.

4 Use the tip of the brush to paint the hedgerow with the same dark mix of cobalt violet and raw sienna. Be careful to leave the top white, as shown.

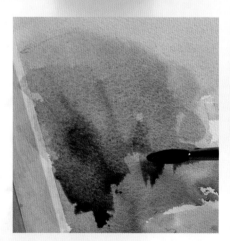

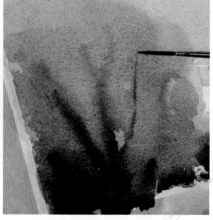

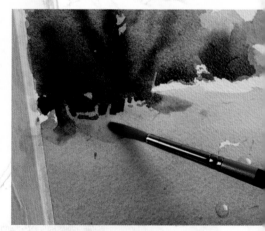

5 Wet the tree on the left-hand side of the house using the size 10 brush. Add dilute light red at the top and the dilute dark mix at the bottom, wet-in-wet.

6 Use the rigger to add branches to the trunk wet-in-wet, using the dark mix.

7 Pick up the bead at the bottom using a clean wet brush to soften the colour in and create a shadow.

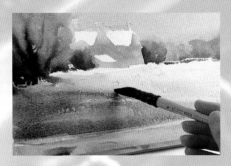
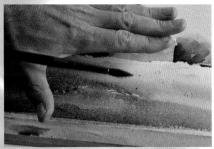
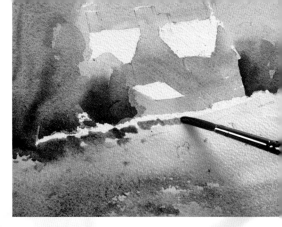

8 Wet the foreground and draw the colour outwards with the mop, adding a mix of ultramarine blue and ultramarine violet wet-in-wet as a cloud shadow.

9 Load the size 10 brush with the dark mix, remove excess paint, then tap the shaft of the brush sharply on your free hand to spatter the foreground.

10 Use the tip of the size 10 brush to paint a broken line of raw sienna and the dark mix to represent the hedge. Remember to leave the top white.

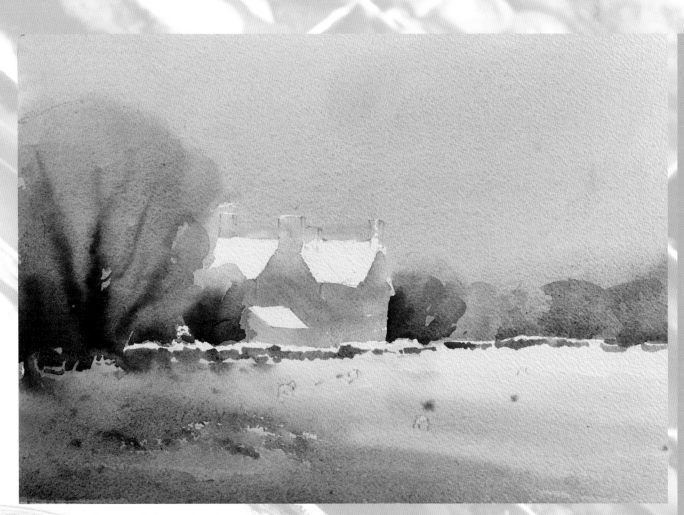

This completes the second stage – allow the paint to dry completely before continuing.

THIRD STAGE

This is where we establish our focal point (the house) and add our bits and pieces to make the shapes 'read' – that is, become fully recognisable as the object it is meant to represent – more easily.

It is important not to overdo this stage and once a shape does read, then I stop.

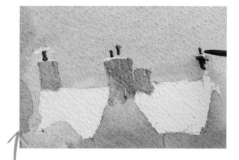

1 Use the size 3 round brush to paint the light sides of the chimneys with a raw sienna and cobalt violet mix. Add cadmium red wet-in-wet for the darker areas in shadow.

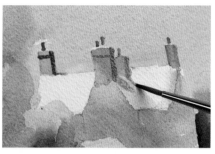

2 Still using the size 3 round, paint the shadows on the roofs with dilute cobalt blue. Add the darker cast shadows of the chimneys using a mix of raw sienna and ultramarine violet.

3 Add burnt sienna to the shadow mix and paint the shaded side of the house wall with the size 6 brush. Work from the roofline downwards.

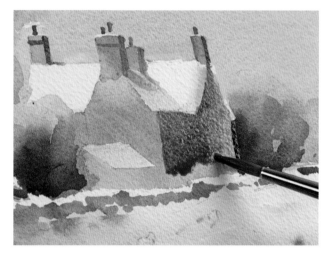

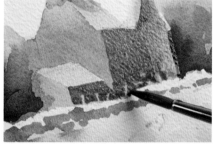

4 As you reach the bottom of the wall, leave small gaps in the wash to suggest fence posts.

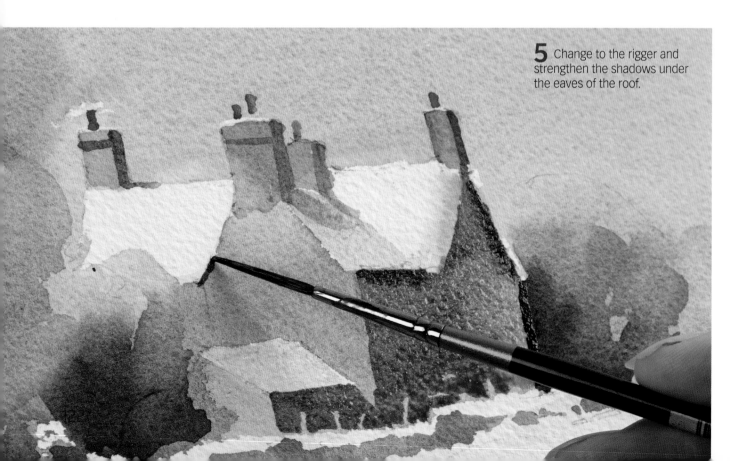

5 Change to the rigger and strengthen the shadows under the eaves of the roof.

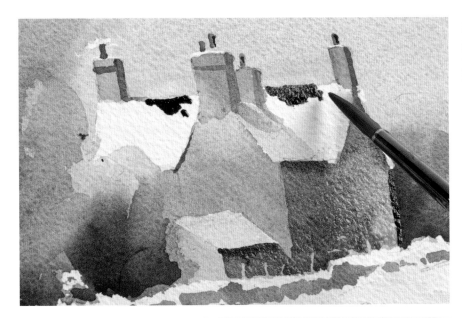

6 Mix burnt sienna with ultramarine blue to make a dark mix and add the visible slates on the roof where the snow has slipped.

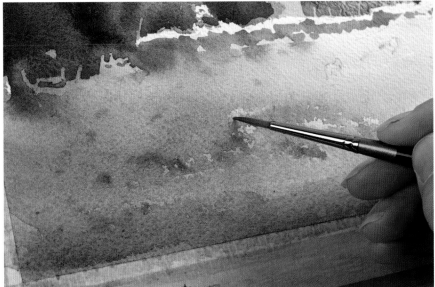

7 Use a damp brush to wet any of the sheep under the cloud shadow and lift out some colour.

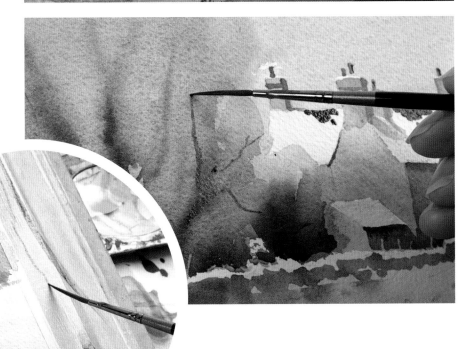

8 Dampen one of the main branches on the tree, then load the rigger with the dark mix (burnt sienna and ultramarine blue). Take off the excess paint by drawing the brush down the masking tape (see inset), then draw finer branches from the dampened area. Let the paint merge with the main branch.

9 By this point, your palette will likely include a variety of interesting darks (see inset). Using the size 6 brush, paint a window on the house, then swap to the rigger to add the heads and legs of the sheep. Use more dilute or paler mixes from your palette to add soft shadows on the bodies of the sheep. If you need to create a new mix – you might run out of darks on your palette, for example – combine raw sienna and ultramarine violet for a neutral dark.

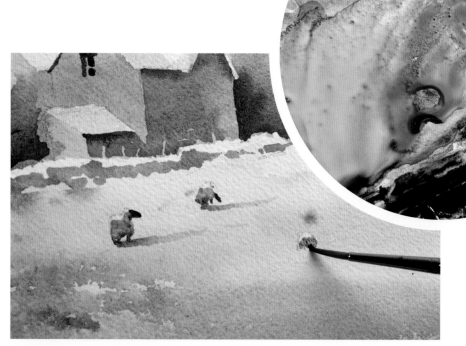

10 Starting from the base of the trees, gently draw out some dilute, cooler (i.e. with more blue in the mix) darks across the foreground as cast shadows.

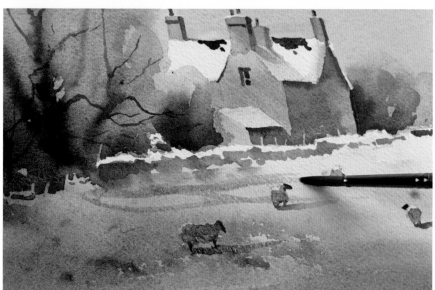

11 Lightly spatter the left-hand side of the foreground with some of the dark mixes on your palette. Don't go overboard – these marks should be relatively subtle.

124

12 Refine the subtle detail in the fence posts using the dark mixes and the rigger. Again, these marks should be subtle – just enough to remove the stark white paper, but not enough to lose the posts in the background.

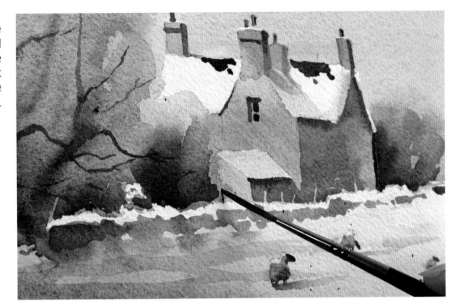

13 Add soft blue shadows on the left-hand rooftop and the top of the hedge to prevent the white being too stark, then use the tip of the brush to hint at one or two windows on the shaded side of the house with simple marks.

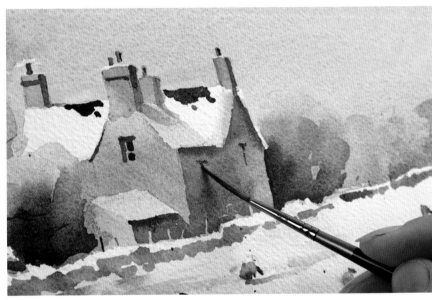

14 Once the paint is dry, carefully remove the masking tape to reveal a crisp border – and the finished painting.

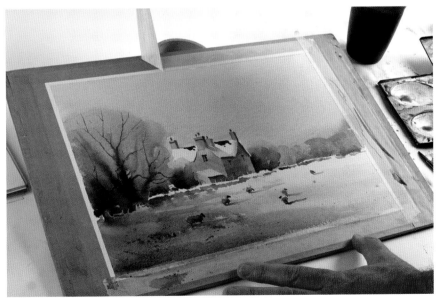

PAINTING *SNOW DOGS*

This was painted from a winter photograph that contained no snow. It proves the fact that if we understand snow in terms of its shape, edge, colour and tone, then we can create as we wish in the studio.

This is an example of what I call a sky/land painting. I use this term to describe a painting where the sky and land are virtually completed in the first all-over wash and then, when this is dry, the shapes that stand on the land are painted on top.

When I paint the second washes, such as trees, buildings and so forth on a sky/land painting, I make sure that I soften certain edges so that these second shapes do not look as if they have been cut out and stuck on like a collage.

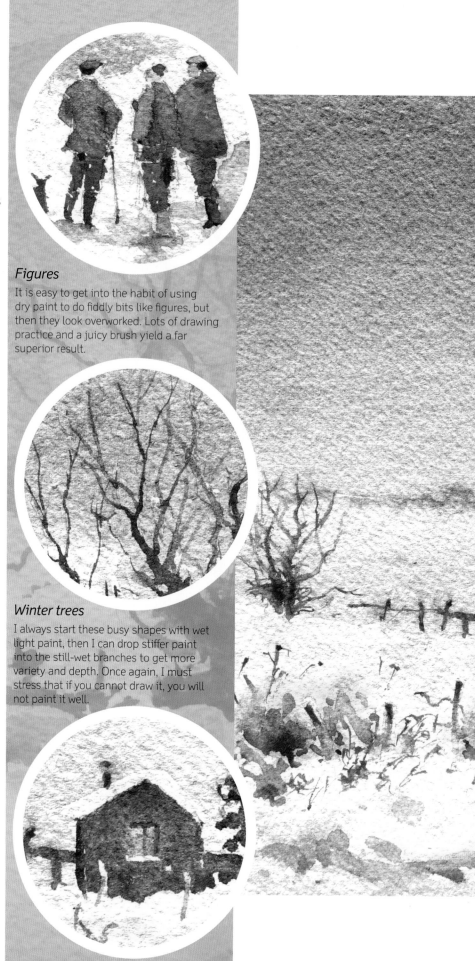

Figures

It is easy to get into the habit of using dry paint to do fiddly bits like figures, but then they look overworked. Lots of drawing practice and a juicy brush yield a far superior result.

Winter trees

I always start these busy shapes with wet light paint, then I can drop stiffer paint into the still-wet branches to get more variety and depth. Once again, I must stress that if you cannot draw it, you will not paint it well.

Shed

This little shape contains a full range of tones as well as varied edges and colour. It makes for a far more interesting shape than one with the same tone, edge and colour.

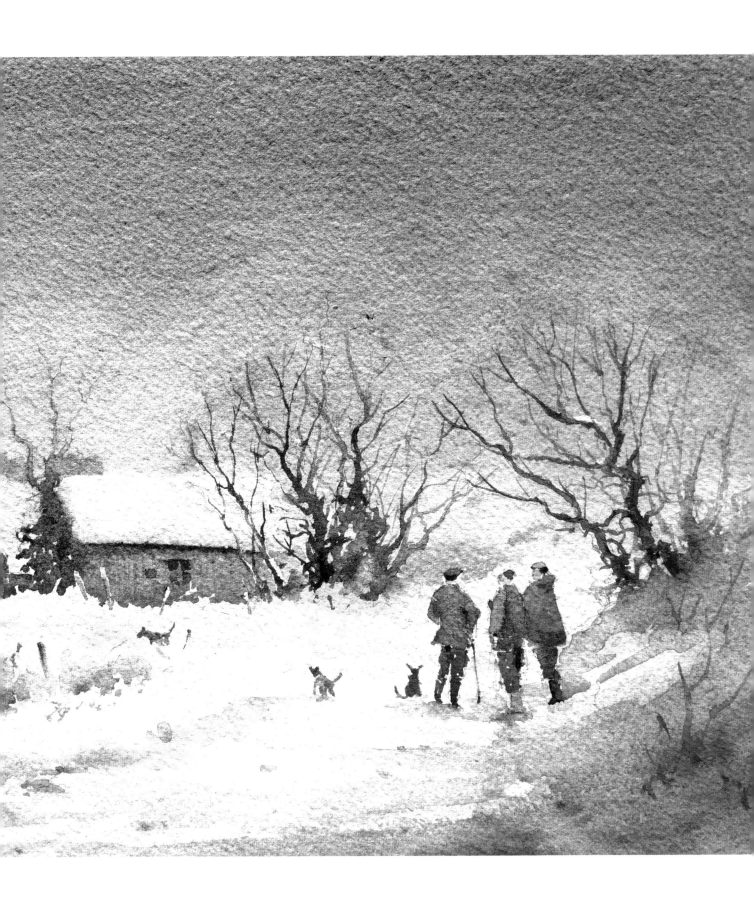

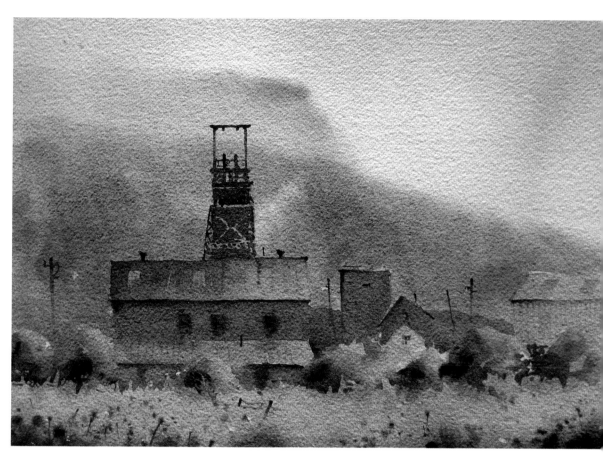

Tower Colliery

Painting on location on a cold, miserable, misty day such as this is a tremendous experience. First, the mood is overwhelming, there is a different emotional edge than with a 'happier' subject and you also have to cope with very difficult, uncomfortable, painting conditions. Despite the solemn mood of this painting, I was immensely satisfied as I headed, cold and alone, back to the campervan.

Opposite:

Lima, Peru

We went all the way to Peru and I ended up on a street corner in Lima, fascinated by the monolithic communications building. I stood on a traffic island sketching the scene. It was a noisy, perilous, dangerous spot, and I almost thought that I would have been better off shopping with the rest of the group. I still have nightmares now – about the shopping, that is!

The painting was completed in three washes, with the sky and sunlit road left as the original first wash. When this was dry the communications building was stated and faded away into the haze and smog by adding water and 'bluing' the original wash. The final wash came down the left-hand building, across the road where it developed the traffic and trees, then back across the road for the foreground shadow.

FOG, MIST AND HAZE

The world grows smaller on a misty day. The horizon appears closer and the familiar becomes shrouded in mystery. Mist, haze and fog are made for watercolour. Gone are the hard edges, strong contrast and overtly colourful palette of sunlight, and in come the soft, diffuse and more muted palette of fog's close relative, rain.

As with rain, foggy, misty or hazy weather conditions are, of course, capable of a shot of rich colour, but the hard, cut edges that rain can still produce on occasion will be absent from our softer friends, with the exception of the immediate foreground. If the sun is on the prowl, our close tones will be lighter and perhaps contain some colour; if absent, then the tonal map stays close but moves darker and colour edges to grey.

Painting outdoors on foggy or misty days is eased by the slowness of drying, but the effect can change by the minute and drying the painting can become problematic with out the aid of the trusty campervan stove or its portable counterpart.

The astute observer will have noticed that painting with the overall wash is predisposed to this soft-edged start. Perhaps the best method for successful foggy, misty or hazy paintings is to push this first wash as far as one can safely go and, once dry, tease as few edges as possible. If painting outside this is no problem, as the painting will stay wet for a very long time, but to do this in the studio a deft, sure touch is needed.

FLOOD MEADOW

This hazy, misty scene met me on my morning dog walk down to our local beach. A rough sea had piled pebbles at the stream mouth, causing the meadow behind to flood. I only had my phone with me so I took a number of photographs from various angles.

The atmosphere of such scenes is gentle and diffuse, with hard edges at a premium. If you contrast this painting with one of the sunny scenes in this book you will fully understand the role of edges in creating mood.

Soft hazy scenes like this demand a thorough knowledge of the wet-in-wet technique and your paint box must be well-moistened to allow rich, juicy pigment to be obtained immediately it is required. In my opinion it is not possible to carry out this type of painting in a hot dry studio or on a hot day, as the water will evaporate off the paper far too rapidly to achieve the required effect.

One way to alleviate this is to wet your painting board, then wet the rear side of a loose (not stretched) piece of watercolour paper. Next, lay the paper onto the board and thoroughly wet the front. You will now have more time to apply your initial washes and, once complete, you can staple the paper to your board, thus ensuring a stretched, tight surface once it has dried.

You will need

23 x 23cm (9 x 9in) Arches 300gsm (140lb) Rough surface watercolour paper, stretched on a board

Large mop brush

Size 12, 8 and 6 sable round brushes

Rigger brush

My usual palette of colours (see page 18)

Masking fluid and ruling pen

Bursts of painting

There are certain days and circumstances that yield a plethora of subject matter for the landscape artist. These events will often result in the production of a greater number of successful paintings than weeks of 'normal' weather and the onset of such an 'event' will send me into a flurry of excitement and activity.

If the circumstance is a lighting condition, then it may be very fleeting indeed. These are times for the camera, as even the fastest artist in the west could not fire off a sketch. Over time, and with practice, I have developed a photographic memory, in that I am able to quickly assess the main relationships of shapes, edges, tones and colours on such days, and use this to make up for shortfalls in the photographs. It also helps to be able to work up such material very soon after the event when the images and feelings are still fresh and alive.

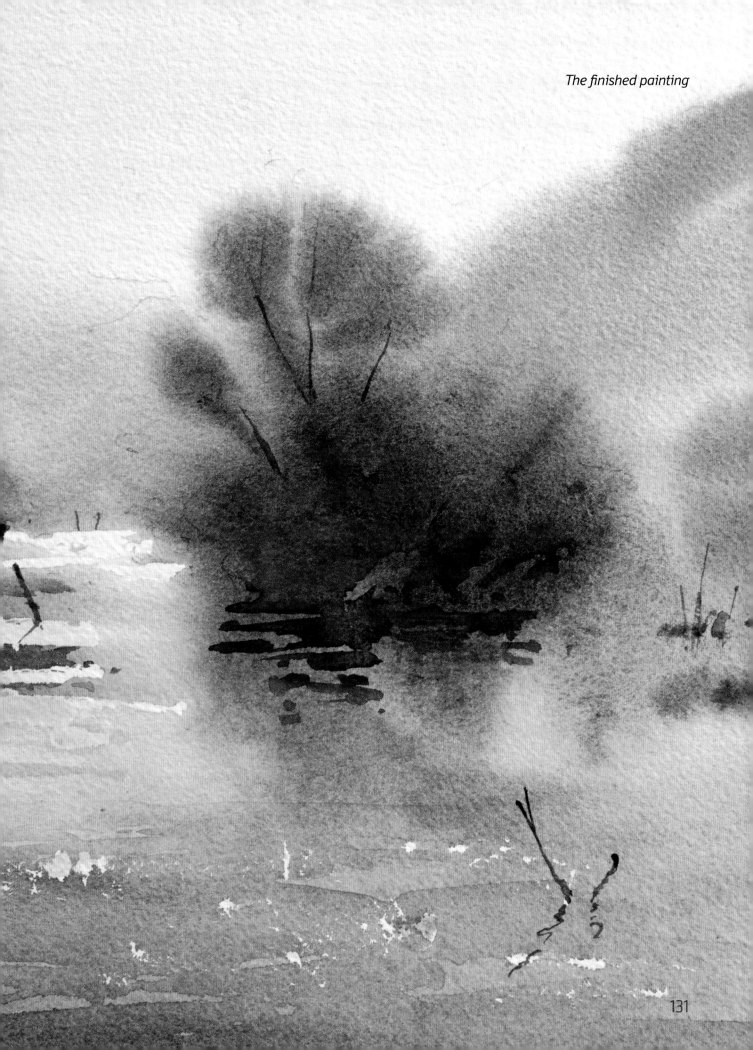

The finished painting

THE SKETCH

Make the initial drawing using a 3B pencil, then secure the paper to your board. Next, run masking tape around the edge of the picture.

As this painting is to be very wet and loose, apply masking fluid with a ruling pen to reserve white paper for areas of the water's surface, as shown here.

FIRST STAGE

For scenes of mist and haze to be successful, the bulk of the painting must be completed to the finished tone and hue in the first wash. We must therefore work in a fast and confident manner, using the side of the brush and with as little fiddling and fuss as possible. If you are inexperienced, then the process for wetting the paper as outlined in the introduction to this painting is well worth following as it hugely extends the drying time and thus the 'live' stage of the wash.

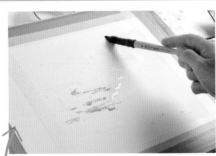

1 Set the board at a shallow angle and wet the whole board using the mop brush and clean water.

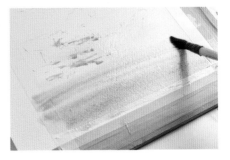

2 Pick up dirty greys from your palette and begin laying in a wash, working upwards from the bottom of the paper. If you are starting with a clean palette, make a fairly dilute mix of cobalt violet and raw sienna.

3 Still using the mop, wet the surface from the top down until you meet the wet lower area. Change to the size 10 brush and deepen the mix with the addition of ultramarine blue (see inset). Use this to paint the distant hill wet-in-wet.

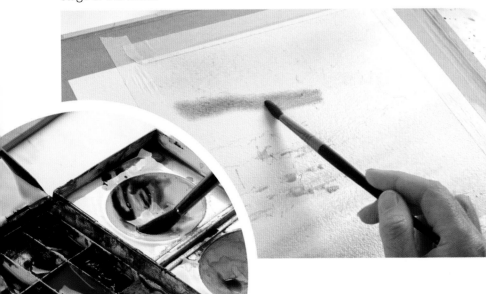

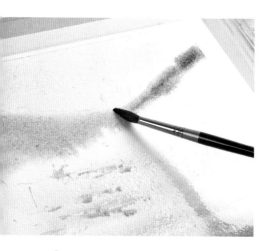
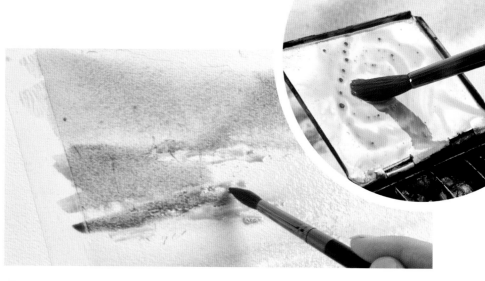

4 Warm the mix with burnt sienna and paint in the nearer hill.

5 Add lemon yellow to the mix to create a green (see inset) and paint in the midground area.

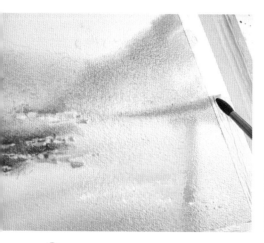
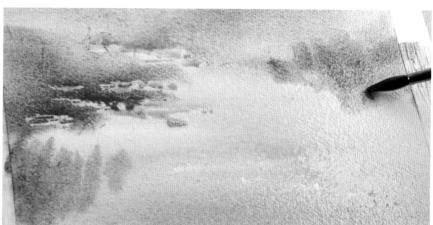

6 Make new mix of lemon yellow and cobalt blue with a hint of light red. Use this to add light touches on the right-hand side of the midground with horizontal brushstrokes.

7 Mix raw sienna with a little ultramarine violet and use this to add foreground grasses and duller bushes.

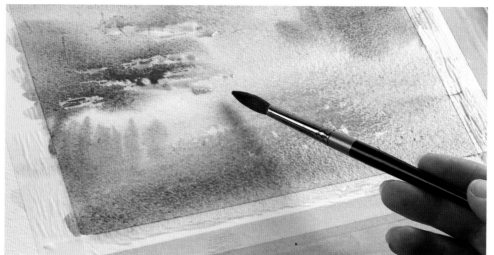

8 Strengthen the foreground with a second wash of grey from your palette. Again, if you need to mix a colour, use cobalt violet and raw sienna.

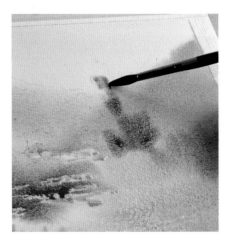

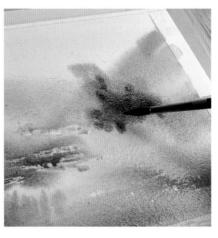

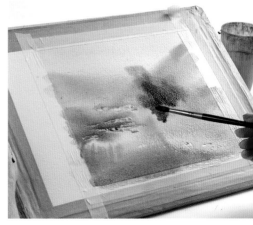

9 Make a strong mix of raw sienna and ultramarine blue with a hint of cadmium red and paint in the central tree with the tip of the size 10 brush.

10 Strengthen the core of the tree by adding more of the same mix wet-in-wet.

11 Tip the board and use the same mix to add the reflection with light touches directly below.

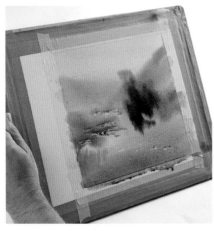
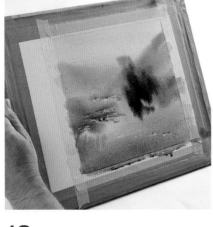

14 Use any paint remaining on the brush to touch in midground bushes.

12 Tip the board up to encourage the paint to drift downwards.

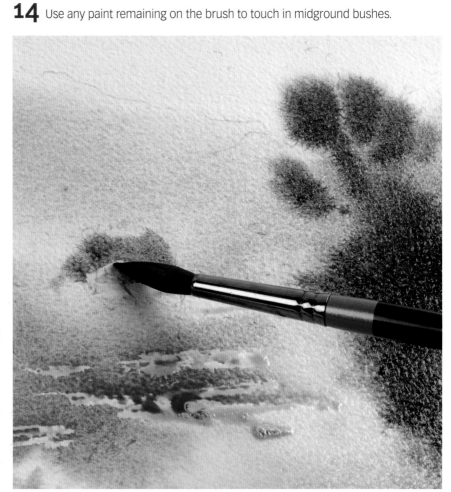

13 Lay the board back down at a shallow angle and touch in a few areas of dense branches.

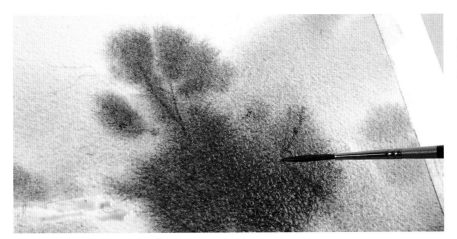

15 Using a strong mix of ultramarine blue and burnt sienna, switch to the rigger and add detail such as finer branches in the foreground bush.

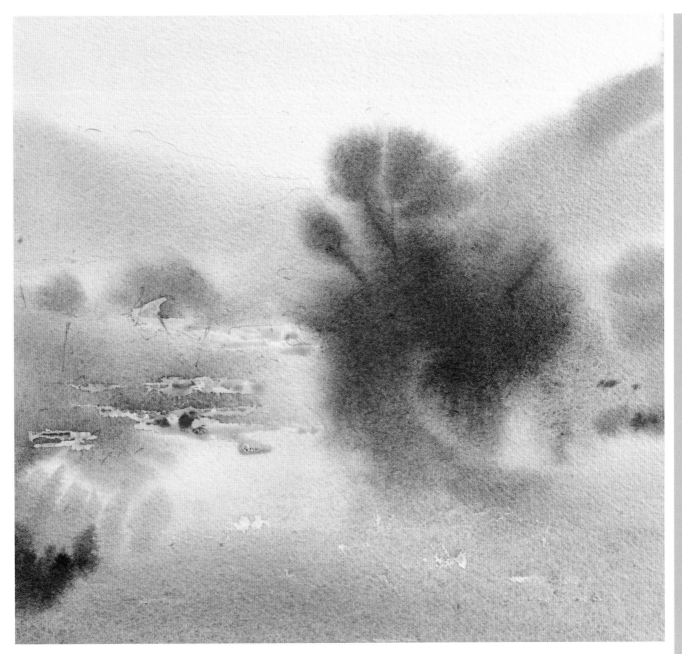

This completes the first stage – allow the paint to dry completely before continuing.

SECOND STAGE

With the bulk of the painting secured in the first stage, this stage is concerned mainly with teasing edges and slightly strengthening tone. How minimal it will be depends on the success of our first wash. The more economy we can exercise, then the better the result will be.

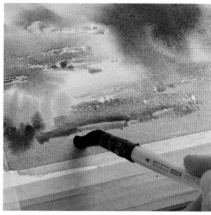

1 Combine any leftover washes in your palette to create a neutral mix.

2 Add a little blue to your neutrals. Using the mop brush, wet the water areas with clean water and add in some darker areas.

3 Switch to the size 10 brush, soften the edges and reinforce the tone in the lower right with the neutrals from your palette added wet-in-wet.

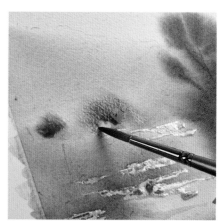

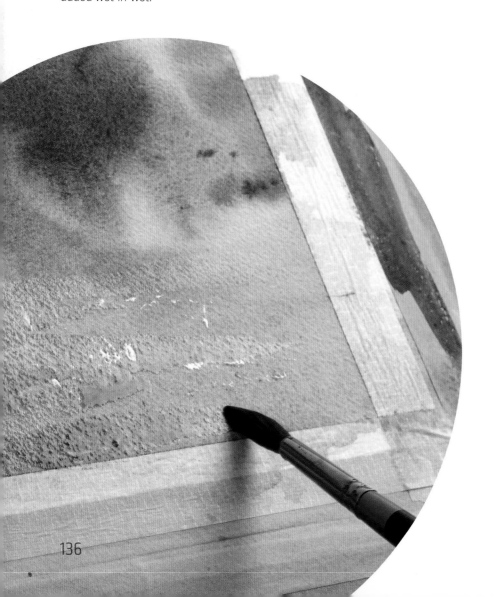

4 Re-wet the midground bushes with clean water, then add some neutrals from the palette using the size 6 brush.

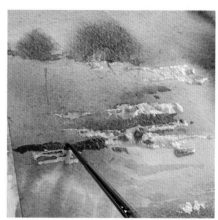

5 Add some stronger greens on the meadow with a mix of lemon yellow, cobalt blue and neutrals from the palette.

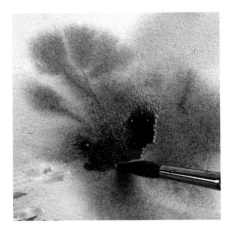

6 Change to the size 10 round and wet the lower part of the tree with clean water, applying it gently to avoid disturbing the paint. Drop in some stronger darks wet-in-wet .

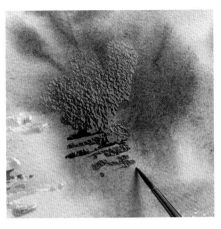

7 Use the rigger to tease out some wet paint from the bottom of the tree and create rippled reflections with short, roughly horizontal lines.

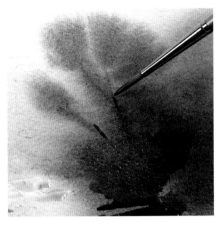

8 Tease up some twigs and branches from the wet, dark area.

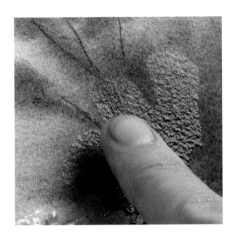

9 Use your finger to break the bottom of the branch, gently smudging it into the dark area.

This completes the second stage – allow the paint to dry completely before continuing.

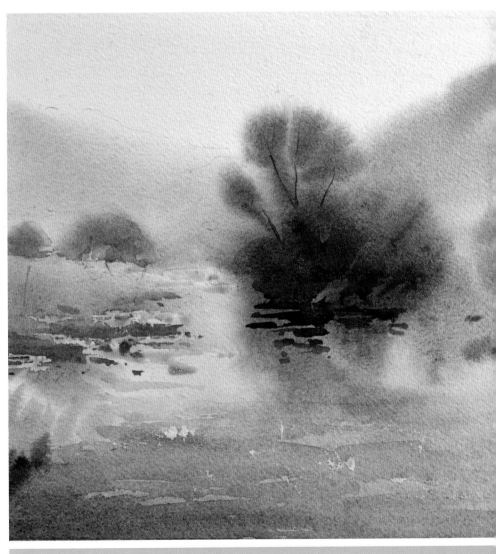

FINAL STAGE

The painting should be well 'in the bag' by now; all that is required are small items like twigs and posts to secure the painting.

1 Gently remove the masking fluid by rubbing it with a clean finger.

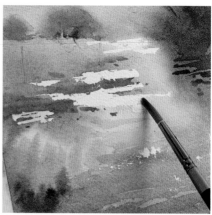

2 Use dilute mixes from the palette to soften some of the hard edges that are revealed by removing the masking fluid.

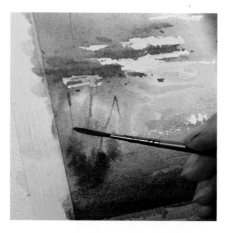

3 Use the rigger to add fine lines and details to suggest foreground bulrushes, with a dark mix of ultramarine blue and burnt sienna.

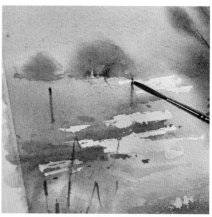

4 Use the same brush and mix to add fenceposts in the middle distance.

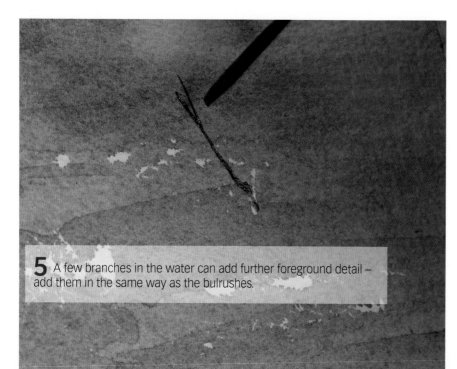

5 A few branches in the water can add further foreground detail – add them in the same way as the bulrushes.

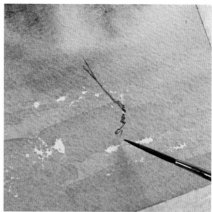

6 Branches in the water need reflections – make sure these are a mirror image.

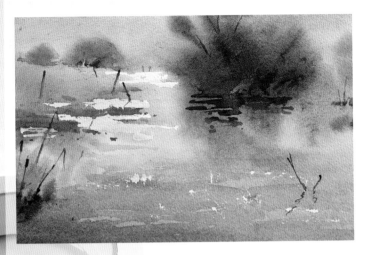

7 Add any further fine details that you wish across the painting, but don't clutter it – add them sparingly. Putting in some smaller fenceposts in the background helps to suggest depth.

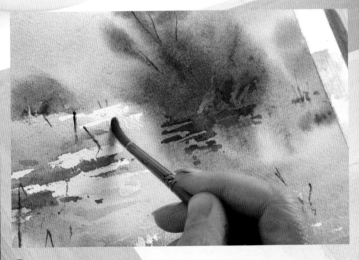

8 To increase the sense of distance and the haziness, use a clean wet size 10 to gently agitate the stark white areas on the horizon. This will soften any hard lines in this area.

9 Allow the painting to dry, then remove the masking tape to finish.

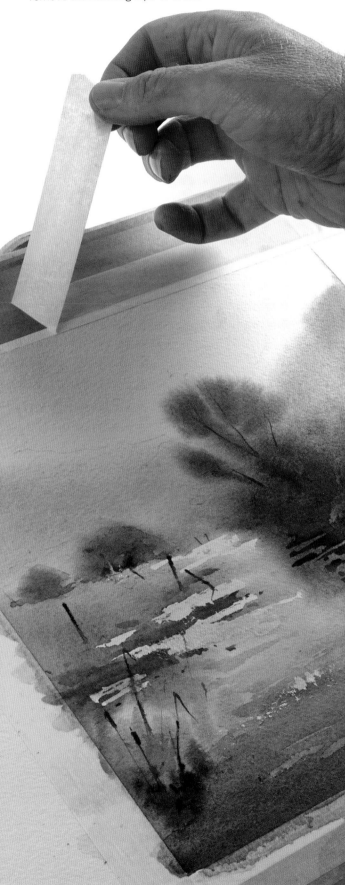

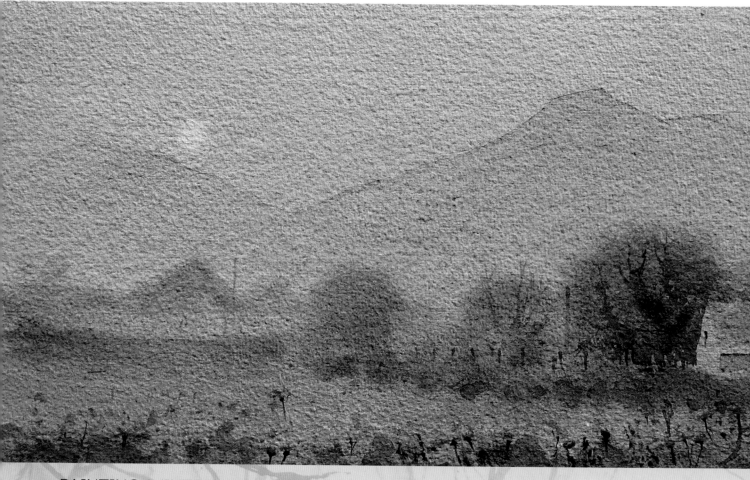

PAINTING *WINTER HAZE*

This was a 'pea souper' of a day and the effect on the landscape was surreal. I love the way the word seems smaller and more magical on such days.

There was the hint of an edge here and there but soft edges and close tones were the order of the day. Just like the demonstration on the previous pages, the bulk of this painting was secured in the first overall wash. Only the hard edged shapes such as the mountain, the barn and the foreground twigs were second wash.

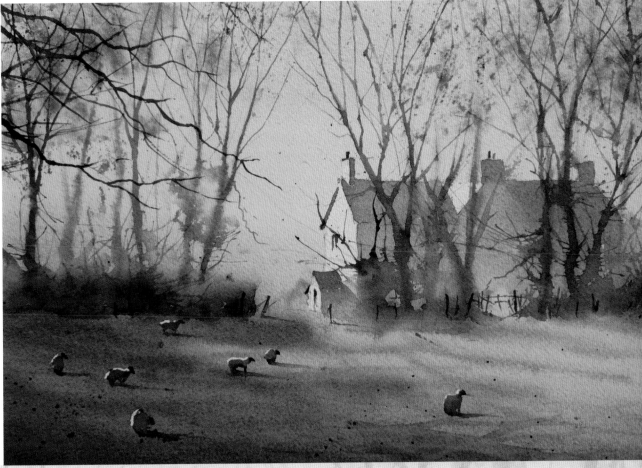

PAINTING *MORNING HAZE*

This painting is of a place I drive past many times; some days it will work as a subject and some days it just does not appeal.

Paintings of sunlight, in my opinion, are much easier than paintings such as this. Sunlight is harsh and obvious, but quite a deft touch is required to render these subtle, more fleeting moments. Quite a lot of wet-in-wet work was placed during the first pass from the top to the bottom of the paper. Once dry, the effect was virtually in place and it only needed a few harder edges to finish the painting.

AFTERWORD

We live in a staggeringly beautiful world and yet we seem to spend most of our time rushing through it, our mind and eyes elsewhere. To many, introspection, compassion and kindness are seen as weaknesses to be replaced by the gods of consumerism and greed. Nature is still out there, in the quiet of the countryside and on the streets of our towns and cities. If I am working in a city, I will tuck myself away and quietly watch the hustle and bustle or I will dash in and conduct a quick raid with a sketchbook. Like many people, I suppose, I have never quite fitted into the overbearing pace and shallowness that make up an ever increasing part of modern life. One of my joys is to go away, out of season, in my campervan and seek out all the remote and quiet places. There is nothing more pleasant than slowing down and taking time to actually look at the world. Painting is a sublime way to do this and I do hope my ramblings have helped you with your journey.

Keep painting and – who knows? – maybe one day you will find yourself on a deserted stretch of coast, easel set up, with you, ready and poised, brushes in hand, for the tussle ahead. The dawn sky is slowly losing colour, lightening as day approaches, as you pounce – and in less than an hour of frantic activity, it's there, it's done. Then, as you slowly pack away the tools of your trade, you glance across at the easel and smile, as you, your heart, and the mood of the hour lie gently and quietly on a sheet of watercolour paper.

Port Isaac

In a large studio painting such as this, it is always a struggle not to get over-busy and spoil the atmosphere with lots of fiddly brushwork.

The foreground puddles had to be placed in the first wash, necessitating a second wash for the foreshore. Without the puddles, I could have completed the foreshore in the first overall wash.

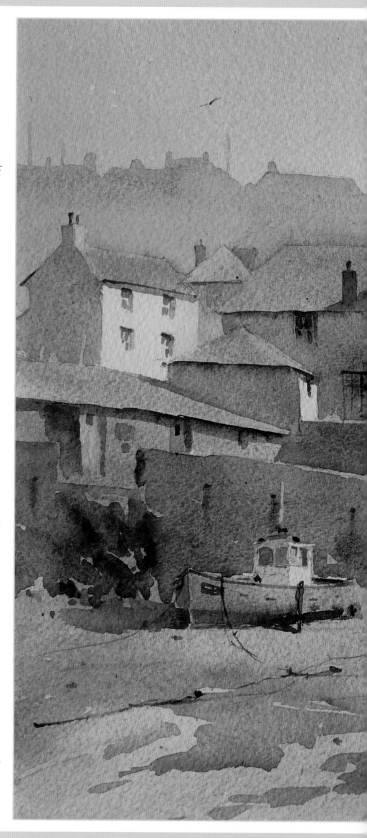

142

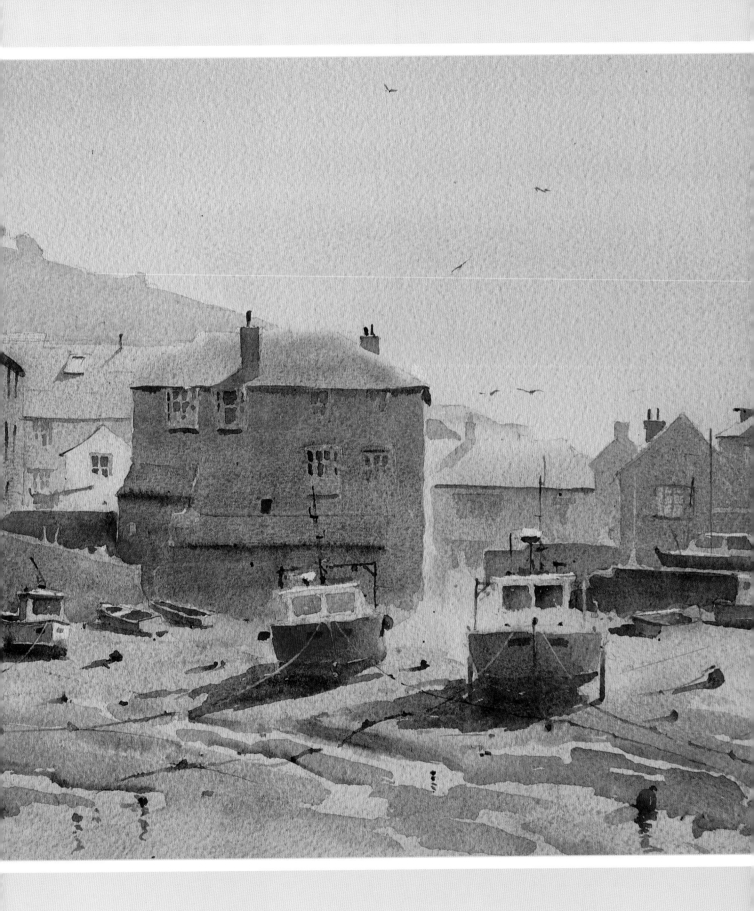

INDEX